Creative Digital Monochrome Effects

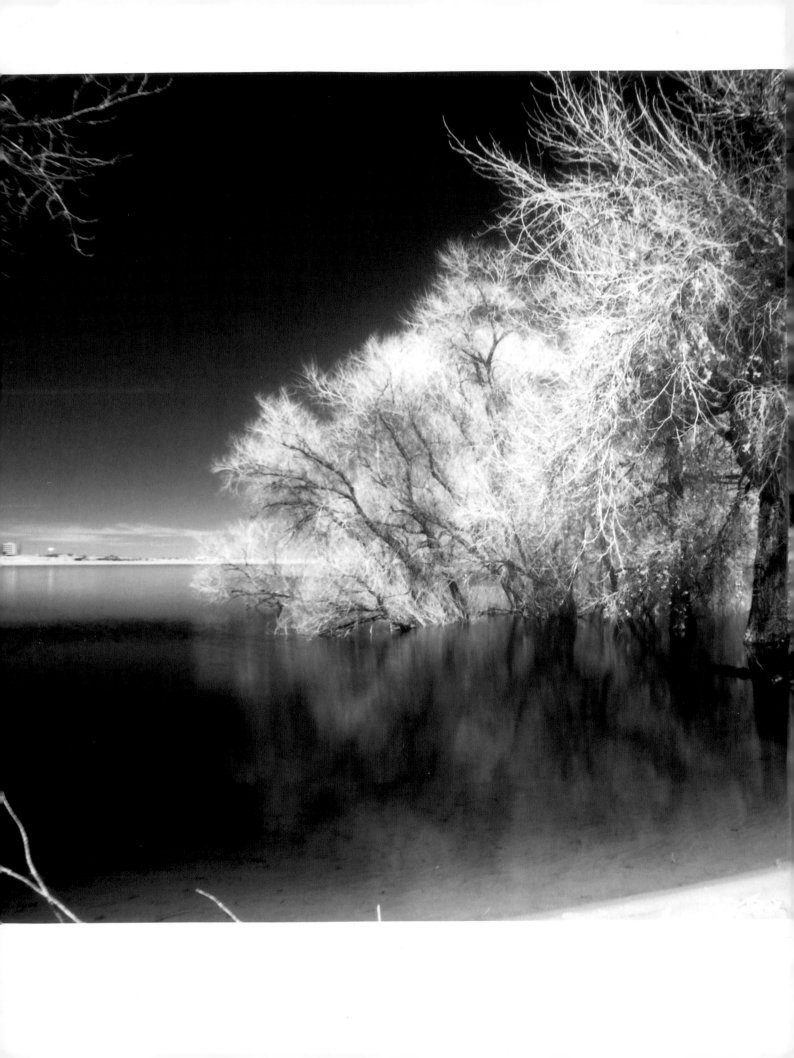

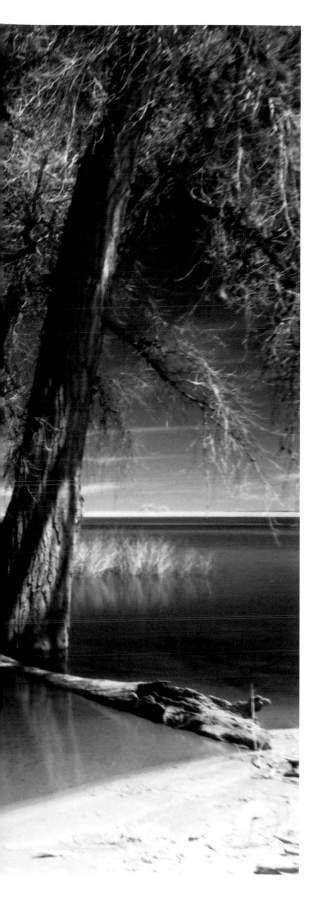

Creative Digital Monochrome Effects

Go Beyond Black and White to Make Striking Digital Images

Joe Farace

LARK BOOKS

A Division of Sterling Publishing Co., Inc.
New York / London

Editor: Haley Pritchard
Art Director: Tom Metcalf – tommetcalfdesigns
Cover Designer: Thom Gaines

Library of Congress Cataloging-in-Publication Data

Farace, Joe.
 Creative digital monochrome effects : go beyond black and white to make
striking digital images / Joe Farace. — 1st ed.
 p. cm.
 Includes index.
 ISBN 978-1-60059-264-5 (PB with flaps : alk. paper)
 1. Photography—Digital techniques. 2. Black-and-white photography. I.
Title.
 TR267.F348 2009
 778.3—dc22
 2008019092

10 9 8 7 6 5 4 3 2 1

First Edition

Published by Lark Books, A Division of
Sterling Publishing Co., Inc.
387 Park Avenue South, New York, N.Y. 10016

Distributed in Canada by Sterling Publishing,
c/o Canadian Manda Group, 165 Dufferin Street
Toronto, Ontario, Canada M6K 3H6

Distributed in the United Kingdom by GMC Distribution Services,
Castle Place, 166 High Street, Lewes, East Sussex, England BN7 1XU

Distributed in Australia by Capricorn Link (Australia) Pty Ltd.,
P.O. Box 704, Windsor, NSW 2756 Australia

If you have questions or comments about this book, please contact:

Lark Books
67 Broadway
Asheville, NC 28801
(828) 253-0467

Manufactured in China

ISBN 13: 978-1-60059-264-5

For information about custom editions, special sales, premium and corporate purchases, please contact Sterling Special Sales
Department at 800-805-5489 or specialsales@sterlingpub.com.

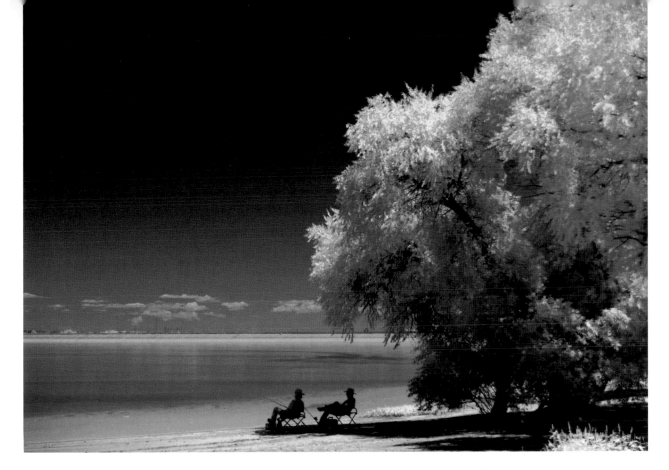

"I awoke this morning with devout thanksgiving for my friends, the old and the new."— Ralph Waldo Emerson

Acknowledgements

Many wonderful people contributed to this book's production. The most important being Lark Books' Marti Saltzman, whose idea for a book about creating monochrome effects that emulate traditional (even archaic) photographic darkroom techniques coincided with my life-long passion for the subject in both the traditional and digital darkroom.

The real fairy godmother of this book is Bea Nettles (www.beanettles.com), whose landmark 1977 book "Breaking the Rules" initially got me interested in some of these "lost" photographic techniques. While I was never a virtuoso darkroom worker, her book and the images in it influenced my photography in 1977 and continues to do so today as I try to apply some of her alchemy to the digital realm. I would also like to extend my deep appreciation to Jack and Beverly Wilgus, who were my teachers at Maryland Institute and showed me that craft and creativity were two sides of the same coin. They were not only my instructors, but they are people whose words and ideas became a constant inspiration for my photography from the first day that I met them.

I would also like to thank Robert Beasley of Acclaim Software for his insights on digital noise and tips on how to use Focus Magic software to remove noise from blurry photographs.

Thanks to DxO's Deborah Gallin for her assistance with the company's film emulation software, and to Adorama's Jerry Deutsch for providing products for testing and evaluation along with Yiddish wisdom about the craft of photography. I want to extend my appreciation to Epson USA and Merritt Woodard from Walt & Company for providing an Epson Stylus Photo R2400 that was used both to explore various printing processes and to make the match prints for all the images that appear in the book.

Many special thanks goes to my own "Baker Street Irregulars" who are a source of ideas and inspiration to me on an almost daily basis. This includes Ralph Nelson (www.ralphnelson.com), Paul Peregrine (www.lightwareinc.com), and Barry Staver (www.barrystaver.com), who offer a continuing stream of ideas and concepts. I'd also like express my deepest gratitude to my loving wife Mary, who has endured my photographic obsessions for more that twenty-five years. She is the inspiration that helps me to get up in the morning, and her support encourages me to continue to make images. Mary also contributed a few images for the book, and I thank her for that as well. These wonderful people's inspirations and contributions are responsible making this book the best it could be.

Joe Farace

Brighton, Colorado

Table of Contents

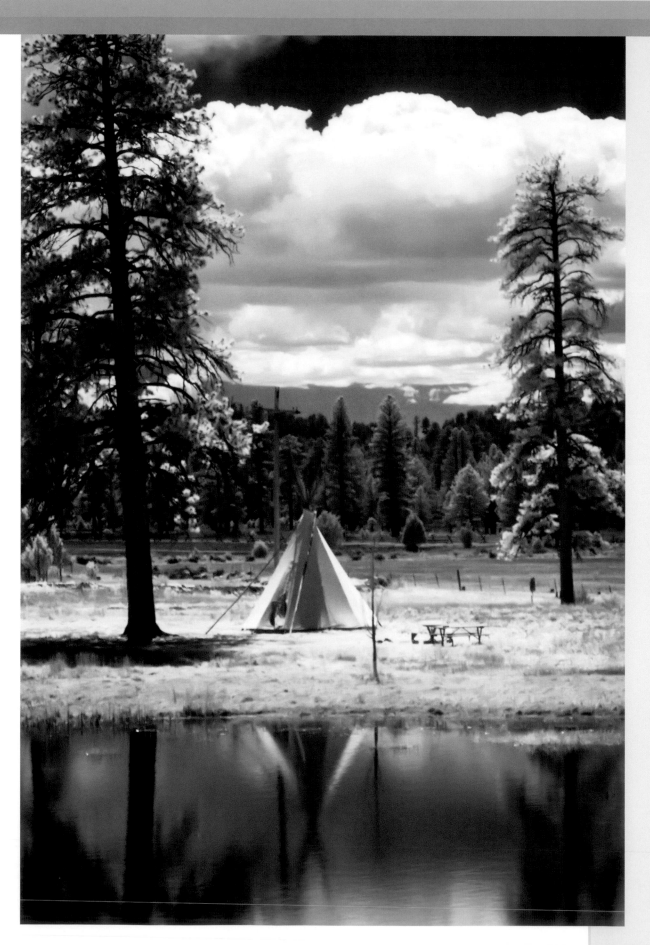

Foreword

If I knew half as much about photography as my colleague Joe Farace knows, I'd be a better photographer. It helps that Joe's immense knowledge is gathered in a remarkable thirty books and countless hundreds of magazine articles. I confess that I haven't read nearly as many of them as I should have. Don't you make the same mistake.

When it comes to our shared passion for black-and-white photography, though, Joe and I are equals. Browse through Joe's impressive body of photographs and you'll see that he's just as good at black-and-white as he is at color. And Joe has taken his black-and-white work seamlessly into the digital realm, while I'm struggling to make that important transition. Just before sitting down to write this, in fact, I was trying to figure out the best way to convert RAW files I shot with an infrared-sensitive digital SLR to black and white for printing. I could have saved myself a bunch of trouble if only I'd asked Joe for an advance copy of the second chapter of this book, which covers black-and-white postproduction, or better yet, the section on infrared in chapter four. I was weaned, just like Joe, on the traditional black-and-white darkroom, but I'm still striving to make sense of photography's brave new digital world.

This is why Creative Digital Monochrome Effects is the one, of all Joe's books, for which I've been holding my breath. And now I'm letting out a sigh of relief because it's among the most comprehensive treatises I've ever seen on digital black-and-white photography. (Call me old-fashioned, but I still prefer that term to monochrome.) The book takes you from the most basic aspects of this subject to the most advanced, covering everything from the different ways of turning color images into black-and-white ones and using in-camera digital filters that eliminate the need for the familiar glass ones, to mixing color with black and white using layers (which still confuse me!) to tritone printing, which gives monochrome inkjet output a rich tonality and delicate image tone. Read this book and you'll also learn how to tone your black-and-white images digitally, a technique much less arduous, and less hazardous, than the chemical process Joe and I used in our former photographic lives.

Joe even delves into digitally simulating 19th-century "alternative" processes that have made such a comeback among artier photographers. These include cyanotype, gum bichromate, and bromoil, a technique so tricky that, when forced to do it the old-fashioned, ink-based way, I gave it up! I'm counting on Joe, and Creative Digital Monochrome Effects, to inspire me to take it up again—digitally, of course.

Russell Hart

Executive Editor, American Photo magazine

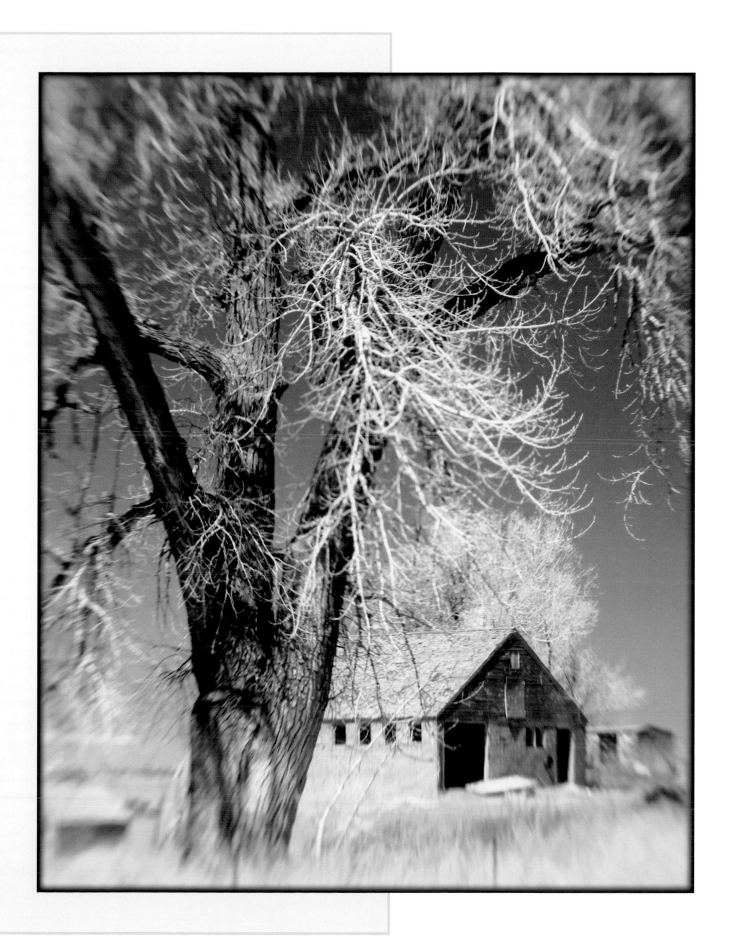

Introduction

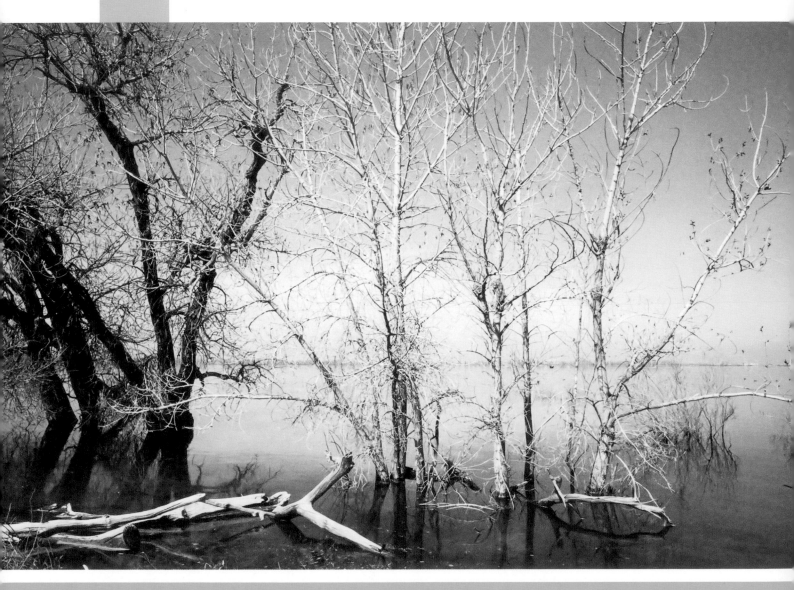

"But Black is the colour of my true love's hair."
—18th century Celtic song

One of the reasons that purists often refer to black-and-white prints as "monochrome" is that it's a much more precise term that also covers prints made in sepia and other tones. There is much more to black-and-white photography than simply an absence of color. Maybe we wouldn't feel this way if the first photographs had been made in full color, but that didn't happen. Like many photographers, I grew up admiring the works of W. Eugene Smith and other photojournalists who photographed people at work, play, or just being themselves in glorious black and white.

One of the advantages of working with monochromatic digital photographs is the original image can come from many sources. Some digital cameras even have black-and-white or sepia modes for capturing images directly in monochrome, and more often than not, these monochrome images are captured as RGB files. That's right, it's a color file without any color! As a creative medium, traditionalists may still call it "monochrome" and digital imagers may prefer the term "grayscale." Either way, to paraphrase Billy Joel, "it's still black and white to me."

Black and white can also be a wonderful media for making portraits because the lack of color immediately simplifies the image, causing you to focus on the real subject of the photograph instead of their clothing or surroundings. Sometimes the nature of the portrait subject demands that the image be photographed in black and white. Arnold Newman's portrait of composer Igor Stravinsky at the piano could never have been made in color and made the same impact it did as a monochrome image.

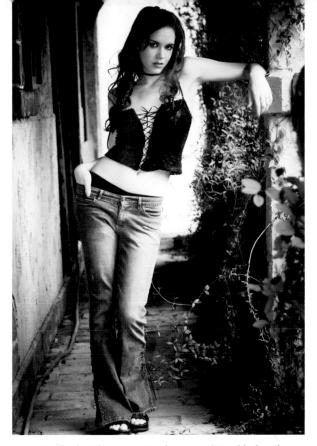

I originally shot this portrait and converted it to black and white using some of the tools covered in this book. Using monochrome for this image gave it more of a gritty, urban look and minimized some of the clutter, such as the green hose in the background, putting the main focus on the subject where it should be.

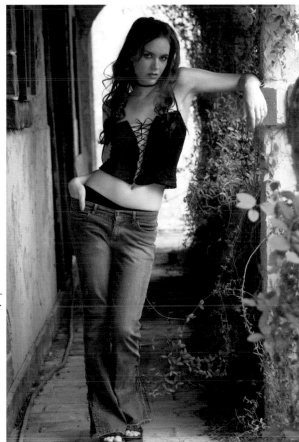

Here is the original unretouched color file for comparison. Exposure was 1/60 second at f/5 with a Canon 420EX flash unit used as fill.

The cyanotype was invented by Sir John Herschel in 1842, and was the first successful non-silver photographic printing process. To create this faux cyanotype, I used only the window light coming through my back door and used an in-camera blue filter option to capture the image. Exposure was 1/125 second at f/2.8 and ISO 320, and I deliberately underexposed to increase the shadows and blue saturation.

One reason that some publications print photographs in black and white is purely economical. It simply costs less to produce their publication in black and white than to use color. This is especially true for small runs of brochures or newsletters produced by companies and non-profit organizations. There are also the trendy aspects associated with creating images in black and white. MTV, motion pictures, and fashion magazines periodically "rediscover" black and white as a way to reproduce images that are different from what's currently being shown. Right now, many professional photographers are telling me that they're seeing a higher than normal demand for black-and-white portraits than previously was the case. Individual and family portrait purchases like these are driven by the same trends that affect the general media.

In the course of this book you will be exposed to many different ways to convert color images to monochrome, as well as learn how to capture the photograph directly in black and white if your camera allows for it. I'll also show you many different kinds of software that can be used to manipulate your images to create a galaxy of different effects. When looking at my examples, the most important point that I want you to keep in mind is that many (if not most) of the techniques and software tools featured are subject dependent. Some programs work great for landscape photographs, while others are best suited to portraits. Still others work best with images that posses a certain tonality or contrast range. Throughout the book, I've tried to pick examples that I believe will work best with a specific technique, tip, or tool, but my suggestions are certainly not cast in concrete. Use all of my imaging and digital darkroom techniques as a jumping off point for your own photographic explorations. I'm not a "my way or the highway" kind of guy; you can have it your way.

About This Book

The first part of this book is about capturing mono-chrome images directly with a digital camera and applying special effects in-camera. Then we'll get into the "digital darkroom" to show you how to make your digital image files emulate classic black-and-white film looks. The examples I include are as cross-platform as I can make them, and most of the Mac OS and Microsoft Windows software products that are featured have free demo versions available for download so you can try them yourself. Many of the power tools that I demonstrate, such as the various Photoshop actions, are also free, and you'll find out where you can download them when I describe how they are used. Throughout the book, Internet URLs for companies or websites will be provided to help you get more details and the latest information on specific products.

The next section of the book takes you into the world of monochrome photography outside the camera and deep inside the "digital darkroom." These chapters will introduce you to the tips, tools, and techniques for converting color images files that you already have—including scanned color prints or film—into stunning black-and-white images. Then I'll take you into the world of alternative processes, including many that were an active part of the history of photography and have been forgotten by new photographers for whom pixels are more important that silver grains. I'll also toss in some history so you can put the process in perspective and help you understand what the artisans of the day were trying to create..

During all of these explorations, I want you to have fun. Having fun is the single most important component of photography, and taking your color image files and turning them into special effects mono-chrome photographs should be fun. It is to me, and I hope will be for you, too.

In-Camera Monochrome Effects

Proving that you can, in fact, change your tune, Paul Simon changed the lyrics of his 1973 hit song "Kodachrome" from the original "everything looks worse in black and white" to "everything looks better in black and white" when he performed the song at a concert in Central Park on August 15, 1991. I happen to agree with him, and I bet you do, too, if you're reading this book.

Monochrome from the Point of Capture

There are lots of ways to create monochrome digital images, but the easiest way is at the time of capture. Many of today's digital cameras offer a variety of in-camera monochrome options, such as black and-white, sepia, and cyanotype. These tools add to any camera's "fun factor" by providing additional creativity without requiring a computer.

The most important advantage of in-camera mono-chrome is that you maintain the black-and-white aesthetic from capture to final image. You don't have to guess how the color photograph you just captured will look later on when you convert it in the "digital darkroom" using any of the tools that I'll show you in the next chapter. Your view through the camera may be in color, but the image on the LCD screen will be monochrome, which helps you to see if you are achieving the kind of results you're attempting. This is especially important when photographing people

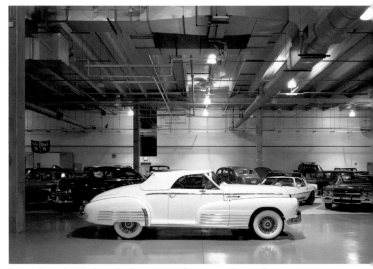

Many digital SLRs have built-in monochrome modes, and some even have modes that enhance gray tones while making the rest of the colors look less vibrant to produce an old-fashioned hand-colored look in-camera. The beautiful old Buick in this image was photographed using the Canon EOS 30D's Nostalgia mode to produce this effect.

because you can show them how they look in black and white and get their feedback. If your subject likes—or, just as important, doesn't like—the photograph, you can make adjustments by increasing or decreasing exposure or by the use of in-camera filters, topics we will also cover in detail in this book.

Canon Picture Styles

In an innovative digital imaging effort, Canon Inc. has expanded on its in-camera Picture Style imaging options by taking them to the Internet. The Standard Picture Style mode accurately reproduces the colors as normally seen by the human eye, which may not be your goal. So in addition to the in-camera monochrome modes and various filter effect options Canon makes available from the point of capture, you can also download others from the company website and load them into internal menu slots that are reserved for "user defined" styles.

Applying Canon's Nostalgia Picture Style in-camera gave this image the look of a hand-colored print from the fifties.

I shot this reference image in Standard mode using a Canon EOS 30D with an exposure of 1/50 second at f/22 and ISO 125. Images shot using the Standard mode look crisp and are supposed to look like successful snapshots.

This image was taken with the Canon EOS 30D at the exact same exposure settings as the previous image, but this time I used the Monochrome mode. The overall look and tonality of the image can be further customized using in-camera color filters that emulate those that are commonly used with black-and-white films.

Color Filters for Black-and-White Photography

In the days of black-and-white film photography, photographers often used colored filters to change the appearance of the range of black, white, and gray tones in their images. Today, these filters still come in handy when shooting digitally with in-camera black-and-white modes. Many camera manufacturers have also included these filter effects as internally selectable items within their cameras' menu systems.

If you're new to the world of traditional camera filters for black-and-white photography, here's a quick primer:

• A yellow filter will slightly darken blue skies, emphasizing the clouds, and is primarily used for landscape photography. When shooting in snow, yellow filters can produce brilliant, dynamic textures.

• Using an orange filter will produce effects similar to the yellow filter, but skies appear darker and the clouds are even more defined. While helpful for landscapes, orange filters are also used to boost contrast in architectural photography, and in portraiture, especially under tungsten light sources, to produce smooth skin tones.

• Red filters produce dramatic landscapes. Skies turn almost black with clouds becoming bright white, and contrast is maximized. In portraiture, a red filter can eliminate freckles and blemishes.

• A green filter is useful for landscape photography as it lightens vegetation but doesn't darken the sky as much as the red filter. Skin tones may also be more pleasing, but freckles and blemishes are more apparent.

Filter Factors

In the world of traditional photography, the light loss caused by a filter's absorption and color density is expressed as a filter factor. A factor of 2X means that exposure has to be increased by one stop; 3X means one and one-half stops. When using several filters at once, filter factors aren't added together but instead are multiplied, reducing depth of field or slowing shutter speeds.

In-Camera Filter Effects

While you can always use actual lens-mounted filters, there are some advantages to using the in-camera digital filters that are available to you. One of the main reasons to use in-camera filters is to avoid having to compensate your exposure due to a filter factor (see the sidebar, above). Most in-camera metering systems automatically take filter factors into consideration, but you still have to compose your shot through a colored filter. In addition, a digital solution is an easier one to live with because the exposure with no filter is identical to the exposure with a filter since all the filtering is done in-camera after you take the shot.

When using filters, whether lens-mounted or digital, keep this one important rule in mind: There is no one-size-fits-all approach to which filter works best. Experiment with different filters as you shoot your favorite subjects and see which ones give you the results you're looking for.

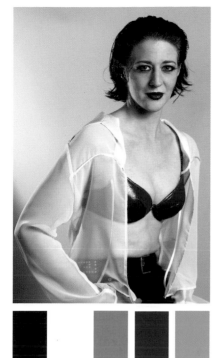

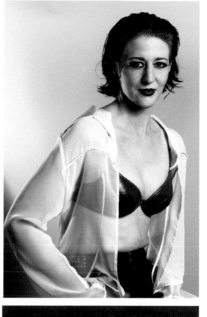

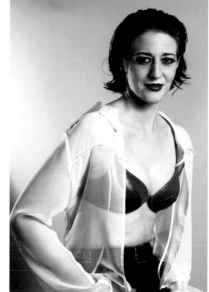

This color reference photo was made with studio lighting using a manual exposure of 1/60 second at f/13 and ISO 200.

Here is the same image taken using the in-camera monochrome mode.

For this rendition of the image, I selected a digital yellow filter in-camera for use with the monochrome shooting mode. As you can see, the shadows on her face are more defined, and her hair and makeup appear slightly darker.

The digital orange filter typically produces a softer look and smooth skin tones for portraitures photographed under warm tungsten light sources, but since that is not how this image was captured, the results appear more "contrasty" than those produced by the yellow filter.

The digital red filter evens out the model's skin tone, but it washes out her red lipstick. If you like this look but want to punch up lip color in black-and-white with this filter, blue lipstick is the way to go.

The green filter is not always my favorite filter for portraits because of what it does for skin tones (often enhancing blemishes), but in this case it ramps up the drama and contrast.

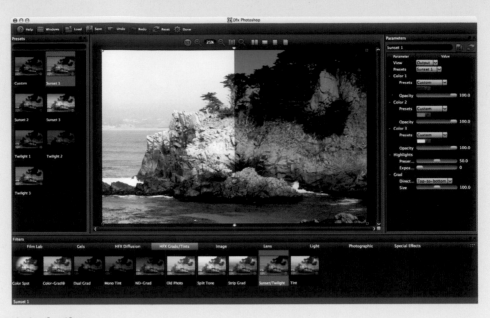

Downloadable Digital Filters

Tiffen Dfx filters are available for download from their website (www.tiffen.com) as standalones or as a suite of application-specific plugins, and are compatible with Mac OS or Windows computers. Unlike other software filters, Tiffen Dfx filters simulate the extensive range of their optical filters. The standard edition of this software features a range of the most popular filter effects, while the complete edition provides the entire range of more than 1,000 Tiffen filter effects and gels. Both editions offer the ability to apply factory presets or save custom effects.

Adding Color In-Camera

Monochrome images are stunning in black and white, but it can also be fun to add some color. That's when your camera's digital toning modes come in handy. Many cameras allow you to apply different digital toning effects, such as sepia, blue, purple, and green. Digital filters and toning can even be applied together, and since you get to see the results right away, you can decide if you like the effect or if you want to make setting adjustments. As with selecting a filter for your monochrome images, there is no one-size-fits-all approach to which toning effect works best. It depends on the subject itself, the original colors in the image (if you want to provide a visual hint), and the mood you're trying to achieve. Not every photograph should be in color; sometimes a black-and-white or toned monochrome image tells a better story.

This rail side location was used in the making of the 1996 Bill Murray film "Larger than Life," and because of the bright color scheme, it is one of my favorite places to take photographs. This color reference photo was made with a Canon EOS 5D. Exposure for this and all subsequent shots in this series was 1/80 second at f/20 and ISO 125.

Shooting this scene in black-and-white makes this image look like it could have appeared in a newspaper circa 1950.

Selecting in-camera filters or toning modes, such as the sepia mode used here, will not affect your exposure settings; the effects are applied in-camera after the initial exposure. Sepia toning produces a wonderfully nostalgic effect.

The blue toning effect applied a wonderful cyanotype look to the scene.

The biggest surprise I had while experimenting with toning effects while shooting this scene was the purple toned image; it was my favorite one in the series. The purple tone produces a POP (Printing Out Paper) "proof" look from the 1940s that I find enjoyable to look at.

The green toning effect may not be the best choice for this particular image, but try it out next time you're shooting monochrome landscape photographs. Make some test shots, try different filter and toning combinations and, as with any creative pursuit, have fun with it.

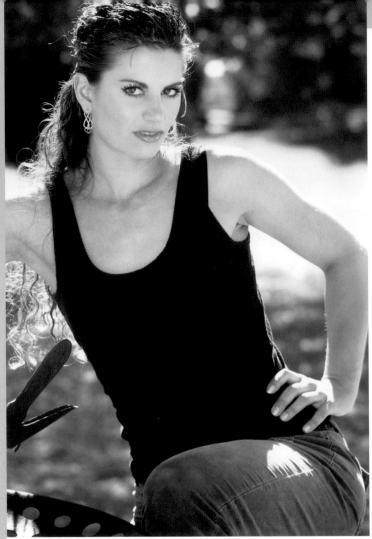

One of my favorite techniques is capturing RAW color and JPEG monochrome files simultaneously using my camera's dual capture mode. This monochrome JPEG portrait was made at the same time as the color RAW file.

But I Can Do That In Photoshop!

You can always make filter effect and toning adjustments after the fact using Adobe Photoshop or your favorite digital imaging software, and I'll show you how to do that in subsequent chapters, but I'd like to give you a few reasons why an in-camera approach is sometimes a better choice.

Aesthetics: Shooting directly in black and white impacts how you see the scene while making the images. Plus, the instant feedback made possible with digital cameras helps focus your vision. Sometimes too much color can take the focus away from the true subject or intended mood of the photograph.

Workflow: There are many ways to use image-processing software and compatible plugins to produce great looking black-and-white images from color files, but not right now! If you want to make prints on-site using PictBridge compatible printers (see page 149) or drop your memory card off at your local printing lab, capturing the original files with the toning or filter effects you want saves time.

Quality: The quality of most in-camera black and white conversions looks like real black and white even though the file type remains RGB, which gives you many more processing options than if it were converted to grayscale mode.

Okay, I know what you're thinking. What if you change your mind and wish you had made that image in color? Many digital cameras allow you to capture both RAW and JPEG files at the same time. That means you can capture color RAW files while recording JPEG files in monochrome at the same time.

Exposing for Monochrome

Proper exposure of your in-camera monochrome image is important, especially for toned images. Changes in exposure affect the density of colors (or lack of color) and overall style of the final image. The best way to obtain proper exposure is covered in lots of other photography publications, such as "The Joy of Digital Photography," by Jeff Wignall. You can get the full scoop on how to attain proper exposure in any number of great digital photography basics books, but in the meantime, here's a quick review of exposure as it applies to monochrome image capture.

Exposure latitude (the range of exposure settings that produce acceptable details in highlight and shadow areas) is greatest with color negative film. Slide film has the least latitude, especially when it comes to overexposure. Correct exposure is more critical for digital capture than film because digital sensors respond like a hybrid of the two: Overexposure wipes out image data but underexposure has more latitude. The downside of underexposure is the inevitable creation of digital noise, which often looks like digital "grain" like we used to see with high ISO films. The secret, as in all forms of photography, is to properly expose the image.

One way to critically evaluate exposure is by using the camera's histogram function. A histogram is a graphical representation of a photograph's exposure values from darkest shadows (left) to brightest highlights (right). It displays light values in 256 steps, where zero represents pure black and 255 is pure white. In the middle are mid-range values representing grays, browns, and greens. All an image's tones are captured when the graph rises from the bottom left corner then descends towards the bottom right. If it starts out too far in from either side, or the slope appears cut off, then the file is missing data and the image's contrast range may exceed the camera's capabilities.

Exposing for monochrome images is almost the same as exposing for color. You need to keep in mind that

Hint: While the classic histogram features a bell-shaped (Gaussian) curve, not every photograph fits this distribution. Dramatic high- or low-key images have lopsided histograms.

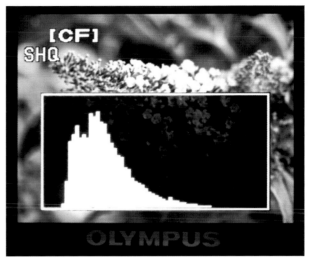

When the histogram is weighted towards either the dark or bright side, detail may be lost in the thinner of the two areas. If highlights are important make sure that the slope on the right reaches the bottom of the graph before hitting the right side.

the in-camera meter is still looking to create an average level of tones, whether you're exposing for color or black-and-white, but the effect of a given exposure on the final image can be drastically different depending on which you're shooting for.

The old rule of thumb when exposing black-and-white film was to "expose for the highlights and develop for the shadows," but the problem is that digital image files don't behave like either slide or negative film. Instead, they are more of a hybrid, with the highlight side acting like slide film, where any overexposure leads to loss of detail, and the shadow side acting like negative film, which has more latitude to handle more or less exposure than the optimum.

The bottom line is that increasing or decreasing a monochrome image's exposure can dramatically change its look, from using underexposure to create a deep, brooding, low-key image, to increasing exposure to produce a light and airy high-key one. We won't be going into a detailed treatise on exposure here, but if you want a more detailed explanation, pick up a copy of Rob Sheppard's "KODAK Guide to Digital Photography." If you're in a hurry and want to shoot some monochrome photos right now, I'll let you in on anther rule of thumb that's often used by even the most experienced pros: When you find yourself in a tricky exposure situation, it's time to bracket. Don't know what bracketing is? Let me explain…

Bracketing

Bracketing is a time honored photo technique where multiple images of the same (difficult) subject are made at different exposure levels. The idea is that one of them will be the best and some may be acceptable. Most D-SLRs (digital SLRs) offer an automatic bracketing mode in which one frame is exposed with no exposure compensation, another is underexposed, and a third frame is overexposed. Exposure compensation is a feature I constantly use to improve captured images. After I make an exposure and look at the image and its histogram, if I don't like it, I'll make another exposure using the camera's exposure compensation, increasing or decreasing the exposure in one third or one half step increments until the image is the best it can be.

Post-Capture In-Camera Effects

Some cameras permit in-camera monochrome and image manipulation after you have captured the image. Options I have seen include transfer to black and white or sepia, softening, brightness, and color

effects. For this kind of in-camera processing, only JPEG's need apply; RAW images cannot be processed without a dedicated RAW conversion software. The upside of using this process is that when a filter is applied, your color original remains untouched. These kinds of effects can be applied later in the "digital darkroom" with image-processing software, but doing it in-camera lets you make prints directly from a kiosk without having to load the files onto a computer. Personally, I prefer capturing directly in monochrome, finding it a bit inconvenient to capture then convert a file.

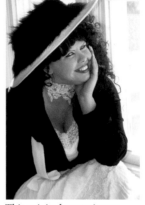

This original portrait was made using window light and an aperture priority exposure of 1/125 second at f/8 with a +1/3 stop exposure compensation to brighten the background and dress.

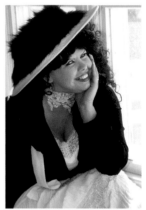

Here is the same image with in-camera black-and-white conversion applied post-capture. The camera saves the modified image as a separate file on your memory card.

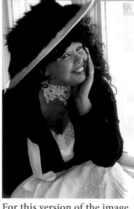

For this version of the image, I applied a blue filter in-camera post-capture. The tonalities produced by the blue filter for this particular portrait are not as pleasant as those produced by the other filter options, so it would not be my first choice for this subject.

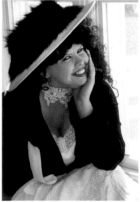

A green filter is generally used for landscape photography because it lightens vegetation but doesn't darken the sky as much as a red filter. However, it can also be used for portraiture in some cases. I like the effect of the green filter here.

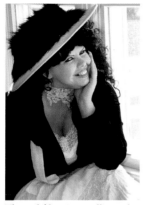

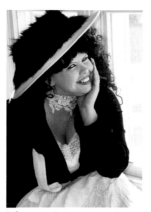

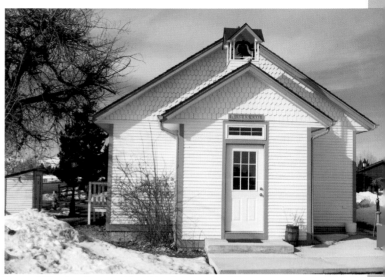

The red filter is usually used to produce dramatic landscapes where the sky turns almost black and the contrast between clouds and sky is at its maximum. In portraiture, freckles and blemishes are eliminated but skin and lip color are lightened.

Like most in-camera sepia effects, this sepia filter is a bit too orange for my taste. If your camera has a internal sepia filter and you like the effects, you can take advantage of being able to print the resulting images directly from the camera without taking extra time to manipulate the files in the digital darkroom.

It was chilly when I was making this photograph of the one-room schoolhouse, shot at ISO 100, 1/90 second, and f/16 with a +1/2 stop exposure compensation to account for the snow in the scene. I initially converted the original a to black and white in-camera, then later created a third file using a digital blue filter, shown here.

I originally captured this image in color and converted it to sepia using an in-camera filter. Then I created a third version of the image by applying a soft focus digital filter, as seen here.

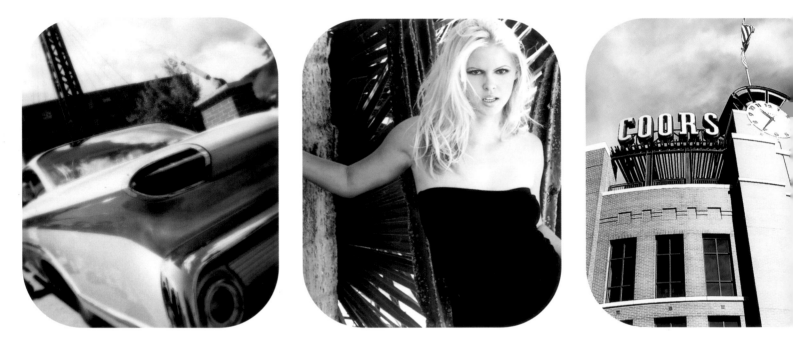

Post-Capture
Monochrome Techniques

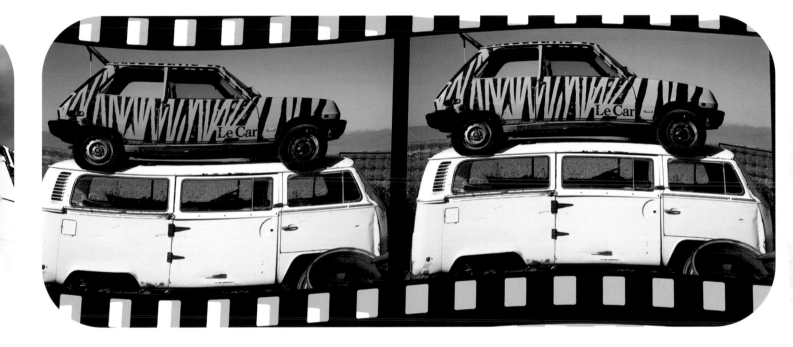

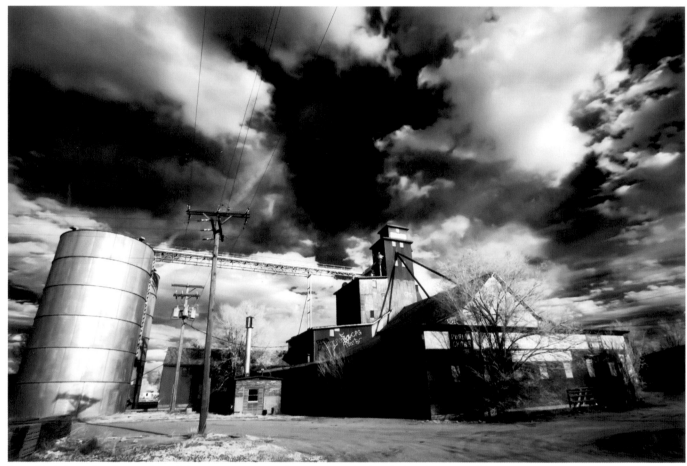

I am a big believer that there are lots of photo opportunities right in your own backyard. This shot was made less than two miles from my home late one Sunday afternoon, and I converted it to black and white using Adobe Camera RAW software.

If you camera doesn't have a built-in monochrome mode, you have no choice but to convert image files to black and white after the fact. There are many ways to convert a color file into a monochrome image, and in this chapter (and subsequent chapters), I'll introduce you to all of the ones that are in my personal bag of tricks. Let's get started with some entry-level methods for turning that living color image into something a little more dramatic.

A Note About File Formats

Digital cameras let you capture images in one of a few file formats. The most common format (which ironically is not a format at all, but a compression scheme) is JPEG—Joint Photographic Experts Group. JPEG is an international standard for image compression and is the most common file type used by digital cameras. Data compression enables devices to capture and store the same amount of data using fewer bits. It does this by discarding colors that may not be visible to the eye, and how well it does this ultimately determines image quality.

Some cameras also allow image capture in the TIFF (Tagged Image File) format, and most allow for RAW capture. In many camera models, there is even a dual capture mode where both a RAW file and JPEG file are captured with a single click of the shutter. The highest image quality option is available with the TIFF and RAW formats, in which no image compression is used. All three formats produce excellent quality results, but when faced with difficult lighting situations, the unprocessed data of a RAW file can be helpful when you go to optimize the image later in image-processing software. On the other hand, the small size of the JPEG file is faster and easier to deal with, both in-camera and in your computer. TIFF files combine some of the advantages of both JPEG and RAW formats but are usually larger files than either, and this format is not available in all digital cameras.

Adobe Camera RAW

The latest version of Adobe Camera RAW software that is part of Photoshop CS3 contains intuitive monochrome conversion control, providing a gateway for converting not only 150 different RAW formats, but also working wonders with JPEG and TIFF files. By working with RAW files, however, which many consider to be "digital negatives," you can achieve the results you want with greater artistic control and flexibility while still maintaining the structural integrity of the original file.

The most important factor in deciding which image file format will work best for you is your own personal shooting style and image-processing "digital darkroom" workflow. If you want to shoot quickly and spend less time in front of the computer, JPEG is the best choice. If you loved working in the traditional darkroom, RAW files are a digital continuation of that process.

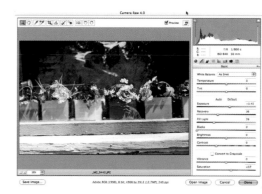

RAW files contain all of the original data that was captured by your camera's sensor and you need special processing software, such as Adobe Camera RAW, to process them. This particular program is built into Adobe Photoshop as well as the much less expensive Photoshop Elements, seen here.

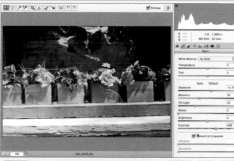

You can think of RAW files as digital "negatives" that need to be processed. Using Adobe Camera RAW, you can reduce saturation, increase contrast, and adjust brightness levels as well as tick the Grayscale check box to convert a color image file into monochrome.

Adobe Lightroom

Adobe Photoshop has changed a lot in its journey from that cute little FotoMat desktop icon, to the all-seeing-eye, to the generic P icon. It's evolved from being a photographer's tool to one embraced by artists and web designers, too. Along the way, stuff—as they say—happened, and some of us have unleashed our internal creative demons and tended to shoot, shoot, shoot. Where once a wedding photographer may have had a hundred, maybe two hundred, proofs to edit, they are now faced with four hundred or more images, and while Photoshop's Bridge, bless it's pea-pickin' heart, is a good way to edit lots of images, it isn't the fastest way. Enter Adobe Lightroom—Photoshop for photographers.

Adobe Lightroom may be the perfect software for photographers who shoot lots of images and don't need extensive tweaking to make images look the way they want. When you launch Lightroom, it opens the Library photo management module that includes a Quick Develop palette that lets you makes minor corrections on color balance, brightness, and contrast. There is also a Convert Photograph to Grayscale option that is a heck of a lot better than what's built into Photoshop.

If you want to add effects or tweak the image file in more depth, use the Develop module, where you can perform image adjustments that include some built-in image tweaks, such as Antique Grayscale, with a single mouse click—no plugins required. There are lots of other tools, too, including a Grayscale Mixer, HSL Color Tuning with separate sets of sliders for Hue, Saturation, and Luminance, Lens Correction, and controls for split toning. Lightroom supports more than 100 camera RAW file formats, along with DNG, TIFF, and JPEG files

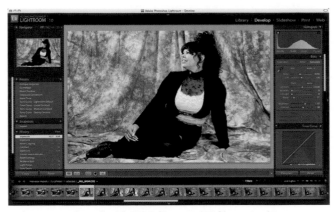

Lightroom works well with JPEG files or RAW files, as in this example, and includes heavy-duty monochrome conversion tools. Lightroom also gives you access to image-enhancing sliders, making it a one-stop conversion program.

Converting to Grayscale

One of the easiest and simplest ways to create a black-and-white image from a color file is to convert it to grayscale. In Photoshop, you can simply go to Image > Mode > Grayscale. Of course, if you then wish to add some color to your monochrome image, you will need to convert the file back to and RGB mode using the same command set. Grayscale mode employs various shades of gray throughout the image and discards all of the color information. The gray levels of the converted pixels represent the luminosity of the original pixels.

Another way to convert to grayscale in Photoshop without changing the image's color mode is to use Photoshop's Desaturate tool (Image > Adjustments > Desaturate). If you are using an image-processing program other than Photoshop, a monochrome conversion tool can be usually be found under the Mode menu. Photoshop's Desaturate command assigns equal red, green, and blue values to each pixel and converts the color image to grayscale values, though the file still remains an RGB image. The lightness value of each pixel does not change. This command has the same effect as setting Saturation to -100 in the Hue/Saturation dialog box (Image > Adjustments > Hue/Saturation).

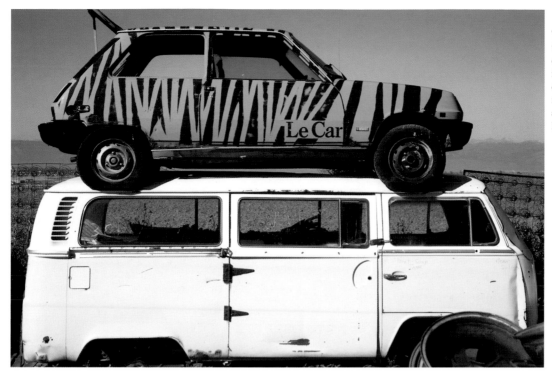

This junkyard image was captured as a color file with an exposure of 1/250 second at f/10 and ISO 100. Automobile cognoscenti will immediately recognize the tiger-striped automobile as the legendary Renault Le Car.

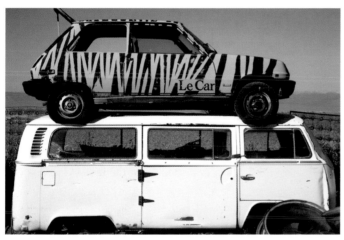

Before you select Image > Mode > Grayscale in Adobe Photoshop, you should rename the file you're working with so as not to overwrite the original. Once you've converted to grayscale, you will probable notice that the resulting monochrome image is somewhat flat looking, lacking the contrast of the original image file.

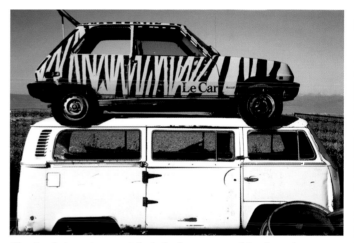

The simplest way to correct the lack of contrast resulting from the conversion is to use the Brightness/Contrast control to kick up the contrast a bit. Gradually move the slider (increasing the contrast) and observe the effect before clicking OK.

Both of these methods produce an image that lacks color, but it also usually also lacks any real impact. They just don't look like the textbook definition of a "black-and-white" photograph. What you need is to take that flat looking image and add some drama.

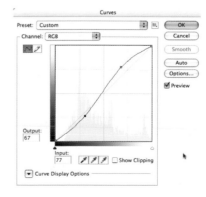

An alternative is to use the Curves tool. Creating an S-shaped curve will produce a more film-like look. This screen shot shows what I actually applied to the finished image, but there are no magic numbers here; the shape of the curve depends on the original tones of your photograph.

Channel Mixer

The Adobe Photoshop Channel Mixer tool produces grayscale images by letting you choose the percentage contribution from each color channel after checking the Monochrome box. It modifies a targeted output color channel, in this case grayscale, using a mix of the existing image's colors. The Channel Mixer is a single-step tool that allows you to optimize your monochrome tones, unlike the previous examples of grayscale conversion followed by adjustments with the Brightness/Contrast slider or Curves. However, mastering the Channel Mixer does take a little more work, but with practice you can whip through it.

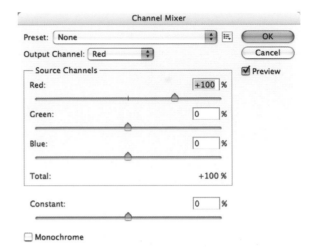

Step 1: The original color image was captured with a 10-17mm fish-eye zoom lens. Exposure was 1/6 second at f/2.8 and ISO 400. To process this image, I started by opening it up in Photoshop.

Step 2: The next step is to open the Channel Mixer dialog box by selecting Image > Adjustments > Channel Mixer. Be sure to check the Monochrome box to set gray as the output channel. This creates a color image that contains only gray values. Even though the image is now in monochrome, the original balance of red, green, and blue in the image still remains, though in grayscale form, and is affected by how you adjust the individual sliders.

Hint: When adjusting the percentages of the source channels in the Channel Mixer, you will often get the best results when the combined values of the source channels add up to 100%. If you go over 100%, you'll overexpose the image and if you go under 100%, you will underexpose the image.

Applying the Channel Mixer command may be all that most photographers will need to convert image files to monochrome, but if you want more flexibility, it's time to reach for a few of the power tools covered in the next chapter on pages 46–65.

In Photoshop CS3, you'll find that Channel Mixer is still there, so if that methodology floats your boat, you can still use it, along with its new presets for a variety of digital filters that mimic traditional black-and-white filter effects.

The latest version of Photoshop also includes and black-and-white conversion command, activated by selecting Image > Adjustments > Black and White. Here you will find a set of sliders that let you fine-tune your monochrome conversion, allowing you to interactively adjust channels in the large preview. Just click an image area to highlight the appropriate color slider, or click and drag an image area to adjust the conversion. And as with the newer manifestations of Channel Mixer, you can also save your preferred settings for black-and-white conversion.

Black-and-White Conversion

If you have Photoshop CS3 or later, you are lucky enough to have access to an advanced black-and-white conversion tool that is simpler and faster than the old Channel Mixer regimen. In CS3, the Channel Mixer has been improved to include black-and-white presets for different digital filters. You also have the ability to save your favorite settings as presets for reuse later. And you no longer have to do the math; the new total indicator keeps you informed of the total percentage contribution from all three color channels.

In the black-and-white adjustment dialogue box, the Auto button analyzes the image and offers conversion settings. You can also apply a conversion from a list of presets, including Infrared and any presents you have predetermined.

More Digital Filters

Colored filters for black-and-white photography (see pages 18–19) are not the only filters that have digital equivalents. Some of the most popular lens-mounted camera filter effects are available in digital form, as well. The polarizing filter eliminates reflections from non-metallic surfaces, increases color saturation, and can enhance an image's overall contrast. Polarizers can be used to improve images in both color and black-and-white photography. Many manufacturers also offer warm polarizers that combine aspects of a polarizing filter with that of a warming filter.

The nik Polarization filter is one of the digital filters in the nik Color Efex Pro collection (www.niksoftware.com), and is a Photoshop-compatible plugin. This Polarization filter emulates the color contrasts created with a conventional polarization filter to enhance blue skies and similar colors, while optimizing the contrast in an image. With nik's Polarization filter, the blue in sky (or water) can be intensified, while detail in clouds and similar structures can be increased.

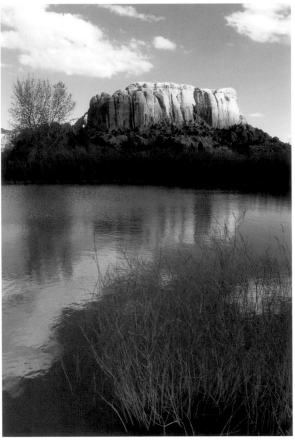

This is the original unretouched photograph made on Ghost Ranch in New Mexico. Exposure was 1/500 second at f/4.0 and ISO 80.

Controls for the Polarization filter include Rotate, which acts to emulate the rotation of a lens-mounted polarizer in its mount. This controls color contrasts and their relationship to the colors created by rotating the filter. The Strength slider controls the amount of the polarization effect on the image.

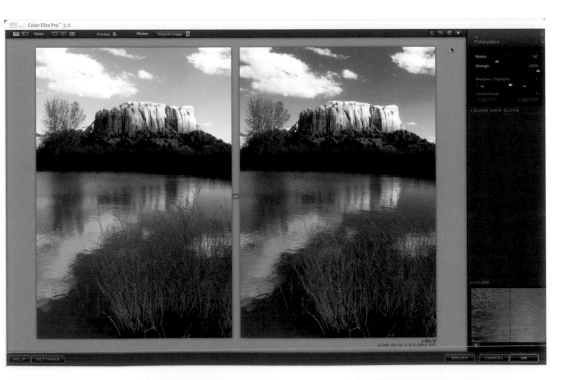

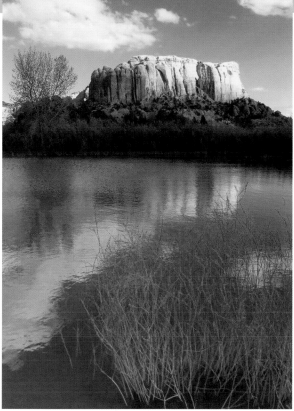

You cannot remove reflections and glare with a digital Polarization filter as you would with a real on-camera polarizer, which in this case is a good thing because it preserves the reflections in the water.

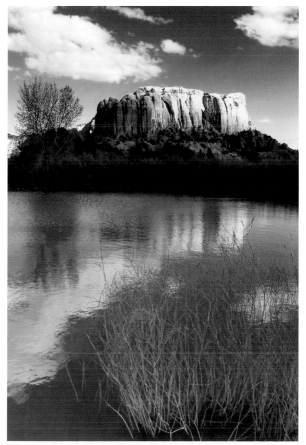

Here is what the polarized image looks like when converted to monochrome.

The Duotone Command

In the world of four-color (CMYK) printing, duotone is the name given to the process of multiple tone printing that can be done using two, three, or four different ink colors. This process requires that the press be set up with special inks instead of the standard CMYK inks used for four-color printing. Typically the paper is printed first using a dark base color and then a second lighter color is overprinted to fill in, tint, and tone the photograph and, more importantly, to add depth. When two colors of inks are used it's call a duotone, when three inks are used it's a tritone, and when four are used it is a quadtone.

As with all photographic techniques. there is more than one way to accomplish the duotone process when working with monochromatic images. Located inconspicuously in Photoshop's Image menu (Image > Mode > Duotone), the Duotone command can open many creative doors for the photographer who is interested in making and printing monochrome images.

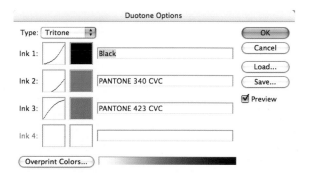

One gateway to adding duotone, tritone, or quadtone effects to a grayscale photograph is through Photoshop's Duotone Options dialog box.

Duotones

In order to apply any of the selections through the Duotone command, the image must first be in Grayscale mode (Image > Mode > Grayscale). When starting with a color image, be sure to convert it using any of the techniques in the first part of this chapter (refer to pages 30–33). Once you have a grayscale image, select Image > Mode > Duotone.

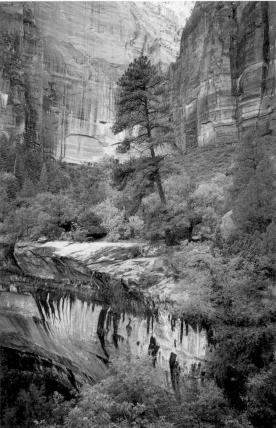

The original color photo of this scene photograph was made in Zion National Park. Exposure was 1/90 second at f/5.6 and ISO 400.

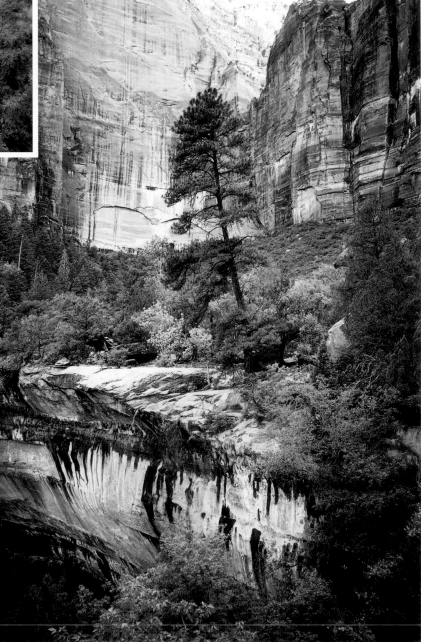

Since the photograph must be in grayscale mode, not just a gray-toned RGB image, I converted it by using the Image > Mode > Grayscale command found in Adobe Photoshop.

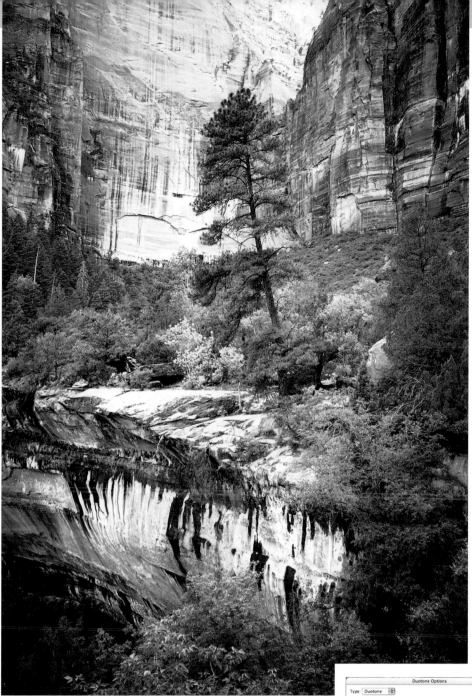

To retain the subtle colors you just added, you will need to convert the Duotone file back to RGB before saving the finished file.

When you select Image > Mode > Duotone, you'll see a dialog box showing the two colors that can be used. To use sets of colors that are guaranteed to work together, click the dialog's Load button to get to Adobe's Duotone Presets folder. This is true for both Mac OS and Windows versions of the program. There are three choices: Gray Black Duotones, Pantone Duotones, and Process Duotones. Open any folder and click on one of the choices. Keep experimenting until you find an effect that you like.

To use sets of colors that are guaranteed to work together, click the dialog's Load button to get to Adobe's Duotone Presets folder. Unless you are a graphic designer and familiar with pantone colors, the best way to find a combination is to click and try. The warm and cool tones are clearly identified, so that will start you in the right direction.

Tritones

The process of making a tritone image is identical to making a duotone; the only difference is that now you have three colors in your palette to work with.

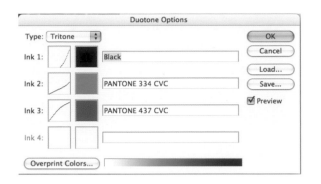

This was the actual Tritone combination used for the final effect.

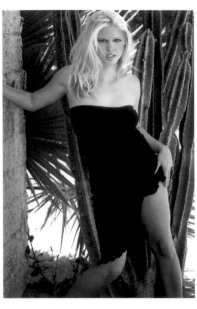

I made the original photograph of this model on an out-door movie set in Phoenix, Arizona. Exposure was 1/200 second at f/6.3 and ISO 200 with on-camera flash used as fill.

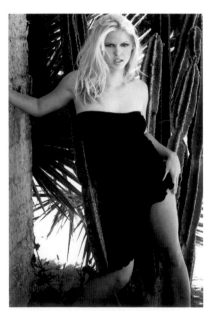

I converted the photograph to monochrome by using Photoshop's Image > Mode > Grayscale command, then used the Curves (Image > Adjustments > Curves) tool to tweak the contrast slightly.

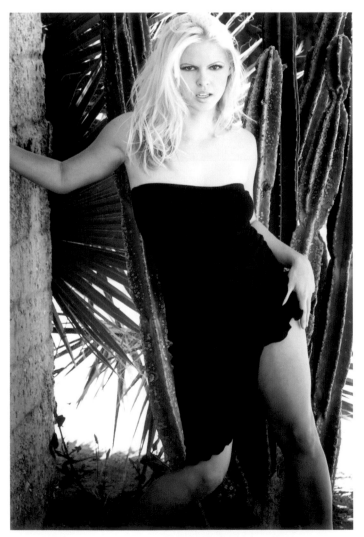

Here is the final result. I was surprised that the tritone combination, which uses green, looked this good. If I wanted to show a snowy landscape, I might have selected a blue-oriented combination.

Quadtones

If you read the previous two sections on duotone and tritone images, you already know how to make a quadtone image. You start by applying the Duotone command that coverts a grayscale image into a duotone file, then you can load into the photograph a collection of four complimentary colors to add depth and color to the monochrome image.

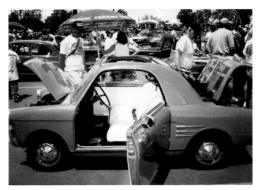

After conversion to grayscale using the Alien Skin Software, the file was still in RGB format, so in order to access Photoshop's quadtone options, I converted it to grayscale in that program using the by now familiar Image > Mode > Grayscale command.

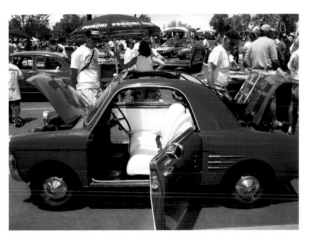

Trying to get a photograph of this terminally cute Autobianchi Bianchina automobile without a crowd of people around it was a challenge, and this was the best I could do. One of the advantages of monochrome over color is that is simplifies the image, helping to focus attention on the subject. Exposure was 1/500 second at f/7.1 and ISO 200.

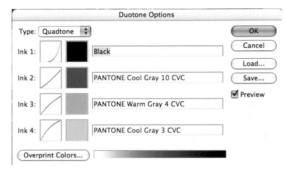

This was the actual quadtone combination used for the final effect.

Before changing the image mode to grayscale in Photoshop to gain access to the quadtone options, I decided to convert the photograph to grayscale using Alien Skin Software (www.alienskin.com), a Photoshop-compatible plugin that will be explored in more detail in the next chapter.

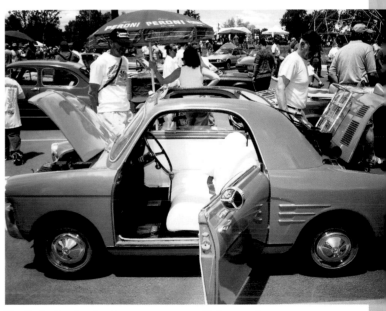

The final mix of cool and warm gray tones added a nostalgic touch to this photograph of a forty-plus-year-old mini car. I also made a few tweaks using Photoshop's Burn and Dodge tools to create the image you see here.

The Panos Efstathiadis Film Machine action set has the ability to combine up to four images in horizontal or vertical filmstrips. Panos Efstathiadis contains three sets with 15 different actions, and each of those produces five different effects.

Introduction to Actions

Do actions speak louder than software? Actions are not applications or even plugins; they are simply a series of instructions that direct the host program to produce a desired effect. Photoshop's Actions palette lets you record a sequence of image editing steps that can be applied to a selection in an image, another image file, or to a batch operation to hundreds of different image files.

Photoshop actions are cross-platform and can be shared with others. If you create an action on your Mac OS computer, anyone using the Windows version of Photoshop can load and apply your original action to his or her images. In Mac OS or Windows, these files use the .ATN extension. The Actions palette in Photoshop (Window > Actions) is your key to creating and using Photoshop actions. The palette has two modes: List View and Button Mode. List View lets you create and edit actions starting with the New Action command that's accessed from the fly-out menu in the upper right-had corner of the palette. Choosing Button Mode from the same menu activates playback or Button Mode.

History	Actions ×
Vignette (selection)	Frame Channel – 50 pixel
Wood Frame – 50 pixel	Cast Shadow (type)
Water Reflection (type)	Custom RGB to Grayscale
Molten Lead	Make Clip Path (selection)
Sepia Toning (layer)	Quadrant Colors
Save As Photoshop PDF	Gradient Map
Screenshot F8	Focal.pix
toned	infrared
softly	Unsharp Mask1
Unsharp Mask2	CMA FileSavers SetUp – R…
CMA Save to PSD Dump File	CMA Save to WEB Dump File
CMA Save to PRINT Dump …	CMA ImageSoft Regular
CMA ImageSoft Soft	CMA ImageSoft XSoft
CMA ImageSoft SSoft	CMA ImageSoft USoft
PA Neuport Taster	PA Neuport N
PA Neuport Soft N	PA Neuport XtraSoft N
PA Neuport SuperSoft N	PA Neuport UltraSoft N
PA Neuport +1	PA Neuport Soft +1
PA Neuport XtraSoft +1	PA Neuport SuperSoft +1
PA Neuport UltraSoft +1	PA Neuport –1
PA Neuport Soft –1	PA Neuport XtraSoft –1
PA Neuport SuperSoft –1	PA Neuport UltraSoft –1
PA Neuport +2	PA Neuport Soft +2
PA Neuport XtraSoft +2	PA Neuport SuperSoft +2
PA Neuport UltraSoft +2	PA Neuport –2
PA Neuport Soft –2	PA Neuport XtraSoft –2
PA Neuport SuperSoft –2	PA Neuport UltraSoft –2
PA HiMidnight Taster	PA HiMidnight N
PA HiMidnight Soft N	PA HiMidnight XtraSoft N
PA HiMidnight SuperSoft N	PA HiMidnight UltraSoft N
PA HiMidnight +1	PA HiMidnight Soft +1
PA HiMidnight XtraSoft +1	PA HiMidnight SuperSoft +1
PA HiMidnight UltraSoft +1	PA HiMidnight –1
PA HiMidnight Soft –1	PA HiMidnight XtraSoft –1
PA HiMidnight SuperSoft –1	PA HiMidnight UltraSoft –1
PA HiMidnight +2	PA HiMidnight Soft +2

Before you can record an action, the palette must be in List View. To do that, access the Action menu (Window > Actions) and deselect Button Mode. To display an action, no matter where it came from, the actions palette must be in Button Mode.

To create a new action, click the Record button from the fly-out menu. The circle icon at the bottom of the Actions palette will now turn red. At that point, work through a series of manipulations on an image or a portion of an image. When you're finished, click the Stop button (the square icon) at the bottom of the palette. Afterwards, the order in which tasks are executed can be edited by dragging-and-dropping in any order you wish.

Although actions apply creative effects, they are not filters and don't have to be treated like plugins. Some pundits recommend that you store actions in a folder or directory and load them as you need them. I don't think that's a good idea. One of the main attractions of actions is that they're convenient. Since the Actions palette is scrollable, you should keep all of your favorite actions stored there, ready for use. The trick is not to blindly accumulate actions, but to explore and test to find ones that fit the way you work. If you uncover a marginal action, you can store it in an "Inactive Actions" folder or dump it in the trashcan or recycling bin.

Prerecorded actions can be found on the Photoshop CD-ROM. Some of them include down sampling images to 72 dpi for use on the Internet, saving GIF and JPEG files with optimal web settings, and adding drop shadows to text. On some versions of Photoshop, you can even find "secret" actions on the CD-ROM stored in the "Goodies" directory.

Commercial actions are available from a variety of companies and are worth every bit you pay for them. I'll introduce you to some of these on the pages to follow. A good source for free or shareware pre-recorded actions is the Adobe Studio Exchange (share.studio.adobe.com). Other sources include Action Central (www.atncentral.com) and deviantART (www.deviantart.com), which uses a uniquely visual method of displaying their actions. Since most Photoshop actions are less than 10 kilobytes (10K), you don't have to be worried about download time or hard disk space.

On the Adobe Studio Exchange site there is a section that lists all the actions that are available for download, along with a sample image showing what the effect looks like. To install pre-recorded actions, use the Load Actions command in the fly-out menu.

Craig Minielly (www.craigsactions.com) offers four volumes of commercial productivity and creativity actions. Production Essentials contains actions for sharpening, dust removal, retouching, facial feature enhancements, logo insertion, copyright and watermarking, and image effects such as cross processing and monochrome. Creative Effects can add a softening effect to your images or provide grain enhancement. When running these actions, there are programmed stops (with hints provided) allowing you to interact and customize the effect. The stops can be unchecked for continuous operation if you like. CMYK Production and Ad Image Producers offer professional applications for CMYK Conversions for business card, brochure or ad production, while StoryTellers1 contains thirty-two actions of artistic effects such as infrared, soft pastels, and selective color.

This photograph of "your father's Oldsmobile" was made with an 18-55mm EF-S zoom lens. ISO was 200 and exposure was 1/320 second at f/11.

After opening the file in Adobe Photoshop, I applied the ShadowSoft Grainy Sepia action from www.craigsactions.com, giving the image a "film noir" look that matches the style of the car. I accomplished this with one button click and no pixels were harmed during the process.

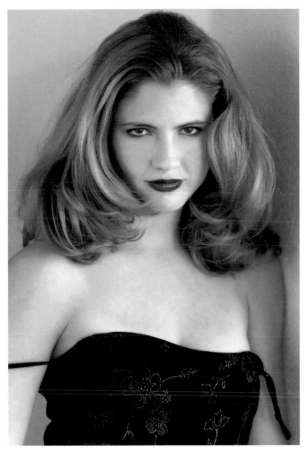

I took this gorgeous original color portrait using available light with an exposure of 1/250 second at f/5.6 and ISO 800.

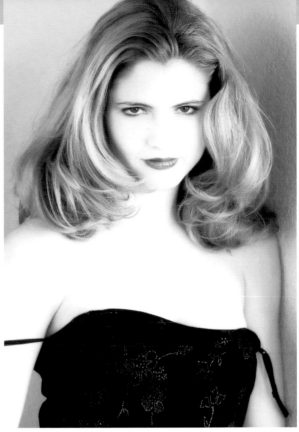

This is what the portrait looks like after I applied Craig's Actions ColorOver (www.craigsactions.com), part of the Storytellers 1 package of Photoshop actions that creates wonderful pastel shadings that can be used selectively or over the entire image. This one-click effect is called Soft Glow and is one of the eight ColorOver Actions.

Kevin Kubota's Artistic Tools, volume 1 (www.kubotaimagetools.com) is a package of actions that contains 50 imaging tools for enhancing, color popping, toning, and glowing. These actions lets you create custom artistic-looking images in seconds and come in a package that costs less than $100. Artistic Tools volume 2 expands on his first set to provide an even broader palette of effects including Hawaiian Punch, color toned B&W, Daily Multi-Vitamin, Edge Blurs, and Digital Fill Flash. And volume three was just launched, so check it out!

This is what the photograph looks like after I applied Kevin Kubota's TastyGlow II action (www.kubotaimagetools.com). Actions can apply multiple effects to a single image, and TastyGlow II starts by converting the image to grayscale, then adds the trademark "tasty" glow to add softness to the image. I also used Photoshop's Burn tool to lightly burn the edges.

The Urban Acid by Steven Almas found on Actions Central (www.atncentral.com) mimics a cross-processing technique used in some glamour, fashion, and urban photography. It skews and saturates colors, while dramatically increasing contrast. The action does all this by creating an aggressive curves adjustment layer (which is user adjustable). Secondly, the action creates a black layer that can be used to desaturate and mute the colors. This can be accomplished by changing the opacity of the layer using the Opacity slider, found in the upper right hand corner of the Layers palette.

This is just an introduction to using actions with Photoshop, and you will read more about how to use specific actions to create different kinds of effects as we get further along in this book. Actions are powerful because they are simple, affordable (often free), and customizable through the use of Layers, as we'll get to in the next chapter.

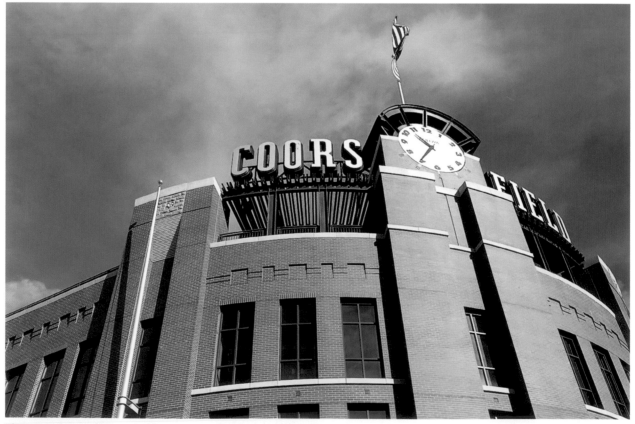

This original image of Coors Field in Denver, Colorado was photographed with an exposure of 1/250 second at f/7.1 and ISO 100.

Actions in Photoshop Elements

Photoshop Elements currently does not have an Actions palette, but that hasn't stopped people from coming up with ways to make it work. In order to use actions in Photoshop Elements, you will need an add-on. One solution is Richard Lynch's "Hidden Power Tool Downloads for Elements 1, 2, 3, 4, and 5" (www.hiddenelements.com/downloads.html). Another option is Ling Nero's snapActions (www.geocities.com/rnlnero/PE2stuff2.html), and Mac users might take a look at Photoshop Automator Actions (www.completedigitalphotography.com/?p=339).

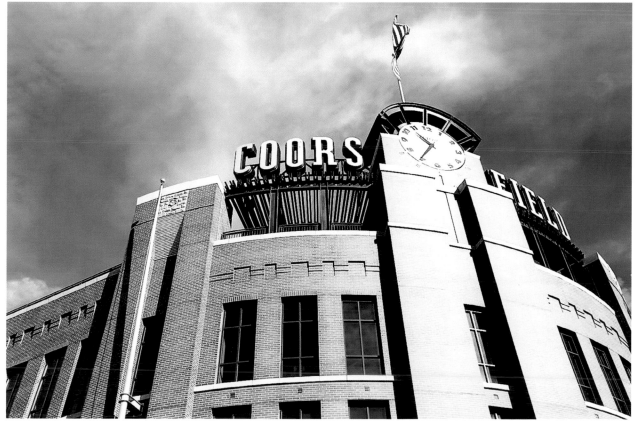

I then applied Steven Almas' Urban Acid action to the photograph, giving it an edgy, cross-processed film look. I also used the Burn and Dodge tools to add to the mood. This is just one way to emulate this effect, and in the next chapter I'll show you some more methods for achieving traditional looks.

Power Tools for Black and White

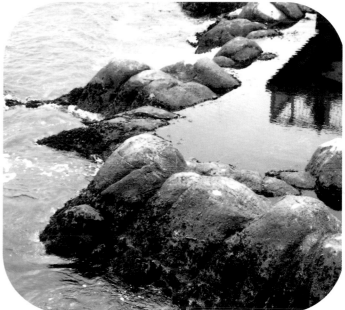

"The Tennessee stud was long and lean / The color of the sun and his eyes were green."—Johnny Cash

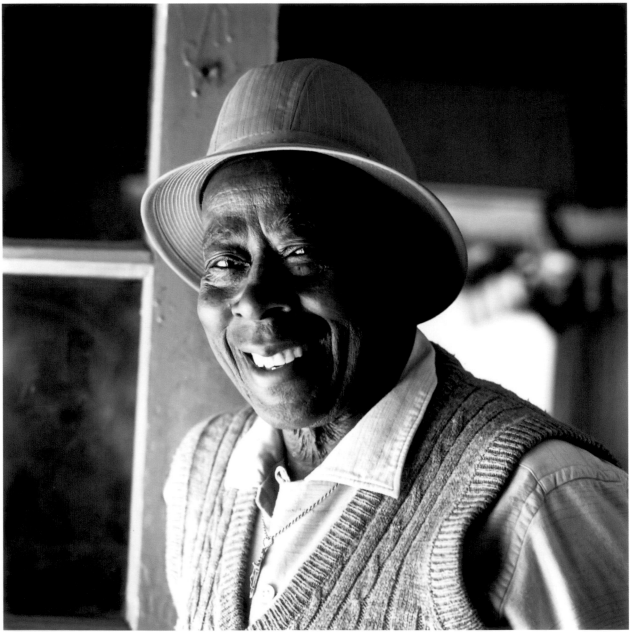

© Mary Farace

Back in the not-so-old days, the only to make a black and white photograph was by shooting black-and-white film. These days, digital shooters can have it both ways; most digital cameras give you a choice of shooting in color or black and white, or allow you to easily convert your captured color image files to monochrome using in-camera digital filters. And, even if your camera doesn't offer a black-and-white mode, you can convert to monochrome tones using any of the basic methods that we covered in the last chapter.

Sure, you can get to a black-and-white digital image in a number of easy ways, but sometimes you may find that you want your image to make a more powerful statement, and that's when it's time to put down the manual tools and pick up a power tool. Before you start building a digital toolkit, however, it's helpful to understand the role that layers can play in the creating of digital monochrome special effects.

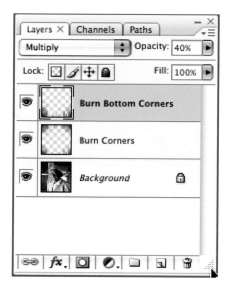

The Photoshop Layers palette features a visible display of all of the layers in an image, from the topmost to the background. It lists all layers, groups, and layer effects for the image file. You can use the Layers palette to show and hide layers, create new layers, and work with groups of layers, as well as to access various Photoshop commands and options.

An Introduction to Layers

The advantage of using layers is that you can manipulate part of the completed image without affecting any of the other parts. This can be as simple as adjusting color or as complex as adding layers of special effects to a select image area. One of the easiest ways to understand a digital imaging program's layers function is to imagine a photograph that has sheets of clear acetate stacked on top of it. Any kind of image—text, graphics, or even another photograph—can be layered onto the photograph. Where there is no image on a layer, you can see through it to the layers below. You can change an image's composition by changing the order and attributes of the layers. At the bottom of the stack of layers is the background, and the number of additional layers and effects you can add to that background image is only limited by your computer's memory.

Adobe Photoshop offers an additional very specific kind of layer, called an adjustment layer, that allows you to apply tonal and color corrections. This lets you try different combinations of how layers react with one another, and when you achieve the desired result on-screen, you can merge the adjusted layers. Adjustment layers let you perform color adjustments without affecting the original image data, allowing you to experiment with different adjustments, such as hue and saturation, brightness and contrast, and overall color balance. You also have the option to undo or refine any of these adjustments later. Creating an adjustment layer in Photoshop is as simple as selecting Layer > New Adjustment Layer.

Your Monochrome Toolkit

Want to take your monochrome images to the next level? Then it's time to break out the power tools—Photoshop-compatible plugins, Photoshop actions, or software utilities that make it a little easier to create the effects you want, from practical to more extreme special effects. Much like an electric screwdriver makes household projects go faster than an old-fash-ioned hand tool, software power tools let you produce imaging projects more quickly and with less fuss.

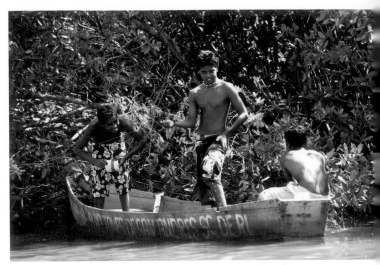

This photograph, made at Tres Palos lagoon, was originally taken in color for a newspaper story about Acapulco. The exposure was 1/320 second at f/5.6 and ISO 200.

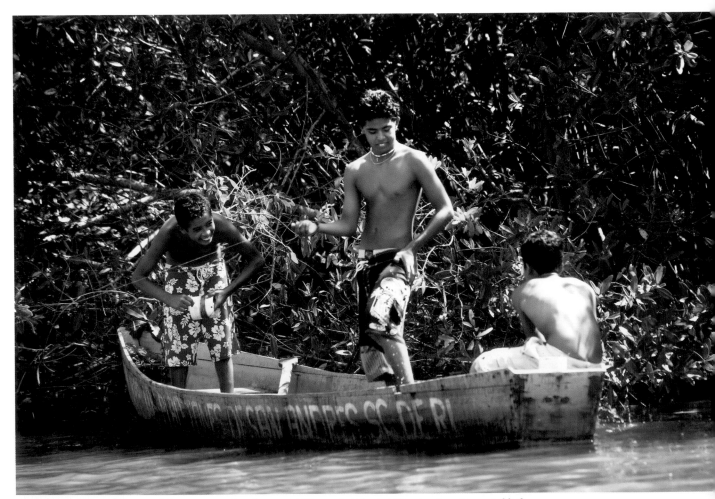

When the story ran, all the rest of the images ran in color except this one that the Art Director chose to run in black and white. While I don't always agree with those kind of editorial choices, I did in this case. The image was converted to monochrome using Alien Skin Software's Exposure plugin.

One of Adobe Photoshop's most useful features is that it can accommodate small software applications called plugins that extend the program's capabilities. The use of plugins lets digital imagers increase the functionality of graphics programs and allows them to customize their software to match whatever kind of project they're working on... but don't let the name "plugin" fool you. You don't need Adobe Photoshop, or even Photoshop Elements, to use compatible plugins. Adobe Systems defined the standard, but compatible plugins can be used with many other image-processing programs, including Ulead Systems PhotoImpact, and Corel's Painter, PhotoPaint and PaintShop Pro, to name a few. Even some freeware image-processing programs support Photoshop-compatible plugins. There are eight different types of plugins, some you might care about, some not, and two that don't have a traditional interface:

1. Color Picker plugins: These plugins are an addition to software program color pickers. They appear whenever a user requests a unique or custom color.

2. Import plugins: Sometimes called Acquire plugins, these interface with scanners, video frame grabbers, digital cameras, and other imaging formats. Import plugins are accessed through Photoshop's File > Import menu.

3. Export plugins: These plugins appear in Photoshop's File > Export menu and are used to output an image, including the creation of color separations. Export plugins can also be used to output an image to printers that lack driver support, or to save images in compressed file formats.

4. Filter plugins: You can access these using Photoshop's Filter menu, but they may appear under other menus in different software programs. Filter plugins are used to modify all, or a selected part, of a photograph.

5. Format plugins: Often called File or Image Format plugins, these provide support for reading and writing additional image formats that are not normally supported by the image-processing program of your choice. They appear in the Format drop-down menu when you enter the Save As or Save a Copy dialog boxes.

6. Selection plugins: These plugins appear under the Selection menu and are used to create shapes or paths for drawing. Before you begin drawing in Photoshop, you must choose a drawing mode from the options bar. The mode you choose to draw in determines whether you create a vector shape on its own layer, or a work path on an existing layer. Vector shapes are lines and curves you draw using the Shape or Pencil tools. Vector shapes are resolution-independent and maintain crisp edges when resized, printed to a PostScript printer, saved in a PDF file, or imported into a vector-based graphics application. Paths are outlines that you can turn into selections, or fill and stroke with color. The outline of a shape is a path.

7. Extension plugins: These are the first of the two I referred to that don't have a traditional interface. These "secret" plugins are not accessible by the average user and permit implementation of session start and end features, such as when initializing devices connected to the computer. They are only called up at program execution or quit time and have no user interface.

8. Parser plugins: This is another class of plugins whose interface isn't public. These perform similarly to Import and Export plugins by providing support for manipulating data between bitmapped programs and other formats.

So far in this book, you have seen a few specific examples of how certain plugins enabled me to achieve a variety of exciting image effects. The following is a list of several additional plugins that you might want to consider as you put together an indispensable monochrome toolkit. Using any of the plugins covered in this book is easy. Most of the time you can select something from a list of provided presets to obtain good results, but chances are that you can also make some changes to those presets to improve the overall effect. Don't hesitate to explore all that these programs have to offer. Look at the various tabs that may be provided to see what's "behind door number three" in the way of options. Don't be afraid to check or uncheck the various boxes to see what happens, and by all means drag those sliders to the extreme ends. What's the worst that can happen? You can always hit Undo and start all over again, but there are also other alternatives.

One of the easiest ways to deal with the application of a plugin effect is to use Photoshop's Fade command, found under the Edit menu only after the plugin has been applied, and it has the name of the filter attached to the command. When you select the Fade command, you can fade the effect of the filter from 1 – 99% to achieve the exact look that you want. Another alternative is to apply the filter to a duplicate layer (Layer > Duplicate Layer) and then use the Opacity slider in the Layers palette to vary the filter's effect on the background layer.

BW Styler

B/W Styler (www.thepluginsite.com/products/photowiz/bwstyler) is a Windows-only Photoshop-compatible plugin for monochrome conversion and creating traditional black-and-white effects. It supports RGB images, recreates the look of various films, lens filters, and traditional darkroom effects, and has modes for inexperienced, intermediate, or advanced users. You can choose between presets for film type, ISO rating, lens filters, development strategy, paper type, color toner, and special lab effects. These effects can be adjusted in ten modes, each of which concentrates on one aspect at a time. There are five special effect modes for monochrome conversions, selective black-and-white, split color, vignette blur, and mist effects. Advanced users can use the B/W Quick Mode for doing sophisticated black-and-white conversions with the help of sixteen different controls.

If you really want to see something completely different when applying the Fade command, experiment with the Blending Mode drop-down menu. There are many options here that endlessly expand your imaging possibilities.

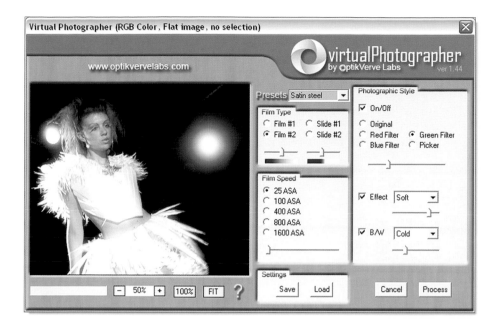

virtualPhotographer

virtualPhotographer (http://www.optikvervelabs.com) includes over 50 presets that automatically apply combinations of film grain, color modification, black-and-white, soft focus, high contrast and many other artistic effects. It is also a double rarity in the world of Photoshop-compatible plugins in that it is Windows-only and is free. There are lots of free plugins out there, but virtualPhotographer is so good you would actually pay for it. Its structure should be familiar to traditional film photographers. It can simulate the film type as Film or Slide, adjust the grain effect to match film speed, and it lets you apply lots of traditional darkroom effects and tints. The best way to use virtualPhotographer is to apply some of the presets to your image to see which ones look best. Then, fine tune the other controls to get the exact results you want. To see the original image, click and hold the mouse on the image in the Preview window.

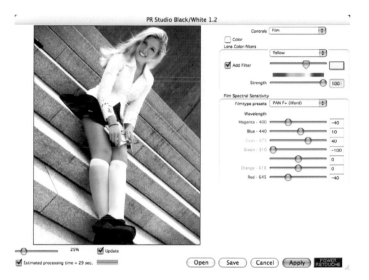

PR Studio Black/White

Everybody has their own favorite method for converting color files into monochrome images but PR Studio Black/White from Power Retouche (www.powerretouche.com) may be one of the best ever monochrome conversion tools. You can use the light sensitivity of traditional films, such as Kodak's Tri-X or T-Max, to make the conversion, or you can create your own sensitivity curves and save them for later use. This plugin features four groups of controls, including Filters, Film, Print (multigrade, exposure, and contrast), and three selectable and adjustable Zones. PR Studio Black/White turns Photoshop into a digital darkroom for monochrome imaging.

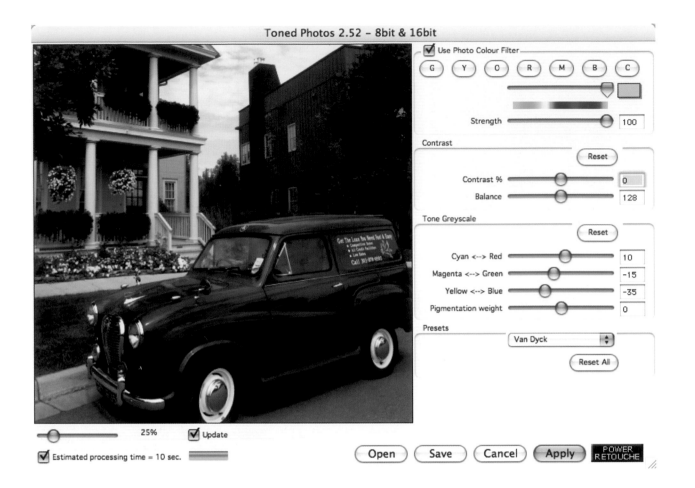

Toned Photos

Power Retouche's Toned Photos plugin (www.power-retouche.com) adds Sepia, Van Dyck, Kallitype, Silver Gelatin, Palladium, Platinum, Cyanotype, Light Cyanotype, or Silver toning by using built-in presets, or you can create your own. (See pages 122–139 for more about emulating old photographic techniques.) Like PR Studio Black/White, it works with RGB, CMYK, Grayscale, or Duotone image files. This image above of an Austin delivery van was originally captured as a color file then converted into monochrome using PR Studio Black/White. I then tinted using the Toned Photos' Van Dyck preset.

nik Color Efex Pro

This may be a plugin, but in reality, nik Color Efex Pro is an imaging environment that clings remora-like to Adobe, extending Photoshop capabilities and allowing you to produce incredible effects in very little time. Color Efex Pro is a major productivity tool. The product includes 52 filters and over 250 effects that are whisked into a single interface.

There are three ways of looking at an image: Single image, Split preview, and Side-by-Side preview. Simply click an icon on the Option bar to choose the view that works for a specific image. Complimenting any of these views is a Loupe window that gives a magnified view of wherever you place your mouse. If you zoom in on the image in the preview window, the Loupe automatically switches into Navigator mode that lets you change the view of your photograph using a thumbnail display. The colored box in the Navigator corresponds to the currently viewable area in the window.

Color Efex has always been unique in that it lets you selectively brush on effects with a graphics tablet and a stylus (like a writing utensil), and the Selective Tool lets you quickly and easily brush effects onto your image, too. Layers and masks are automatically created, so you're free to experiment. Not all of us like using a stylus, however, and are more comfortable with a mouse, especially one as ergonomic as Logitech's (www.logitech.com) cordless Laser Mouse. For us "Mousketeers," nik has a secret weapon: U Point-powered Control Points—first seen in Nikon's CaptureNX software. These let you selectively control where each filter is applied or not applied without making complex selections or masks. You simply click the point on a given area and control its effect and opacity via some clever sliders. You can add as many control points as you like. Some of the filters Color Efex Pro offers include Bleach Bypass, Cross Balance, Film Effects, Film Grain, Glamour Glow, Low Key, High Key, Polaroid Transfer, and Tonal Contrast.

nik Software offers a family of monochrome conversion plugins as part of the Color Efex Pro package. The B/W Conversion filters transform a color image to a black-and-white version of the original, providing control over the highlights, shadows, and relationship of the original colors using color spectrum, brightness, and contrast sliders.

The nik B/W Conversion filter creates a "traditional" conversion from color to black and white, enabling a portion of the color spectrum to be targeted while providing control over the image's tonality and contrast. © Mary Farace

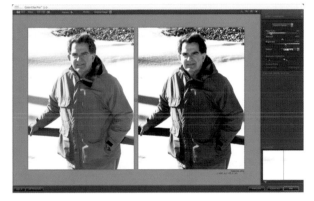

The Tonal Enhancer filter converts the image to black and white while providing specialized contrast control, simulating the traditional black and white darkroom technique of using contrast filters while printing. The little warning strips on the Contrast sliders are nik's suggested boundaries. You can ignore them if you like. © Mary Farace

The Dynamic Contrast filter uses a unique Contrast Enhancer adjustment to create an exaggerated dynamic range to convert a color image to black and white with adjustments to produce an artistic effect.

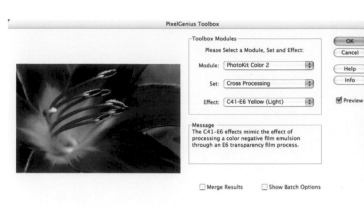

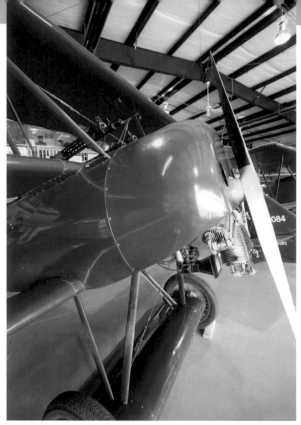

Yes, Snoopy... it's the Red Baron! I captured this original color image with an exposure of 1/50 second at f/4.5 and ISO 400.

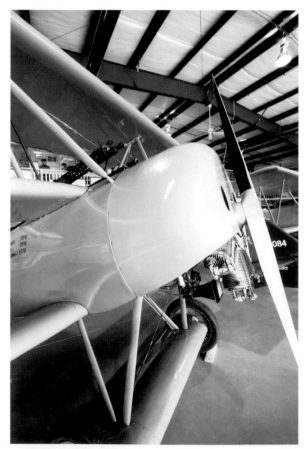

I made the final monochrome image using a combination of two Photoshop-compatible plugins. First, the color photo was converted using nik's B/W Conversion: Dynamic Contrast filter. Then I used the Platinum Toning feature from the Pixel Genius PhotoKit plugin.

Pixel Genius PhotoKit

Pixel Genius PhotoKit Color (www.pixelgenius.com) is a comprehensive Photoshop plugin for applying automatic color balance, color corrections, and creative color effects to your image files. Their Dodge and Burn tools sets are indispensable. The Special Effects series contains filters including color infrared, sunshine, and color transfer effects. You can mimic the look of a faded color print or recreate the look of certain color movie processes. This set also includes grainy pastel and contrast effects that simulate high-speed color film. PhotoKit Color also lets you recreate creative effects like monochrome split toning and fourteen different kinds of cross processing.

Digitizing the Film Look

Photographers are a contrary lot. For a long time they wanted to make photographs look like paintings, and now there's a growing trend to make digital images look as if they were captured on film. For many shooters, this was initially driven by the desire to produce monochrome photographs, but a logical progression was to apply the palettes of their favorite color films as well. Kodak Ektachrome 64 doesn't look similar to Fuji Velvia, and like other digital shooters, I miss these favorite color palettes.

Some manufactures have built film-like parameters into their cameras for direct capture. That's one way to capture a "film look," but the safest method may be to make the conversion in the digital darkroom where you can work on a copy of the original image, preserving the original file, just in case. The quickest and easiest black-and-white film effects can be applied directly within digital imaging programs such as Adobe Photoshop using a simple technique: Convert the color file to monochrome (see pages 30–33) and add grain.

Step 2: Then I opened the image in Photoshop, selected the Channel Mixer (Image > Adjustments > Channel Mixer), and checked the Monochrome box. The sliders control the amount of detail and contrast in the image based on the original color array. When adjusting the percentages of the source channels, you'll usually get the best results when the combined values add up to 100%.

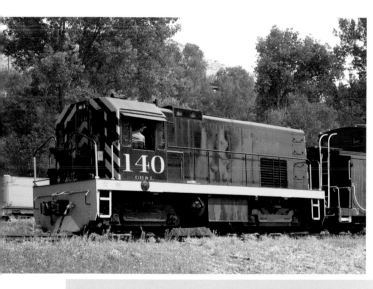

Step 1: I captured this original photograph of the locomotive in color with an exposure of 1/800 second at f/8 and ISO 200.

Step 3: Next, I selected Film Grain from the Filter gallery (Filter > Filter Gallery). The Film Grain filter, part of Photoshop's Artistic filters, applies an even pattern to the shadow tones and midtones. A smoother, more saturated pattern is added to the lighter areas.

After converting to black and white and adding grain, the result is decidedly Kodak Tri-X-like in overall appearance, but if you really want to match the tonalities of specific film, you're going to need those power tools we talked about.

If you already have Adobe Photoshop or Photoshop Elements, you can use the built-in Grain filter (Filter > Texture > Grain). Then again, that method may seem too easy for those who like to find more complex ways to create effects that look a little bit different. Fine arts photographer M.P. Hunt suggests using the Diffuse Glow filter (Filters > Distort > Diffuse Glow). This method produces a more subtle grain effect and doesn't produce the mutilated RGB pixels that the Grain filter does.

Grain is the Name of the Game

Photographers love to tinker with their images. If there's too much grain in a photograph, we experiment with finding methods to eliminate it. If there's no grain, we work in the digital darkroom to add some. Bear in mind as we delve into the topic of grain here that, in some of the small photographs that appear on these pages, the grain may be too subtle to appreciate. The best way to see how the grain looks is try some of these techniques yourself and apply as much or as little grain as you like. When working with grain in the digital darkroom, I use the "20-minute rule." If you can't achieve the effect you want in twenty minutes, you probably never will.

Photoshop's built-in Grain filter offers a drop-down menu that gives you access to ten kinds of grain structure, including vertical, and adjustable sliders that let you increase the amount of grain and contrast to makes sure it pops out.

Another way to archive a grainy effect is to use Photoshop's Diffuse Glow filter. Set the Clear slider to near maximum, place the Glow slider to the end of the scale, then play with the Graininess slider and, as Emeril says on The Food Network, "season to taste."

Visual Infinity's Grain Surgery has several sliders that let you create grain from scratch, but you can also reproduce the actual grain structures of more than twenty real-world films, including some from Agfa, Kodak, and Fuji.

One of the most practical Photoshop-compatible plugins around is Visual Infinity's Grain Surgery (www.visinf.com). Not only can it remove grain or digital camera noise from an image file, but you can also use it to add grain. You can even sample your favorite grainy film stock (mine is Ilford 3200 black-and-white film exposed at an EI of 100), import its grain structure into the plugin, and apply it to your digital images.

nik Multimedia's Old Photo is a fast way to add grain and convert the image to monochrome while producing a grainy "old newspaper" look. It's part of their Color Efex Pro package of Photoshop-compatible plugins. Old Photo makes it a one-step process to convert the image to monochrome and add grain at the same time. Just move the sliders that control the various effects, including grain, and look at the results in the preview window.

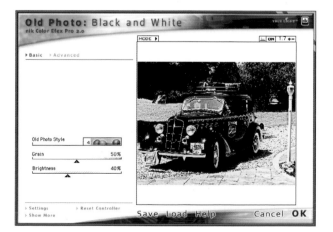

I captured this original photograph of a 1947 Plymouth taxicab with a D-SLR and lightly tweaked it in Photoshop to make it look it's best. In order to give the photograph a faded, old newspaper look, I extended the Grain slider almost as far as it would go.

Other Power Tool Options

Bill Dusterwald is the genius who created Silver Oxide (www.silveroxide.com), a family of Photoshop-compatible plugins allowing digital images to emulate the tonalities of "real" analog film, such as the Kodak's classic Tri-X, or my favorite, Panatomic X. Now's he's begun a series of new monochrome filters designed to optimize images based on subject matter. And, in addition to the typical filter options, SilverOxide offers a new purely digital filter called BANG (Blue Algorithm Neutral Gray) that acts like a polarizer filter.

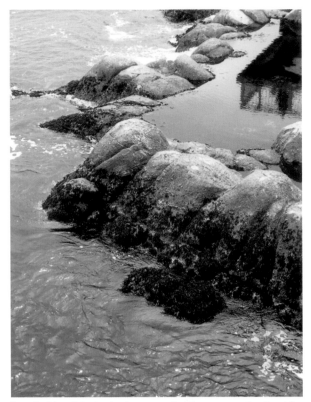

I made this original color image on the Monterey peninsula with an exposure of 1/500 second at f/4.0.

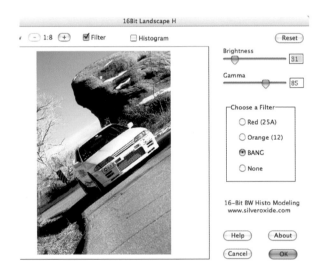

Usually Silver Oxide filters are modeled on the existing analog world, but creator Bill Dusterwald says that the BANG filter is "pure digital whiz bang." All I can add is that it sure is.

The Imaging Factory's Convert to BW Pro (www.theimagingfactory.com) has good user control and the ability to save favorite settings for later use. The floating control palette contains four tabs for adjusting all relevant parameters needed for conversion. The Prefilter tab lets you to filter the original image to enhance or dampen certain areas. The Color Response tab is like using different black-and-white film types when shooting a film camera and acts as a color equalizer.

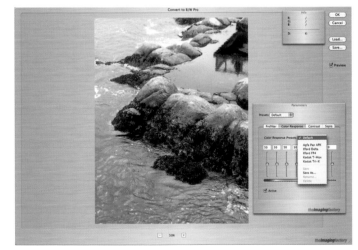

A combination of a red filter, emulation of the color spectrum of Agfa Pan APX, and sepia toning, all found in The Imaging Factory's Convert to BW Pro plugin produced this result.

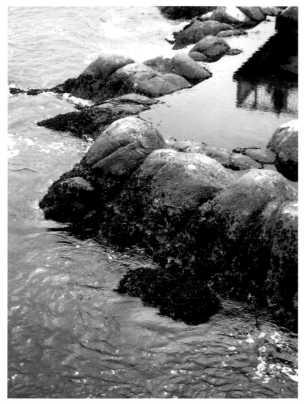

The Convert to BW Pro plugin automatically compensates exposure for pre-filtering and color responses. For the Contrast tab, Ilford provided their original curves data, allowing the Multigrade slider to set contrast that matches their traditional darkroom papers.

Another way to add film frames is with onOne Software's PhotoFrame Pro (www. ononesoftware.com). It lets you create gorgeous edge effects, including Drop Shadow, Bevel, Glow, Border, and Texture. This Photoshop-compatible plugin supports 16-bit images and has an auto-rotate feature that detects the orientation of digital camera images and automatically rotates frames.

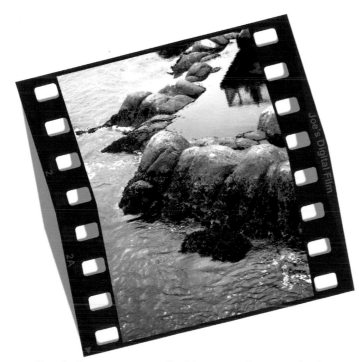

To make the image even more film-like, I wrapped it in a simulated 35mm film frame using the free B&B Filmstrip35mm (www.panos-fx.com) that works with Adobe Photoshop version 6.0 or later. For more information on film edge effects, see pages 76–78.

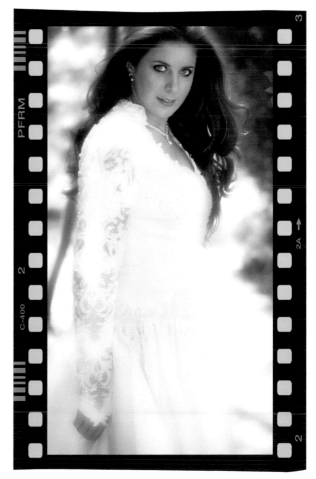

The latest version of PhotoFrame Pro offers native support for Intel and PowerPC-based computers and is compatible with Windows XP and Vista as well as Adobe Photoshop CS3 and later.

DxO FilmPack, which offers emulation of nine kinds of black-and-white film, is available as a Photoshop plugin, stand-alone application, and an add-on to DxO Optics Pro version 4.2 or later.

Based on detailed analysis and calibration of the originals, DxO FilmPack enables photographers to add the effect of more than 20 black-and-white, color negative, and slide films to their digital images. DxO FilmPack even permits users to combine the color rendition and grain profiles from different films. It also has a range of toning renditions that can be applied to any digital image in JPEG or TIFF format, regardless of source. When used within DxO Optics Pro, these effects can even be applied to RAW images.

Alien Skin Software – Exposure

If Adobe Photoshop is the 800-pound gorilla of image-processing software, Alien Skin Software's Exposure is the 800-pound gorilla of plugins. If you're like me and have been making images for a while, you enjoy the immediacy and convenience of digital capture, but every now and then there's a little voice in your head that says, "What about GAF500 film? Don't you miss it?" It's true, I miss using a lot of different film stocks that, like Ilford's 3200 Delta, have character and weren't digitally perfect. Well, kiddo, I've got some news for you: Alien Skin Software's Exposure plugin can take your new digital files and make them look old again.

Exposure is really two separate plugins that appear under the Exposure submenu in the Alien Skin Filters menu. The first is Black and White Film, which includes a dozen different film stocks. The second is Color Film, with similar options. Exposure is based on an analysis of real-world film stocks and brings the look and feel of film to digital photography. Hardly the first to do this, Alien Skin Softaware's Exposure is clearly the most extensive software currently available, and offers the most capabilities. It not only recreate a film's distinctive look with more or less one click, but saturation, color temperature, dynamic range, softness, sharpness, and grain are managed at the same time. The built-in presets are just a starting point, and can be tweaked to suit a particular subject or applied to a batch using Photoshop Actions (see pages 40–45).

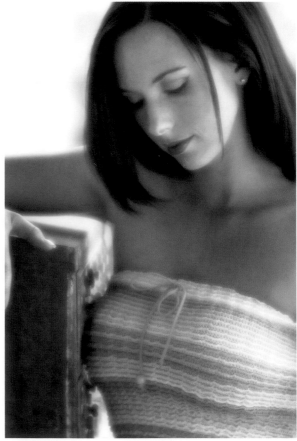

I captured this original portrait with an exposure of 1/160 second at f/3.3 and ISO 200. I used Canon's 135mm f/2.8 SF soft focus lens, so the softness you see is intentional.

The Color Film plugin that's part of Alien Skin Software's Exposure manages saturation, color temperature, dynamic range, softness, and sharpness. It can add grain to an image file's shadows, midtones, or highlights, and models the size, shape, and color of real-world grain.

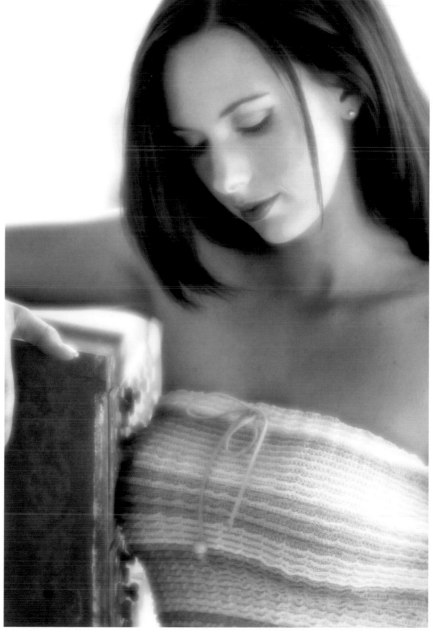

Here, I selected Fuji Provia from the Exposure plugin's film emulation choices. I could have added grain by going to the Grain tab at the top of the interface, but didn't want to conflict with the soft focus look.

The Exposure plugin's preview system includes an optional split preview in addition to a Before/After button. It also combines unlimited undo/redo with fast rendering, allowing you to pan and zoom using Photoshop-style keyboard shortcuts. There are several additional features that reproduce studio and darkroom effects, such as cross processing, split-toning, push processing, and glamour portrait softening. It even includes presets for cross-processed Lomo-style image shots with your choice of four different manufacturer's films. It doesn't get much more avant-garde than that.

The Exposure plugin allows you to select from a multitude of different film effects to apply to your image.

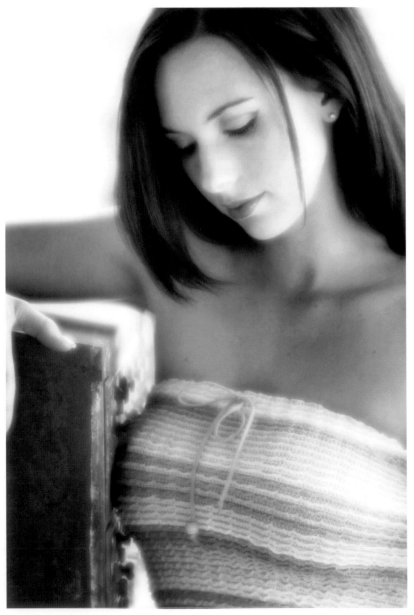

For this rendition, I selected the Fuji Neopan preset because it's a film I liked to use when making portraits. It delivers fine grain along with rich gradation.

So Many Plugins, So Little Time

By now you must be asking yourself, "Which one of these plugins is the best?" Well, I believe that there is no such thing as one choice that is "the best" for everyone; there is only what specific technique or software product is appropriate for a given image file at a given time. What works for your portraits may not work for your landscape photography.

So, what to do? That's easy. Most, if not all, of the plugins that I mention in this book offer free trial or demo versions of their products that you can download and use with your own photographs—that's why I provided the URLs. Use the suggestions I've provided as a guide, not as a rulebook. There are endless possibilities for converting your color image files into dramatic monochrome photos. Experiment with different plugins, try out the slider techniques I've suggested, and make up your own mind as to what is the "best" for you. And remember, the methods and programs outlined in the previous pages are hardly the only ones available. There are lots of others, including some that we'll explore in upcoming chapters, but for now, consider these as a jumping off point for your initial explorations.

This handsome pachyderm was photographed at the San Diego Wild Animal Park using and exposure of 1/400 second at f/7.1 and ISO 640. the color image was converted to black and white using onOne Software's PhotoTools plugin (www.ononesoftware.com). The program offers ten different black and white treatments. In this case, I applied two, starting with the (Kevin) "Kubota-B&W GM Warm 1 + Snappy A1" effect, and followed by the (Bill) "Davis- Add Glow" effect. they were layered from within the plugin.

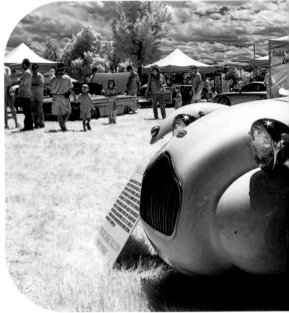

Monochrome
Special Effects

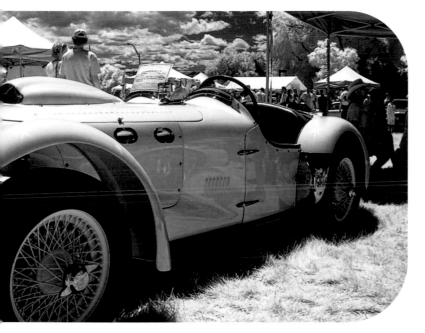

The World of Invisible Light

Shooting infrared has the power to transform mundane subject matter into unforgettable images. Everyday scenes that you might walk by and never think of photographing take on a more dramatic look when seen in infrared.

Every color's wavelength is measured in nanometers, or one billionth of a millimeter, and light with wavelengths ranging from 700 – 900 nm (nanometers) is called infrared light. This band of infrared light is a thousand times wider than that of visible light, and totally invisible to our eyes.

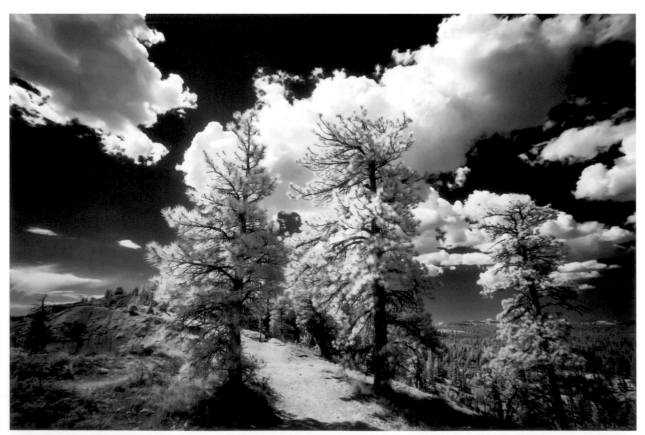

While hiking in Arches National Park, I saw this dramatic cloud formation. I captured this image with a infrared-modified Canon EOS D30 with an exposure of 1/125 second at f/14 with a +2 exposure compensation at ISO 400.

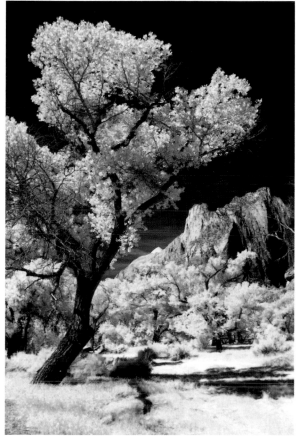

IR capture illuminated these deciduous trees, found all over Zion National Park. I captured this image with an infrared-modified Canon EOS D30 with an exposure of 1/125 second at f/8 with +2 exposure compensation at ISO 200. I then applied subtle toning using PixelGenius PhotoKit (www.pixelgenius.com).

Back in the "bad old days" of shooting IR (infrared) film, you needed to use a special film stock and load and unload your camera in total darkness to reduce the risk of fogging the film. To shoot IR film, you also needed special filters—although that hasn't changed— and to either process the film yourself or find an ever-dwindling pool of specialty labs to do it for you. Shooting infrared film was a process of click and hope, but with digital, IR images can be made in-camera and you'll immediately see the results on the LCD monitor.

Infrared Camera Modification

The imaging sensors used in digital cameras are sensitive to more than visible light, so some manufacturers place an infrared filter in front of the sensor to block IR light from striking it and causing color balance problems. Some digital cameras allow enough IR light through to permit what techies would call "near infrared" photography when an IR filter is placed in front of the lens. If your camera has a black-and-white mode, it is likely that you will be able to achieve this effect.

When I get a new digital camera, I give it the "remote control" test to see if it's capable of infrared capture. Simply point a TV remote control at the lens, press a button, and take a picture. If you see a point of light coming from the remote in your image, go ahead and try to make IR digital images.

If your digital camera is not IR sensitive, or if you decide to get really serious about digital infrared photography, you might want to have your camera converted to IR-only operation. The IR Guy (www.irdigital.net), LifePixel (www.lifepixel.com), MaxMax (www.maxmax.com), and Australia's Khromagery (http://khromagery.com.au), among others, are all companies that convert digital SLRs into IR-only cameras.

There are several companies that also covert digital point-and-shoot cameras to IR-only if you don't want to sacrifice your D-SLR. Let the Internet be your guide.

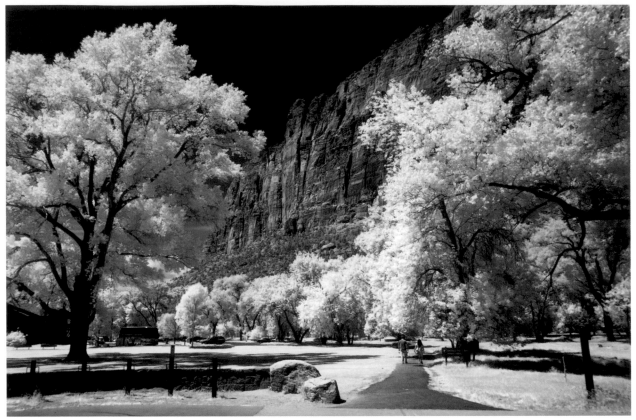

The Lodge at Zion is surrounded by beautiful deciduous trees and red rock cliffs, making it a wonderful place to capture IR images. Exposure in Shutter Priority mode was 1/125 second at f/11 with a +1 exposure compensation at ISO 200.

Palm trees, the ever-popular tropical photography cliché, look like white feathers when shot in IR, adding an exotic look to an exotic location. Tree leaves in general appear white. This is an infrared effect that is commonly produced by deciduous trees and grass because they reflect the sun's infrared energy instead of absorbing it. Coniferous trees (evergreens) display a less intense but often still visually interesting effect in infrared photographs.

One of the first things you have to do when shooting IR images is forget everything you know about lighting and the best time of day to capture images. To give foliage that famed infrared glow, you need to shoot at a time of day when there's more sun on the scene than not, which puts most of your best shooting around midday, the "golden hours" for infrared. If you need a rule of thumb, try this one: The best time of day to shoot digital IR is when it's the worst time of day to shoot normal images. So instead of being stuck in paradise with only boring, harsh lighting for color photographs, shoot infrared!

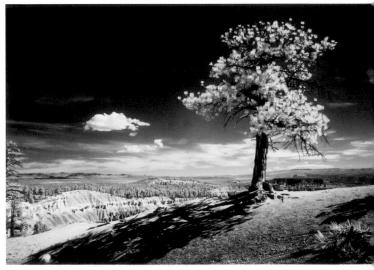

Hiking along in Arches National Park, I liked the way this lone pine stood out from the background. I captured it as a RAW file at 1/160 second at f/16 with +1 2/3 exposure compensation at ISO 400.

Infrared Filters and Holders

Different IR filters are engineered to kick in at a certain level of IR light, which is why results can vary depending on the filter's design. For most of my filtered digital IR images (as opposed to ones I shot with an IR-modified D-SLR—see page 69), I use Hoya's Infrared R72 filter (www.thkphoto.com). It's affordable and works great.

Cokin (www.cokinusa.com) offers a 007 filter that attaches via a filter mount (though I usually hold it in place to avoid light leaks—see my explanation, below). If you're not sure of which Cokin filter to get for your particular lens, visit the "frequently asked questions" page of Cokin's website (www.cokin.com/ico5-p1.html). The 007 filter is a modular implementation of their 87B infrared filter that was previously only available as a gel. My biggest concern when using these Cokin filters—which require a filter holder and are not actually lens mounted—is that visible light can leak in from the sides and can pollute the IR image. So, instead of a holder, I use my fingers and hold the filter flat against the front of the lens. The camera is on a tripod anyway because the optical density of all IR filters produces long exposure times, so handholding the filter is not too much of a hassle.

Fans of premium filters from B+W (www.bwfilter.com) and Heliopan (www.hpmarketingcorp.com/heliopan.html) will have to spend a little more than they would on their Hoya or Cokin counterparts, though the prices are still somewhat comparable. One of the most interesting of the currently available premium IR filters is the Singh-Ray I-Ray infrared filter (www.singh-ray.com). This totally opaque filter eliminates all visible light and transmits more than 90% of the near-infrared electromagnetic wavelengths between 700 – 1100 nanometers. The slight cost increase over other filters is well worth it if you are serious about capturing digital IR images.

This is just one of a few images I was able to make using an opaque Singh-Ray I-Ray infrared filter before the wind picked up and wiped the reflection from the lake.

This image was made with a Singh-Ray I-Ray infrared filter in the early afternoon near the entrance to Arches National Park. The trees are coniferous pines and the infrared effect is not as great as it would've been with deciduous trees, but I like the look nevertheless.

Adding Color

You can add color to your infrared photos at the time of capture using in-camera filter effects, or afterwards in the digital darkroom. The easiest and fastest way is to do it in-camera. Many cameras offer a built-in black-and-white mode that allows you to directly capture monochrome IR images, and some also have a sepia mode. If you opt to add color later, try the digital toning filters found in Pixel Genius' PhotoKit (www.pixelgenius.com), or use layers in Photoshop to add hand-coloring effects.

Brad Buskey's InfraRed Adjustment action (www.outdooreyes.com/photo94.php3) adds subtle color to digital infrared. Like all tweaks, the more tone you start with in your original image, the more color you end up with. David Burren created a Photoshop action for adding color to IR that applies all its changes via non-destructive adjustment layers, allowing you to easily undo or tweak each of the changes (khromagery.com.au/FalseColoursAction.zip). You can also add layer masks in Photoshop to make the changes selective.

You can also tone black-and-white IR image files to add a different look. This photograph, taken in Arches National Park, was made with a modified Canon EOS D30 and then I applied toning using PixelGenius PhotoKit (www.pixelgenius.com).

I shot this classic Allard sports car was with a modified Canon EOS D30 and an exposure of 1/160 second at f/16 and ISO 200. I then applied David Burren's free FalseCoulor Photoshop action to achieve this look (burren.cx/photo).

I love the tonal rendition of IR capture with the B+W 092 infrared filter. Here, I set exposure to 1/90 second at f/11 and ISO 400 with the FujiFilm FinePix S3 Pro UVIR. The B+W 092 filter is really dark red, and filters at IR light below approximately 650 nm. The filter factor is approximately 20 – 40, which is why all filtered shots were made in Manual mode.

Clearly the best bargain in IR filters, the Cokin Infrared 007 (89B) filter in Series A provides 50% transmission at 720 nm. Be sure to hold the filter flush to the lens with your fingers, though, to avoid any light leakage coming through. If you use a Cokin modular holder, there's a possibility of light pollution from the open space on the sides. Exposure for this shot was 1/90 second at f/11 and ISO 400, and I used the FujiFilm FinePix S3 Pro UVIR camera.

An IR Camera from FujiFilm

The FujiFilm FinePix S3 Pro UVIR is the first production digital SLR that's capable of capturing photographs in the ultraviolet and infrared light spectrums. It was designed for science, medicine, and fine art photography. Law enforcement agencies use ultraviolet and infrared photography to uncover evidence, such as traces of gunshot residue and blood that cannot be seen by the human eye, as well as to recover altered, burned, or otherwise obliterated writing. IR photography is also used for nighttime surveillance. That's one of the reasons the FinePix S3 Pro UVIR has a live CCD previewing feature that enables manual focusing while dark filters are attached to the lens, but this feature is also useful for fine art capture. It is important to note, however, that a straight color image taken with the FujiFilm FinePix S3 Pro UVIR contains lots of IR contamination (see page 74), so you will have to do some image editing to produce typical color effects.

With the Peca 904-1 filter on the FujiFilm FinePix S3 Pro UVIR camera, exposure was 1/60 second at f/11 and ISO 400. The shutter speed lends itself to a handheld shot, but you can't see anything through the viewfinder, so this and all of the other shots of this scene were made with the camera mounted on a tripod.

Singh-Ray's I-Ray infrared filter transmits over 90% of near-infrared light between 700 – 1100 nm while blocking virtually all visible and UV light. Exposure was 1/90 second at f/11 and ISO 400 with the FujiFilm FinePix S3 Pro UVIR camera.

What's in a Filter?

Almost all digital cameras have a filter in front of their imaging sensors to prevent infrared light from polluting the color. To enhance its infrared photography capabilities, the FujiFilm FinePix S3 Pro UVIR camera (see page 73) lacks this filter, so if you're wondering what digital capture looks like without IR protection, take a look at the following examples. My first landscape pictures looked like they were taken in autumn even though they were made in early summer. All of the green grass and tree leaves came out yellowish orange. The ultimate answer was to attach a Tiffen Hot Mirror filter designed to remedy this problem by reflecting most infrared light. The results produced with the Hot Mirror filter were dead-on accurate, and if you want to be able to capture natural-looking results with a camera that lacks an IR filter, you'll want to pick one up.

This playground is one of my favorite test subjects because it includes a colorful play set, green grass, trees, and blue sky. This photograph made using Auto White Balance mode and you can clearly see the effects of IR pollution in the scene, especially in the trees and grass.

I color-corrected the image in Adobe Photoshop, but while I was able to get the play set and the sky to appear "normal," I could never get the trees or grass to appear as vividly green as they did to my eyes.

This image of the same scene was made with a Tiffen Hot Mirror filter screwed onto the front of the lens. What an amazing difference the filter made!

Infrared Software Effects

You can capture infrared images in-camera with modified cameras or by using special on-camera filters, but you can also create them after-the-fact using digital imaging software. I found Dave Jaseck's infrared action set on Action Central (www.atncentral.com). "You cannot create a real IR look in Photoshop," Dave says, "but you can fake it if the picture has some blue sky and white clouds." Jaseck's action set also allows you to add some color back into the image by reducing the opacity of the layer that has the infrared effect.

Craig's Actions InfraRedders (www.craigsactions.com) is part of his Storytellers One package of Photoshop actions and includes nine actions to get you started in IR emulation. With custom variations for Portraits, Strong, and even ExtraStrong effects, you have control of the final look and the ability to modify it.

Note: If you want to learn even more about infrared photography, pick up a copy of the book I wrote on the subject, "The Complete Guide to Digital Infrared Photography" (ISBN 1-57990-772-5).

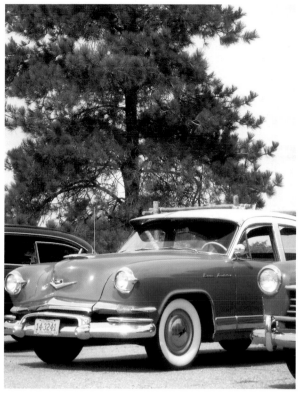

The original unretouched image of this Kaiser Manhattan was captured at a classic car show with an exposure of 1/125 second at f/8 and ISO 200

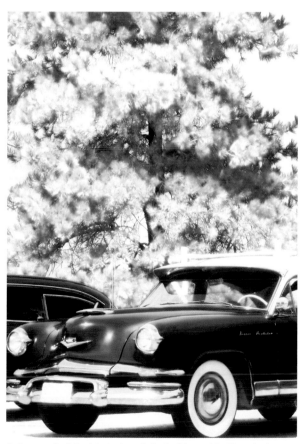

I then applied Craig's Actions InfraRedders with Glow Action to the image. During application of the action, you will see several dialog boxes, but to produce the effect shown here, I only adjusted the Saturation slider. As a final touch, I cropped the right edge of the photograph to put the picture's main focus on the Kaiser.

Creative Edges

One of the hottest trends in digital imaging these days is adding irregular, ragged, or artistic edges to photographs. Even staid National Geographic magazine used soft-edged photographs to illustrate their story on famed cartographer David Thompson. While the option of adding creative edges to photographs using traditional darkroom techniques has been around for quite some time, I've found that it's much easier to produce these kinds of effects with digital imaging software. In case you're wondering why you might want to add creative edges to your own photographs, here are a few reasons to consider:

• Photographs with irregular edges add variety to your portfolio images by providing visual relief from straight-edged vertical and horizontal rectangular shapes.

• Images with white or light-colored corners tend to have their edges disappear from the final print. A creative frame adds a decorative border to the photograph while giving the finished image a clearly defined edge.

• Instead of cropping to clean-up distracting elements, you can use creative edges to hide minor compositional flaws while adding a touch of panache at the same time.

• Creative edges can add an artistic touch to an image that might otherwise appear too literal.

• Playing with creative edge effects is fun, and gathering from viewer reactions, many other people like them as well.

OnOne Software's Photo Frame Pro plugin (www.ononesoftware.com) added an urban touch to this photograph but also hid the photograph's edges that went askew because the image had been rotated using the Image > Rotate Canvas > Arbitrary command in Photoshop to line up the window and the balcony's horizontal and vertical lines with the edge of the frame.

Creative Edge Power Tools

Auto FX (www.autofx.com) is the company that first made adding creative edge effects popular with digital imagers. Their Photo/Graphic Edges software can add torn, ripped, deckled, feathered, painted, film frame, and darkroom-styled edges to any image. The latest package contains four visual effect modules—Edges, Montage, Vignette, and Frames—and each module gives complete control over your edges and also lets you apply surface grain, lighting, shading, matte, or colored backgrounds. It also has 17 volumes of effects, including Traditional, Darkroom, Painted, Etched Scratchboard, Darkroom Transfers, and lots more. Included in the package are more than 10,000 edges and well as hundreds of color frames and feathered vignettes. There are 1000 matte textures and 200 lighting tiles to give images and edges a custom look and feel, allowing you to load multiple edges for an infinite combination of effects.

Auto FX Photo/Graphic Edges is both a Photoshop-compatible plugin and a standalone application. (Photograph courtesy of Auto FX Software).

Splat! Comes with a selection of stamp and frame files, but lots more can be found in the Download section of Alien Skin Software's website. Check it out for yourself, download a demo, and start framing those digital images. © Mary Farace

I've always liked adding creative edges to a photographs, and my favorite plugin for accomplishing this has always been on One Software's PhotoFrame Pro. It offers thousands of frames, including color, traditional, and realistic looking frames, and there are several tools that let you try variations before making a selection. For example, multiple frames and edge effects can be selected to compare how they look. The Random Frame Generator will add three to five frames that can be adjusted and then applied. A built-in Frame Browser helps you find the frame that's "right" for your image. The Frame Preview Grid lets you preview multiple frames at once with your image as the background. You can apply a border as a layer mask and save your favorites for access later. PhotoFrame Pro is compatible with Max OS and Windows computers.

Alien Skin Software's Splat! (www.alienskin.com) is a package of useful Photoshop-compatible plugins that contains six filters (Border Stamp, Edges, Fill Stamp, Frame, Patchwork, and Resurface) and has lots of built-in presets and textures. Splat! lets you add lots of special graphic effects, such as the ability to add realistic looking mats and frames to digital photographs. The interface, while lacking some of the style of previous Alien Skin offerings, has that most important feature any plugin needs—a large preview window.

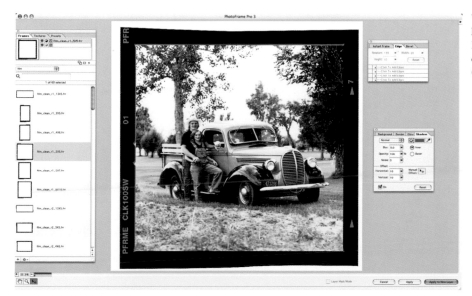

Want to make your digital image look like it was shot on film? PhotoFrame Pro contains an entire collection of digital film edges (www.ononesoftware.com).

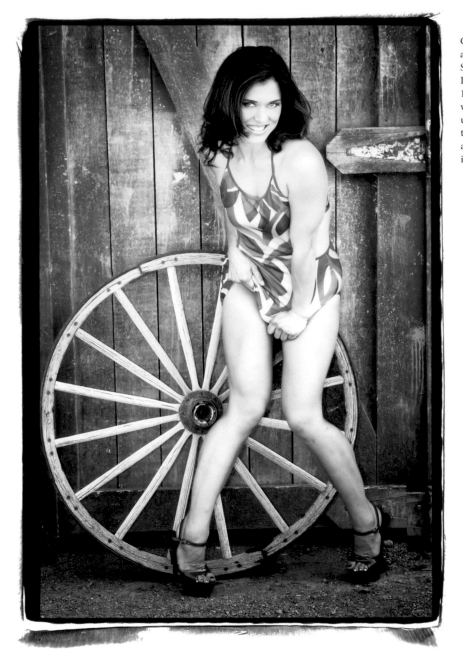

Give your black-and-white images a traditional darkroom look with Sloppy Borders from Kubota Image Tools. This is a package of 100 border variations that anyone with Photoshop CS or newer can use. Sloppy Borders is a combination of Photoshop scripts and actions that can be added to one image at a time or run in a batch.

Nobody loves sloppy image borders on their photographs more than me, and when I saw Sloppy Borders Volume 1 from Kubota Image Tools (www.kubotaimagetools.com), I fell in love. Kubota has done all the hard work and created a package of more than 100 ready-to-use borders that anyone with Photoshop CS or newer can use. Kevin Kubota and Lensbabies' Craig Strong worked in the darkroom and printed the borders using a variety of filed out negative carriers. The prints were scanned at high resolution and prepared for overlay with any image file. Kubota created

scripts to size the border to match the original image file resulting in an easy way to apply a border to any image no matter what its size, cropping, or orientation. Borders can be added to one image at a time or run in a batch for a folder full of images. You can add color to the borders with the bundled Sloppy Colorizer action. Also included in the package is a bonus Photoshop action that automatically creates 4 x 6-inch (A6) prints with sloppy borders for printing proofs.

Emulating Motion Picture Film

Even before the first Godzilla movie premiered in 1954, I was a fan of monster movies and special effects films that were produced by masters such as Ray Harryhousen. I thought it would be fun to recreate a strip of film from an imaginary monster movie and I drafted my wife, Mary, into playing the damsel in distress.

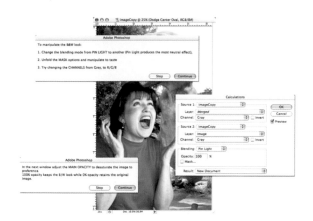

Step 1: I photographed Mary in our kitchen in front of a collapsible Westcott Chroma-key 5 x 6-foot (1.52 x 1.83-meter) blue background. The Tyrannosaurus Rex was photographed outdoors at the Utah Field House of Natural History in Vernal, Utah. Then I combined the two images using Digital Anarchy's Primatte Chromakey (www.digitalanarchy.com), a Photoshop-compatible plugin that allows you to create a composite image by removing the blue/green screen background from a photograph, leaving the subject against a transparent background.

Step 2: I then converted the composite color image into black and white using a free Photoshop action from PanosFx (www.panosfx.com) which is one of my favorite websites, offering high-quality, inexpensive, and free software. Their Black & White Conversion and Image Desaturation Photoshop actions provide more control for monochrome conversion and image desaturation than Photoshop's Desaturate and Grayscale commands. The action will prompt you with some of the dialog boxes you see above (although one at a time) so you can interact with the program, or you can use the defaults like I do.

Step 3: The PanosFx Action uses advanced techniques to produce perhaps the best monochrome conversion I've ever used, but I was only halfway finished. I knew that this vertical image would not crop into a perfect horizontal frame, and I wanted to produce a finished

image where Mary wasn't crammed against the left edge. To do this, I started by using the Canvas Size (Image > Canvas Size) tool in Photoshop to enlarge the canvas (not the photo) on the left-hand side, filling it with white space. You do this by clicking the dark square in the Canvas Size dialog box to show where you want the center of the new canvas to be. I clicked on the right-hand side, so it gave me blank space on the left-hand side. Then I used the Crop tool to produce a final frame with an approximate ratio of 16:9, but I still had the empty space to fill.

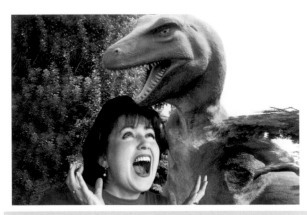

Step 4: The problem was what to do with the empty space. Using the Clone/Stamp tool in Photoshop, I recreated part of Mary's right shoulder. It's not perfect, but neither were the special effects in all of the early Godzilla flicks. I also used the Clone/Stamp tool to fill in the rest of the left-hand side of background with tree branches. This is also decidedly imperfect, but I knew that this part of the photograph would only appear in the final frame of the film strip. After a bit of burning and dodging, I was ready to make the other three film frames that would appear in the strip.

Step 5: To keep the image frames the same size, I entered the length, width, and dpi in the Crop tool settings option bar. To create the look of motion in the finished filmstrip, I used the Crop tool to create three other (for a total of four) differently cropped images, starting with a close-up of the T-Rex's face and ending with something not quite as wide as the final retouched frame. Now I was ready to drop the images into the digital film frames.

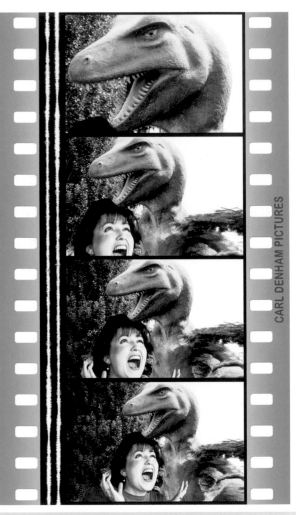

Step 6: Once you have the four film frames ready, it's time to run the Movie Film Photoshop action available from PanosFx (www.panosfx.com). It's free, but you have to become a member of the site (which is also free). Movie Film combines four landscape layout images to create a movie-camera filmstrip. On the left edge of the filmstrip, the action also creates the sound waveform stripe. In addition, the action gives you the option to type your own text on the right film edge. I should have used "Toho Studios," but instead used "Carl Denham Pictures" as an homage to the original King Kong. Finally, the action lets you choose from four different filmstrip variations.

While a Holga and its many variants are inexpensive to purchase, the cost of film, processing, and time spent scanning makes the camera one best suited to film aficionados. If you would like to experience the "Holga Effect" in the digital realm, read on. One of the easiest ways to create digital Holga images is to buy a Holga lens fitted with a mount for your D-SLR. Yes, boys and girls, HolgaMods will slice and dice that optically imperfect lens right off a Holga body and put it on a lens mount that will let you attach to almost every kind if D-SLR.

The Digital Holga

The Holga is a box camera that first saw the light of day in Hong Kong in 1982. It used 120 film because that was the most widely available film in China at that time. It's name, while disputed by some, comes from the Chinese phrase ho gwong meaning "very bright." A combination of the camera's toy-like construction and 60mm plastic lens often yields vignetting, blur, light leaks, and distortions, and it is famous for the optical imperfections it creates. Not surprisingly, these unpredictable results and a toy-like price have made it popular with photographic cognoscenti around the world. In fact, HolgaMod's (www.holgamods.com) Randy Smith says, "Each Holga is like a finger print, no two are alike." In a day in which cameras are technological wonders, the Holga is the anti-camera.

This is a real Holga lens mounted on my Canon EOS Rebel XTi. HolgaMods (www.holgamods.com) sells Holga Digital Body Cap Lenses that are real Holga lenses mounted on Canon, Nikon, Olympus, and Pentax body caps. You can, after a fashion, focus the lenses, and the results are pure digital Holga without any light leaks from the body.

This is my personal Holga 120N that I purchased from Adorama. A cult favorite with a global following, the Holga camera produces low-tech works of art with the minimum of mechanical functionality. Soft focusing, vignetting, and light leaks all contribute to the Holga's bag of "effects."

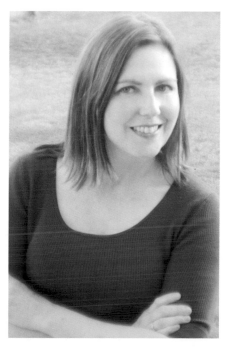

How does HolgaMod's Digital Body Cap Lens work? Pretty well. Here is a portrait of my wife made using the lens on my Canon EOS Rebel XTi. The camera was in Aperture Priority mode, and since the lens is about f/8, I set the ISO at 800. That produced a shutter speed of 1/25 second.

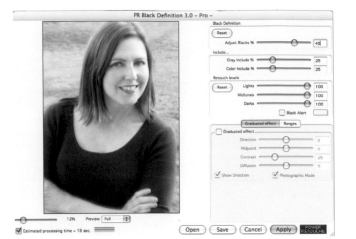

Power Retouche's Black Definition plugin (www.powerretouche.com) lets you control black as if it's a color channel. You can edit the black content of colors without changing hue, strengthen the clarity of objects in the photo, and target saturated or unsaturated colors for filtering.

Since the Holga lens lacks any contrast, I boosted the black with Power Retouche's Black Definition plugin and lightly burned the four corners of the photograph with Photoshop's Burn tool.

Another way to capture a digital Holga-like photograph is with a Lensbaby (www.lensbabies.com). The Original Lensbaby is a flexible camera lens that creates an image with an area of sharp focus (or not) that's surrounded by a graduated blur. This mostly plastic lens is available for many different camera mounts and brings the "Holga look" to D-SLRs while adding more creative control. With digital, you'll see the effects right away, so if you don't get exactly what you want the first time, you can try again.

Looking something like a prop from a 1950s Ed Wood sci-fi epic, Lensbaby 3G makes capturing images more precise, if that's a word that can be applied to soft-focus imagery. The Original Lensbaby and the Lensbaby 2.0 lens require the photographer to manually hold the lens in a bent position while pressing the shutter release. Lensbaby 3G allows photographers to lock the Lensbaby in a desired bent position simply by pressing a button. Then, using a traditional barrel focus mechanism, photographers can do fine focusing and precisely place the sweet spot of sharp focus before pressing the shutter release.

When using a Lensbaby, you shift the in-focus area by bending the flexible lens tube in any direction using a technique than can vary from photographer to photographer, but involves wrapping your fingers around the lens as if you were smoking a cigar. As you move the lens up, down, left, or right, this area of sharpness shifts, producing blurring and prismatic color distortions in the rest of the image. You can control the size of the sharpest area and the overall level of blur by using one of four apertures. This is accomplished by replacing the aperture ring, which looks like a washer, then replacing that with another one to try for a different effect. Four are provided, including f/2.8, f/4, f/5.6, and f/8, but if you're like me, you'll find one you like the best and just leave it in.

I photographed my wife Mary in the front yard of our home next to a flowering apple tree with a Lensbaby 3G at the f/8 aperture, which I have found to be the "sweet spot" for being able to focus the 3G—for me anyway.

When is a Holga-like photograph not produced with a Holga? When you use a Lensbaby! To enhance the Holga look, I added dark framed edges with the Soft Black Rule Fat effect that's part of Pixel Genius PhotoKit (www.pixelgenius.com).

Holga in the Digital Darkroom

One of the best ways to add the Holga effect in the digital darkroom is by using a Photoshop-compatible plugin or Photoshop action. The best way to digitally replicate a Holga photograph may be Alberto Campione's Holga Simulator action. He recommends that you use a camera that has at least a four-megapixel resolution when running his action. Unlike other, similar actions, Holga Simulator even crops the photo into a square, although it is interactive and you can move the crop lines to suit the subject. Using a complete set of layers, it adds all of the stuff you love about Holga, including blur, light leaks, vignetting, and even film grain. Each layer may then be tweaked to produce the final effect. The Holga Simulator is available through the Adobe Exchange (share.studio.adobe.com).

Step 1: This original cow photograph was made in color with an exposure of 1/320 second at f/10 and ISO 200. © Mary Farace

The Old Toy Camera action adds some of the general elements that make photos captured with toy and antique cameras so beautiful. This version looks like the "real deal" old photo of an old car, something the color version lacks.

Step 2: The original color digital image was then transformed into a digital Holga photograph. The result you see was a one-click operation after downloading and installing the Holga Simulator action. © Mary Farace

Another way to emulate "the Holga look" with software is to apply the Old Toy Camera Photoshop action (www.flickr.com/photos/94336434@N00/18330448), which gives photos a look similar to shots made with a Diana, Holga, or antique camera. The file also includes two additional actions that imitate the borders and edges often produced by vintage and toy camera images.

This photograph was originally captured in color with an exposure of 1/80 second at f/7.1 and ISO 250. It was a cool morning that was still overcast from a light rain that stopped just moments before I made the shot.

This original photograph was captured with an exposure of 1/500 second at f/9 at ISO 200. It was cropped into a square before processing with Flaming Pear Software's Melancholytron (www.flamingpear.com). © Mary Farace

Pear Software's Melancholytron provides lots of controls to make your pictures moody and nostalgic. You can use a full set of sliders to subdue hue and focus to direct the viewer's attention and produce full-color, mid-color, and sepia-like effects. © Mary Farace

The final result was achieved after applying Pear Software's Melancholytron plugin and some tweaks with Photoshop's Curves function. As a final touch, all of the corners were darkened using the Burn tool. © Mary Farace

Mixing Black and White with Color

> "A quality of justice, a quantity of light, a particle of mercy makes the color of right."—Rush

The mixing of monochrome imagery with color is not new. Photographic artists have been producing hand-colored photographs since the early 1800s. Swiss painter Johann Baptist Isenring made the first colored daguerreotype circa 1840. Hand-colored photographs are different from tinting and toning, which we already covered but will be examining in more detail in this chapter.

In tinted photographs, a single color permeates the image. These were typically made using dyed printing papers produced by commercial manufacturers "back in the day." In traditional photography, toning refers to various photochemical methods for altering the overall color of the image. In addition to adding color to a traditional monochrome print, toning usually improves image stability and increases contrast. Compounds such as gold, platinum, or other metals were used in combination, with variations in development time and temperature to produce tones ranging from warm browns to purples, sepias, blues, olives, red-browns, and blue-blacks. In the expanded third edition of Bea Nettle's book "Breaking the Rules," she talks about the three basic materials used for hand-colored photographs. To her list of oil, lacquer, and water-based materials, I would like add another—digital media.

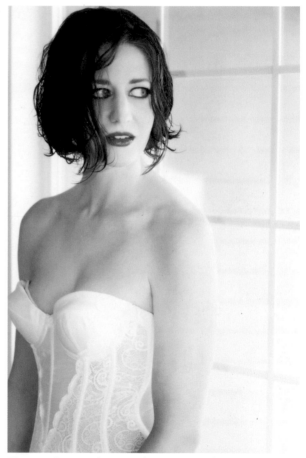

Photographers are always in a hurry, so one of the quickest ways to add a hand-colored look to a photograph is to apply Photoshop action such as Panos Efstathiadis Black & White Conversion and Image Desaturation (www.panosfx.com), which provides more control for monochrome conversion and image desaturation than Photoshop's own Desaturate and Grayscale commands. This action produces a monochrome conversion on a separate layer, allowing you to change its opacity to create a hand-colored look.

Digital Hand-Coloring Techniques

Using Photoshop actions is one of the easiest ways to mix color and monochrome images. PanoFx (www.panosfx.com) is one of my favorite websites to offer high-quality software ranging in cost from free to inexpensive. Their latest freeware is a Black & White Conversion and Image Desaturation Photoshop action that provides more control for monochrome conversion and image desaturation than Photoshop's own Desaturate and Grayscale commands. It also lets you change the layer's opacity to create a hand-colored look.

The Adobe Exchange (www.adobe.com/cfusion/exchange) is another good source of actions, including Hand Colored Vintage Photo, by Jenny W. This action includes Ageing, Colour, Cracks, Bending, and a bonus action called Old Paper Style. You should read the instructions first before you run the action. It's free for personal use.

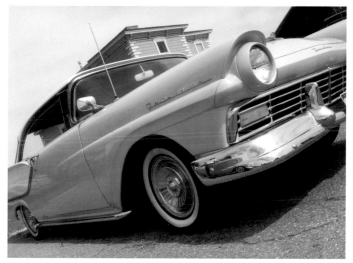

This 1950s-era Ford two-door hardtop was originally captured in color with an exposure of 1/250 second at f/7.1 and ISO 50.

Panos Efstathiadis Black & White Conversion and Image Desaturation lets you change the monochrome layer's opacity to produce a hand-colored look. In this case, I selectively erased parts of the monochrome layer (over the eyes, lips, hair, and coat) to let more color show through.

Depending on the speed of your computer, the Hand Colored Vintage Photo action can take some time to run, but the results are always interesting. You can adjust the opacity of the various layers to produce infinitely variable effects.

This photograph was made inside a shed at a salvage yard and was originally captured in color with an exposure of 1/80 second at f/5.6 and ISO 800.

I used AsylumXL's Selective Color action set to first create a monochrome layer, then used the Red and Blue actions that are part of the set to pull the red and blue from the original photograph and adjust their intensity.

Another good source of free shareware Photoshop actions is ActionCentral (www.atncentral.com), which is where I downloaded Selective Color by AsylumXL. The current version of this popular action first converts your image to monochrome, then isolates one user-selected color in an image and allows you to adjust the intensity of the color. The version works through layers and is non-destructive to the original pixels.

Working with Monochrome Layers

When working with most image-processing programs, digital images can be composed of several parts, or layers. Whether you add one color or fifteen to a photograph, the process is based on using layers to add and adjust each color or let the colors show through a monochrome layer.

The advantage of using a program's layers function is that you can manipulate part of the completed image without affecting any of the other parts. One of the easiest ways to combine monochrome images with

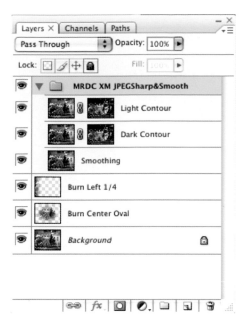

Photoshop's Layers palette lists all layers, groups, and layer effects for an image file. You can use the Layers palette to show and hide layers, create new layers, and work with groups of layers. You can also access commands and options.

color is by creating a duplicate layer (Layer > Duplicate Layer), converting the duplicate later to monochrome (see pages 30–33 for details on monochrome conversion), then erasing part of that layer to let some color through. This can be a tedious process (don't even ask me how long it took to erase the shoelaces on the models red-trimmed shoes in the example that follows), but be patient, working initially with small brushes/erasers then moving to bigger ones. By starting with an original color image, you can use it to bring some color through a selected opening in the monochrome duplicate layer by using the Eraser tool. Here's a quick breakdown of how to accomplish this using Photoshop. Check your software's instructions for similarly named commands and functions if you are using a different program:

1. Open an original color photo.

2. If you are using Photoshop, select Layer > Duplicate Layer to create a new adjustment layer on top of the original. Or, you can use a Photoshop action, such as PhotoKit's Brown Tone (www.pixelgenius.com), that will automatically create a duplicate monochrome layer for you.

3. Convert the duplicate layer to monochrome using one of the techniques outlined earlier in the book (see pages 30–33) if you didn't select a Photoshop action that automates this step.

4. Now the image you see looks as though it is completely monochrome, but in reality the color layer is still right underneath. To selectively bring some color through, use the Eraser tool to erase the parts of the duplicate monochrome layer where you would like the color underneath to show.

5. When you are satisfied with the results, flatten the image by selecting Layer > Flatten Image.

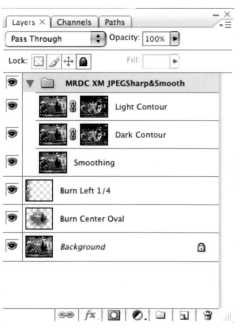

I captured this original color image with an exposure of 1/60 second at f/5.0 and ISO 200, and I used fill flash.

To create a selectively toned duplicate layer, I used the B&W Toning set that's part of PixelGenius' PhotoKit plugin and applied the Platinum tone. Using Photoshop's Eraser tool, I erased all of the monochrome areas covering the red in the original photo—including those tiny shoe laces—allowing the full color background layer to show though and create the selectively toned monochrome effect.

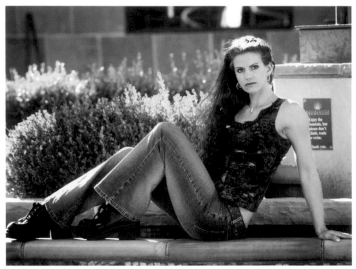

I captured this original color portrait with an exposure of 1/400 second at f/4.0 and ISO 400.

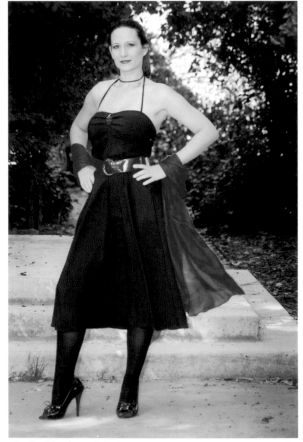

The final image with the layers flattened (Layer > Flatten Image) combines both the monochrome layer with the erased "holes" that only allow the red clothing and shoes to show through from the background layer to create an image that successfully combines black and white with color accents.

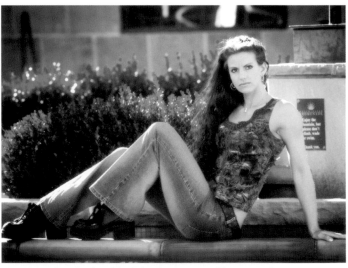

To create a hand-colored look for this portrait, I first created a monochrome layer using PhotoKit's Brown Tone action, which automatically creates a duplicate monochrome layer. Then I applied B+W's digital Soft Focus filter to that layer and lowered its opacity to let some color come through all over the image. Next, I flattened it, created a new Brown Tone action layer, and used the Eraser tool to selectively let some of the soft color created by the first layer through.

Using the Duplex Plugin

nik Software's Duplex plugins for monochrome and color are designed to produce the effect of a duotone (see pages 36–37), or duplex, print. Each plugin provides control over color, saturation, contrast, and blur. The Duplex: Monochrome filter achieves this effect while preserving the image's original color mode. With the Duplex: Color filter, control is provided to blend in the original colors of the image. A stylistic blur can also be applied with the Diffuse slider to create a subtle softening effect. These two Photoshop-compatible plugins provide two pathways to create a hand-painted monochrome print look.

After applying the Duplex: Monochrome plugin, I changed the duplicate layer's opacity using the Opacity slider in the Layers palette to 50%, allowing half of the original background layer's color to show through the monochrome layer, creating a wonderfully soft hand-colored look.

I shot this original macro flower photograph in color with an exposure of 1/110 second at f/3.6 and ISO 100.

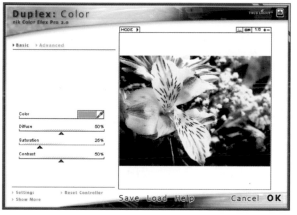

When applying nik's Duplex: Color plugin I did not need to create a duplicate layer. I applied the filter directly to the original image file.

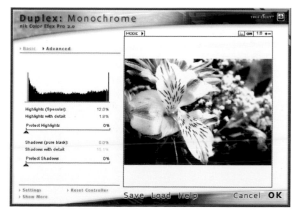

Before applying nik's Duplex: Monochrome plugin, I created a duplicate layer in Photoshop (Layer > Duplicate Layer) and applied the filter to the duplicate rather than background layer.

The Duplex: Color plugin creates an effect that merges the original colors of the image into an overall color cast, giving sort of a faded old-photo look to the image.

Unabashed Pictorialist

OK, I'll admit it, I'm an unabashed Pictorialist, a fan of the photography of the late William Mortensen, and an ardent admirer of the work A. Aubrey Bodine, one of the two patron saints of Maryland Pictorialism (Edward S. Bafford is the other). One of Mr. Bodine's most famous images was a high contrast photograph of a "fence in snow." In fact, that was its title. Follow along with my homage to that image, and because this is a chapter that is about combining mono-chrome and color images, I'll add a dash of blue.

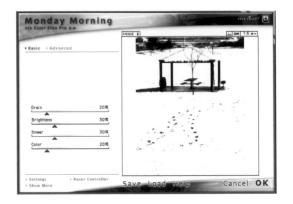

Step 2: To add some contrast and retain color, I used nik Software's oddly named but effective Monday Morning plugin, which also applies a soft-focus effect. Often used in the same way as the Midnight filters (see pages 101 and 121), the Monday Morning filters create a very bright and high-contrast image with control over the addition of grain, color, and detail through the use of sliders.

Step 1: This photograph was made during my daily walk; I walk past this little picnic pavilion every day and have photographed it many times, this time in snowy January.

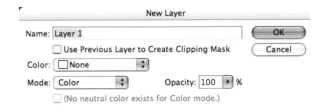

Step 3: Instead of applying the filter directly to the image, I applied it to a duplicate layer (Layer > Duplicate Layer, in Photoshop) so that I could do two things. First, I planned to lower the opacity of the duplicate layer with the Monday Morning filter applied at 90 – 95% so that just a little blue from the roof would show through. Second, I used the Eraser tool to erase at only 20% to remove some of the remaining blue that shows through the snow. This digital two-step allowed part of the roof's color to show through but not all of it.

Step 4: Since the photograph literally no had no edges at this point, I wanted to apply virtual edges using some of the same blue that's on the roof of the pavilion. I reached for OnOne Software PhotoFrame Pro (www.ononesoftware.com) and applied one of the Camera edges, using the eyedropper tool to select the blue from the roof.

Painting with Layers

The other way to add color to a monochrome image is to start with a black-and-white photograph and paint in the colors on separate layers. You can start this process with any black-and-white image, either one that was captured directly in monochrome or converted post-capture. For the example that follows, I'm using a black and white infrared image (see pages 68–75 for more on infrared imaging).

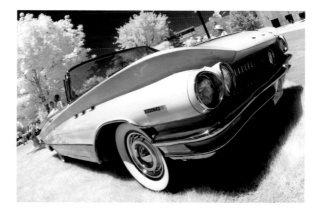

Step 1: I shot this red Buick Invicta convertible with a Canon EOS D30 that I converted for IR-only use (see page 69). Exposure was 1/60 second at f/16 and ISO 200. I originally captured it as a RAW file then converted it to monochrome using the techniques we've discussed (see pages 30–33).

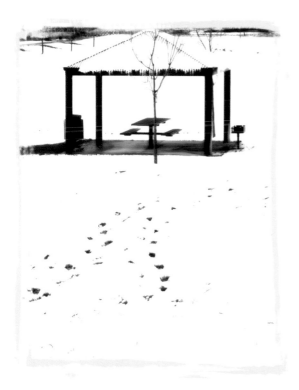

Step 5: The finished photograph is my feeble homage to Bodine's "Fence in Snow," although it was created in the digital darkroom rather than the traditional darkroom where he created all of his masterpieces.

Step 2: Next, I added a blank layer by selecting Layer > New Layer and set the blending mode to Color through the Mode drop-down menu. If you skip this step, everything that you paint onto this layer will be opaque. Using the Color blending mode allows the shading and shadows from the background to be visible through the painted sections.

Step 3: Then I clicked on the Brush tool and used the Brush menu that appears in the Option bar when this tool is selected to choose a soft-edged brush at a size that was appropriate for the object being painted. The way I usually work is to select a smaller brush and paint around the edges and then use a larger brush to fill in the center sections. Don't be afraid if you can't paint "within the lines." Just paint away, and afterwards you can clean up any excess using the Eraser tool.

Step 4: I used that identical technique to color each of the balloons that it looks like my wife Mary is holding in the background. In fact, she was standing next to the balloons; I don't know who was holding them! There are six balloons and part of a seventh and each one is a different color, so I needed to make a separate new color layer for each different balloon. I ended up with eight layers. If you want to save the file with all of the layers intact so you can adjust them later, the best thing to do is to save it as a Photoshop (.PSD) file. That way you can have access to each layer in the future. For printing and distribution, you will want to flatten the layers (Layer > Flatten Image) and select Save As to save the file in TIFF or JPEG.

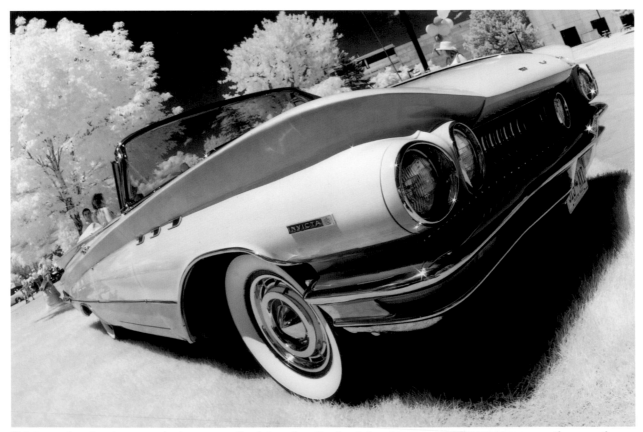

This is one of my favorite automotive images, as well as being a favorite of my infrared images. A small version appears on the cover of my book, "The Complete Guide to Digital Infrared Photography." If you've ever wondered how I created that image, now you know the story.

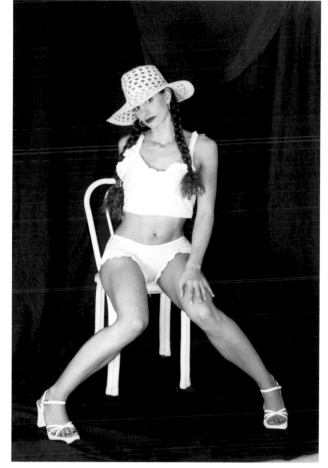

Using a Digital Brush

The Brush tool in Photoshop works like a traditional drawing tool by applying color with brush strokes. Photoshop's Options bar for the Brush tool allows you to customize the brush by entering values for the size (diameter of the stroke) and hardness. Specifying opacity determines to how much of the image under the brush stroke will remain visible.

Split Toning

Split toning is a traditional darkroom technique where liquid toner acts only on certain parts of the print, leaving the rest with no color change. The result is prints with greater depth. In the traditional darkroom, this process can be quite messy, but it's easily accomplished digitally using a Photoshop-compatible plugin such as Pixel Genius' PhotoKit Color.

The PhotoKit Color Split Toning set allows you to replicate split toning effects in Photoshop. These effects will work well on any monochrome photographs, but the image you are working on must be in RGB mode first, so if you convert to monochrome using the Image > Mode > Grayscale method, be sure to then select Image > Mode > RGB before proceeding.

When you apply the Split Toning filter from the Pixel Genius PhotKit plugin, it will create a layer set with two layers. The lower layer produces the shadow to midtone coloring effects and is set to an opacity of

50%. Increasing or reducing the opacity will produce a stronger or gentler color in the blacks to midtone areas of the image. The layer above is a semi-transparent layer (also set to a 50% opacity), which applies a second color in the midtone to highlight areas. By adjusting the opacity of these two layers you can vary the split tone effect as desired.

I captured this original photograph directly in black and white with an exposure of 1/60 second at f/5.6 and ISO 800. Lighting was from a large window to the left and I also used fill flash with a diffuser. The PhotoKit Color plugin brings up a simple dialog box with many choices for split toning, and other effects. For this image, I chose the Blue/Sepia Split filter.

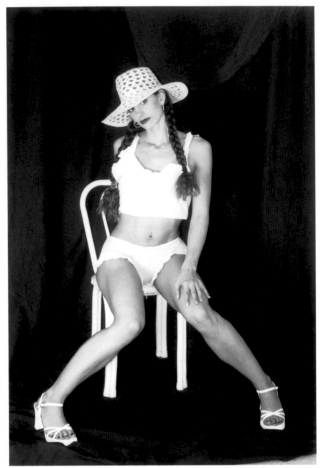

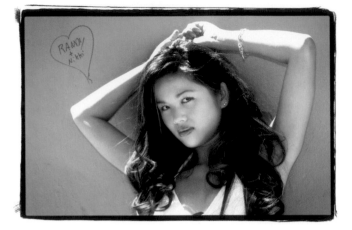

I originally captured this his portrait in color, then added a border from Kuboto Image Tools' Sloppy Borders (www.kubotaimagetools.com) for a moody touch.

No selections were made in Photoshop to indicate what color would be applied to which area of the image; PhotoKit automatically makes all those decisions. All of the PhotoKit Color Effects create new layers or layer sets, leaving the original underlying image untouched, so it's always safe to experiment.

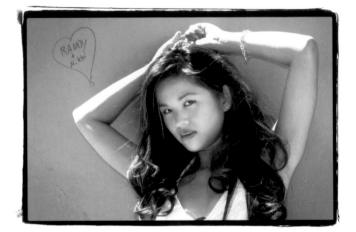

Pixel Genius PhotoKit 2, unlike PhotoKit, lets you preview split toning effects and I was able to keep trying different combinations before settling on the Sepia/Cyan combination you see here. Since the effect was also applied to the borders, I selected the border area on both the sepia and cyan layers and used Photoshop's Clear (Edit > Clear) command to let the black border show through from the bottom layer.

Hint: Also be sure to check out Pixel Genius' PhotoKit Special Effects series, which contains filters for color infrared, sunshine, and color transfer effects, to name a few. You can mimic the look of a faded color print or recreate the look of certain color movie processes.

Using PhotoKit 2 you can even recreate the cross-processing (negative film processed in transparency chemistry, or vice-versa) effects seen in Tony Scott's film, "Domino" if you layer several filters. Here, my wife Mary stands in for Kyra Sedgwick.

Selective Toning

Selective toning is different from split toning, although the effect is similar because the image maker gets to determine which specific area of the photograph is toned with which color by employing masking techniques. In the traditional darkroom, the effect can be achieved by coating the areas of the print that you do not wish to tone with liquid rubber cement, but it's much easier to accomplish using digital techniques and layers! As before, the following example is an homage, this time to Phil Borges, who is not only an extremely gifted photographer, but is also a wonderful humanitarian.

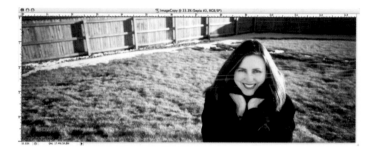

Step 3: Next, I created a duplicate layer (Layer > Duplicate) and named it "Sepia" because that's what I planned to do next.

Step 4: Using Joe Cheng's Sepia action (www.adobe.com/cfusion/exchange), I applied a Sepia tone to the duplicate layer.

Step 1: I made this portrait of my wife Mary in my back yard using a Hasselblad Xpan, and this is the full image of the 35mm panoramic frame. For this example, I will be creating a photograph that is black and white, but the skin tones will be sepia.

Step 2: First off, convert the photograph to monochrome using any of the many techniques shown throughout the book; pick your favorite. In this case, I also used the Dodge tool on Mary's face after the tonalities changed during monochrome conversion.

Step 5: Using the Eraser tool, I then I removed everything from the sepia-toned layer except Mary's skin.

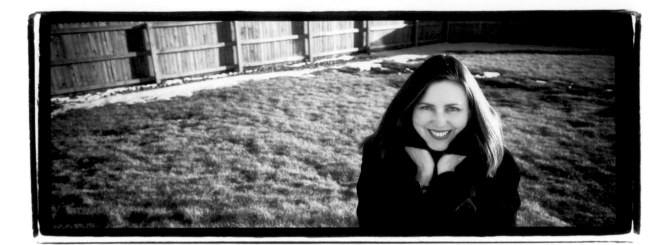

The final image, with a little burning, a little dodging, and the addition of Kevin's Kubota's Sloppy Border effect, completes my homage to Phil Borges.

Adding Nighttime Effects

Nighttime doesn't mean just dark. In the real world of night, there's a softness in the light and color is harder to perceive; in short, it's the perfect pseudo-monochrome time of day. Add a few fireworks and you've got color and black and white, making this tutorial a perfect fit for the theme of this chapter.

© Barry Staver

Step 2: Before applying any effects to Lady Liberty, I wanted to move her off of the daytime background and onto a separate layer. To do this, I used the Magic Wand tool to select the blue background, then used the Inverse (Select > Inverse) to select only the statue. To place it on another layer, I used the Layer Via Copy command (Layer > New > Layer Via Copy) to place only the Statue of Liberty on a separate layer. Since I would not be working on the original background layer again, I turned off the background layer by clicking on the eyeball icon beside it in the Layers palette.

© Barry Staver

Step 1: This original color image of Lady Liberty was obviously captured during the day.

© Bill Craig

Step 3: The Midnight filters that are part of nik Color Efex Pro create the illusion of a photograph taken at night, adding a dark, moody feeling. The Midnight filters include Blue, Green, Sepia, Violet, and Midnight, and also soften details throughout the image. Controls include Blur, Brightness, Color, and Contrast.

© Bill Craig

Step 4: Next, we add the nighttime sky and fireworks that were photographed in Colorado—not New York City!

© Bill Craig

Step 5: I dragged the fireworks layer on top of the Statue of Liberty, thus creating a new layer. One image is a horizontal and the other is vertical, so holding down the Shift key while dragging the fireworks image over with the Move tool ensured that I maintained the same ratio. I dragged the fireworks layer until it filled up the sky behind Lady Liberty.

© Bill Craig

Step 6: Since the sky was now covering the statue, I needed to move its layer below, which is just a matter of clicking on the layer and dragging it below the Lady Liberty layer in the Layers palette.

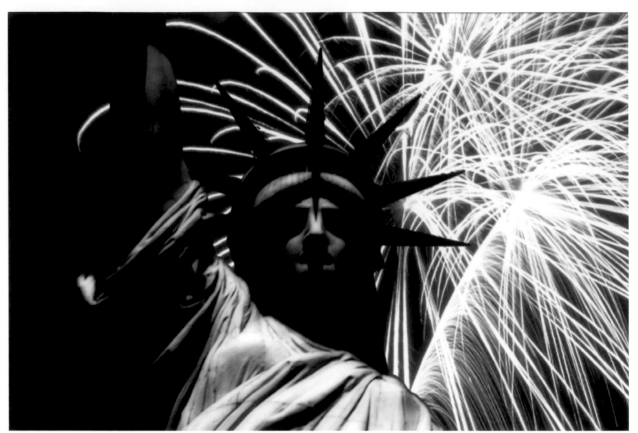

© Barry Staver and Bill Craig

Now all that's left is either saving the image as a .PSD file to preserve the layers for later adjustment, or flattening the image (Layers > Flatten) and saving it as a TIFF or JPEG file. You can also choose to save it as a TIFF file with layers, but that just makes a big file even bigger.

Adding Water

Working outdoors can be fun, but it also introduces a bunch of variables that you can't control, starting with the weather, including wind, and let's not forget bugs! After just a few shots of my model on a photo shoot one day at a lake close to my home, she had had enough of the bugs crawling on her. Believe me, it's hard to photograph anybody when they're jumping up and down while being assaulted by creepy-crawlies. So, when another model asked me to photograph her next to a lake and she didn't want to deal with the bugs, I new just how to give her the kind of photograph she wanted: I created a digital lake.

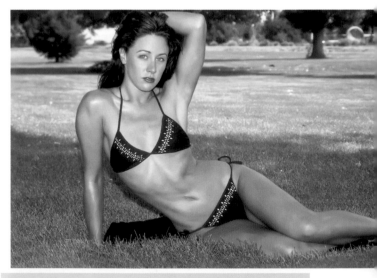

Step 1: To start, I shot this color photograph at a local park.

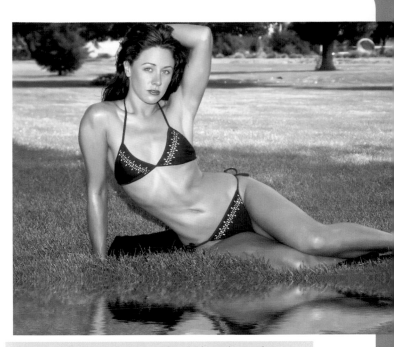

Step 2: The next thing to do was to create space at the bottom of the frame for me to add the "water." I could have planned ahead and made this space in-camera, but it would have resulted in the model appearing smaller in the frame. This is a trade-off you'll need to consider when you try this technique.

Step 4: After you click the Flood plugin's OK button, you're finished adding a digital lakeside.

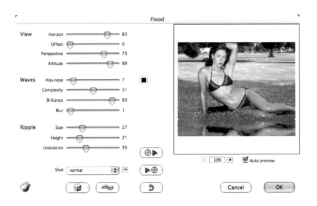

Step 3: The best way to add digital water to an image is with Flaming Pear Software's Flood plugin (wwwflamingpear.com), and I used it with Photoshop to create the effect that matched my concept of a peaceful lake with a light breeze. Flood has lots of controls, but the simplest approach is to click on the dice that throws random combinations at you. You can refine one of these combinations with the sliders or just keep clicking until you find one that you like. I use both approaches as the mood strikes me.

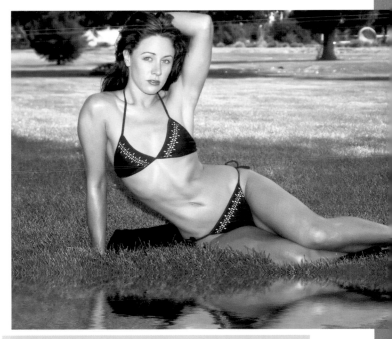

Step 5: In keeping with the theme of this chapter I then created a duplicate layer (Layer > Duplicate Layer) and converted it to monochrome. Then I used the Eraser tool to remove the part of the mono-chrome layer that covered the water and reflection effect I had created. The result is a cool color reflec-tion of a monochrome scene.

Adding Color

Toning is the classical way to add overall color to a monochrome image and here's a brief example that will serve as a preview to the examples later in the book (see pages 122–139) where we will explore the application of digital technology to classic wet darkroom techniques.

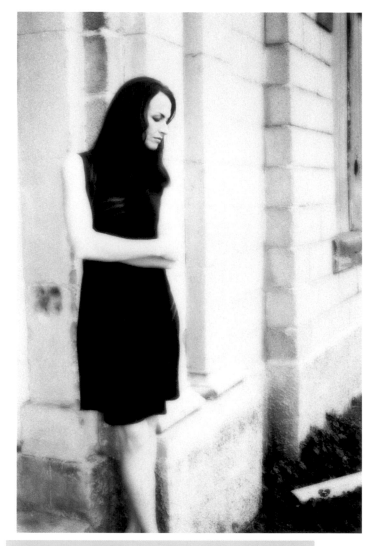

Step 1: I originally captured this image in black and white.

Step 2: Photoshop actions again come to the rescue. In this case, I used Craig's Actions Shadowsoft & Grainy Blue action (www.craigsactions.com). The entire set consists of actions that produce a diffused shadow glow and render the image in choices of Natural Color, Black & White, Blue, Sepia, or Green tones. It also provides additional options for creating a grain texture within your photograph. One click to select Blue, a little dodging and burning, and bada-bing! This is what you get.

I shot this image in color originally with an exposure of 1/50 second at f/2.4 and ISO 400 using only avail-able light coming from the door to my left. After opening the photograph in Adobe Photoshop, I created a duplicate layer and then converted the background photograph to black and white. I then used the Eraser tool on the duplicate layer, erasing everything but her green eyes to create the final look you see here.

Artistic Effects

> "It's my living condition / Etch on a sketch on a rhyme like an architect..."—Vanilla Ice

Turning Digital Images into Sketches

Rather than the subject, Pictorialism is more concerned with the aesthetics and the emotional impact of the image. Followers of this way of creating photographs employed whatever handcrafted means necessary to achieve that focus, from manipulating negatives, to complex darkroom techniques, adding artistic touches that sometimes went so far as to emulate traditional disciplines such as painting and sketching. In many photographic circles today, Pictorialism has less of a positive connotation that "straight" photography, but I'm guessing you are not concerned, or may not even know of, the culture war fought in the 1940s between Ansel Adams speaking for Group f/64 and Edward Mortensen for Pictorialism in a battle for the soul of photography. In the end, it was a ten-round decision for straight photography and a TKO for the Pictorialists, but there are many who would never let it die. The advent of digital image manipulation let a lot of Pictorialists out of the closet and into the daylight, allowing us to create the kind of artistic images we've always dreamed of producing.

I always look for Photoshop actions first when trying to create any kind of special effect. Actions are simple, fast, and if not free (many are), they are always inexpensive. Here are a few sets that are available from all of the usual websites.

Panos Efstathiadis' Sketch Effects (www.panosfx.com) is a set of Photoshop actions designed to give your images a nostalgic, old-fashioned sketch look. The set uses a number of tools to produce four different effects, and it works with a single mouse click.Photographers are always in a hurry, so one of the quickest ways to add a hand-colored look to a photograph is to apply Photoshop action such as Panos Efstathiadis Black & White Conversion and Image Desaturation (www.panosfx.com), which provides more control for monochrome conversion and image desaturation than Photoshop's own Desaturate and Grayscale commands. This action produces a monochrome conversion on a separate layer, allowing you to change its opacity to create a hand-colored look.

I captured this original photograph in the architecturally unique community of Prospect, Colorado using an exposure of 1/180 second at f/95 and ISO 100.

Dave's Sketch is a set of free Photoshop actions that area available from author Dave Jaseck on Action Central (www. www.atncentral.com) and includes this one-click effect that produces a straight monochrome line sketch.

Dave's Sketch action also includes a Sketch with Color version that adds back some color for what Jaseck calls a "Currier and Ives" look.

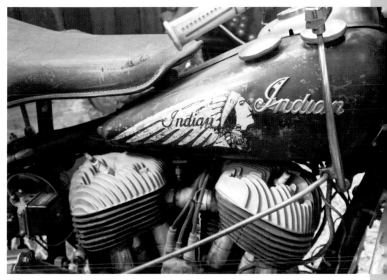

I photographed this old Indian motorcycle at a bike show with an exposure of 1/125 second at f/5.6 and ISO 800. I slightly tweaked the image in Photoshop with Levels and Curves to produce the result that you see here.

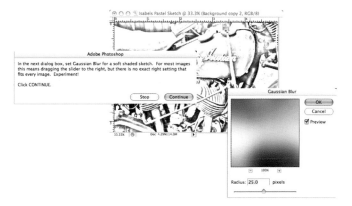

One of the features that I like best about Isobel's Pastel Sketch action, which is available through Action Central (www.atncentral.com) is that before you interact with the process, the action pops open a window that has some hints about what you need to do next. You remain in control, but the guidance provided will be invaluable when you are using the action for the first time.

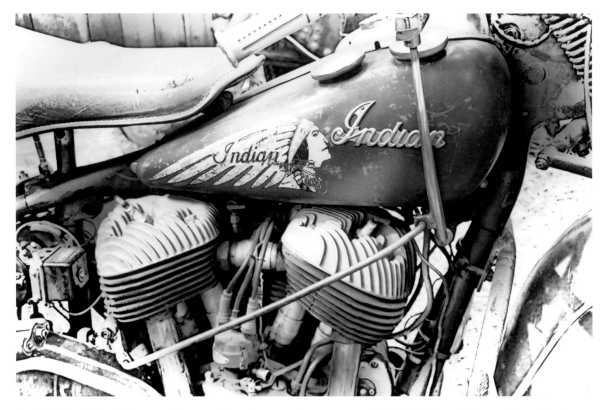

Isobel's Pastel Sketch is a set of two actions that are a joint venture. Isobel Cutler and Sharon Lee Core have joined forces to turn Isobel's rough pastel technique into a Photoshop action. It is available in two versions: Isobel's Pastel Sketch A or B. I used the B version here.

Using Photoshop's Filter Gallery

As I've said before in this book, Photoshop actions, much like plugins, are image dependent. An effect that looks great with one image will look bad with another. The secret is to experiment and see what you like better. That's really the purpose of this book. I don't want to tell you what I think may be the best and only way to do anything; I want to expose you to lots of different methods, techniques, and tools for you to choose from and play with. Have fun!

While Photoshop Elements sometimes borrows features from Photoshop, the reverse happens occasionally, as well. The File Browser function in Photoshop that ultimately became Bridge originally appeared in Elements, as did Filter Gallery. Finally, for Photoshop versions CS and later, Filter Gallery has found its way to the latest Photoshop Creative Suite. It appears under the Filter menu, and not only provides a more visual way of selecting effects filters (individual filters can still be selected without going through the gallery), but also lets you stack multiple filter effects on top of one another to blend effects. Filter Gallery also provides a bigger workspace instead of the small dialog box that you get when selecting an individual filter from the Filter menu. You can even have it fill the entire screen, as I do when working with multiple filter effects.

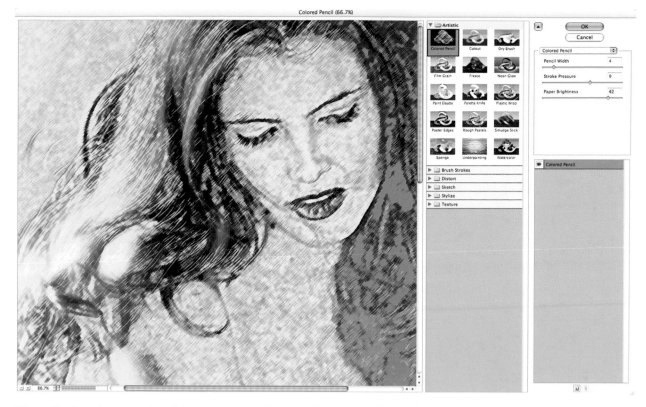

Filter Gallery's workspace consists of three main areas: a live resizable preview window on the left, a stack of thumbnails for each filter effect in the control area, and controls and sliders for the selected filter, which appear on the right. Below is a list of all the applied filters that you can then change and apply additional functions to in much the same way as with Photoshop's Layers palette.

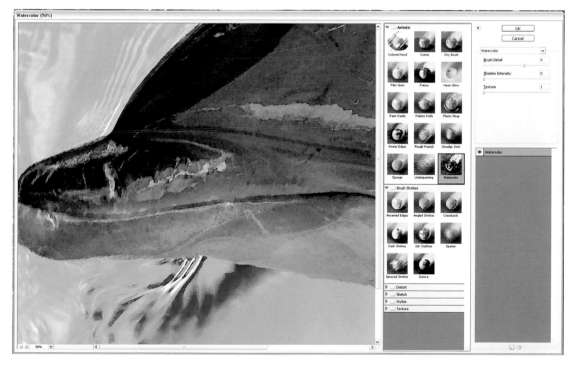

Here is a view of Filter Gallery in Photoshop Elements. Looks familiar, doesn't it? and that's why Elements is a perfect gateway to lots of artistic plugins and effects that are also part of the more expensive full version of Adobe Photoshop.

The following illustrations show some of the effects that are possible with Photoshop's Filter Gallery. The ones illustrated here are listed under Sketch in the gallery. Digital imagers with long memories will remember that before these effects were built into Photoshop, they were part of an Aldus (who was later acquired by Adobe) collection of creative plugins called Gallery Effects.

Hint: Take my advice for working with plugins and experiment by first dragging the sliders to extremes ends and then gradually moving then back top achieve the final look you want. Typically these sketch effects are not good for using the Fade command on later. If you like these effects and like Filter Gallery, but don't like Photoshop's big price tag, consider using the less expensive Photoshop Elements software that contains many of the same filters.

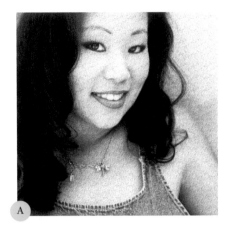
A

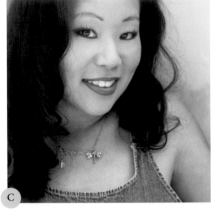
B

C

D

E

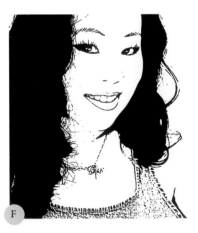
F

G

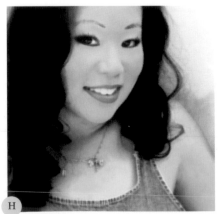
H

I

A I shot this original photograph outdoors with flash and an exposure of 1/200 second at f/5.6 and ISO 200. I then tweaked the image a little in Photoshop and cropped it into a square.

B The Conté Crayon filter produces a subtle and realistic effect that mimics the texture of dense dark and pure white Conté crayons. The filter uses the foreground color for dark areas and the background color for light areas. For another effect, you can change the foreground color to one of the traditional Conté Crayon colors such as sepia or sanguine (red) before applying the filter. For a muted effect, change the background color to white, add some foreground color to the white background, and then apply the filter.

C The Graphic Pen filter produces a different kind of subtle effect and has fine, linear strokes to capture the details from the original image. The filter replaces color using the foreground color for ink and the background color for paper.

D In this example, the Plaster filter creates an effect that makes it look like the image is printed on metal. This filter digitally molds and raises dark areas while lighter areas appear recessed.

E The Photocopy filter produces really nice sketch effects. Large dark areas tend to be copied only around their edges, and midtones fall away to either solid black or solid white.

F The Stamp filter simplifies the image so that it appears to be created with a rubber or wood stamp, giving it more than a passing resemblance to a wood cut print. Adobe recommends that this filter is "best used with black-and-white images" but I like the effect it has on this color photograph.

G The oddly named Torn Edges filter produces an Ortho film look that resembles the effects created when using Kodalith film in the traditional wet darkroom. (There's more about Kodalith in the next chapter.) Torn Edges reconstructs the image so that it appears composed of torn pieces of paper and then colorizes the image using the foreground and background colors. When you change foreground and background colors, you can change the effect.

H While found with the Sketch filters, Water Paper is more of a painting effect than a drawing one. It digitally recreates the effect of blotchy daubs painted onto fibrous, damp paper causing the original photograph's colors to flow and blend.

I The Note Paper filter creates an effect that is the opposite of the Water Paper filter, and makes the photo look as if were constructed of handmade paper. Dark areas of the image appear as holes in the top layer of paper, revealing the background color. Once again, when you change background color, you also change the effect.

In addition to Sketch effects, Photoshop's Filter Gallery gives you access to a collection of other various artistic filters that can be used to produce sketch-like artistic effects. Here are just a couple of them:

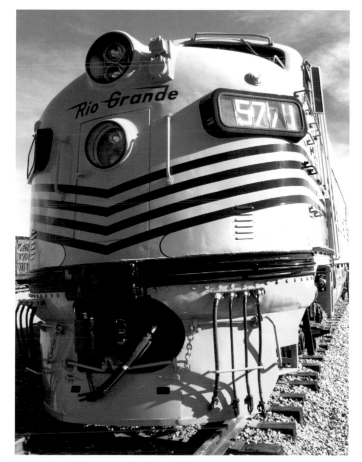

I made the reference image of this diesel locomotive at the Railroad Museum in Golden, Colorado with an exposure of 1/80 second at f/8 and ISO 80.

Power Tools for Artistic Effects

nik Color Efex Pro filters are available in three filter collections, including Standard, Select and the Complete Edition. Some of these plugins contain very cool artistic effects, often yielding surprising results. Each filter adapts its effect based on the detail structures, colors, and contrast range of a particular image. By identifying the unique qualities of the image that is being processed, each nik filter can be applied with the same settings across a wide range of images. nik Color Efex Pro filters also adapt to any previous filter adjustment or any other change made to the image to provide natural color or light enhancements. This feature is important since applying filters in a different order will provide you with more control, as well as more options, for great, natural photographic enhancements.

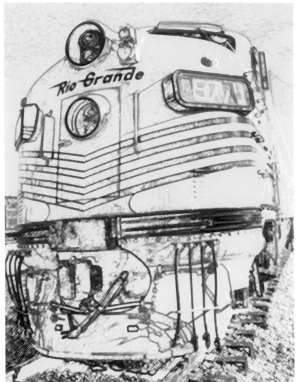

The Colored Pencil filter creates a true sketch-like effect and draws an image using digital colored pencils on a solid background. The photograph's important edges are retained and given a crosshatch appearance, and the background color shows through smoother areas. For a parchment look, change the background color just before applying the Colored Pencil filter to a selected area using any of Photoshop selection tools (i.e., the Marquee tools, Lasso tools, or the Magic Wand tool).

Sometimes the best software tool for creating digital artwork is one that is dedicated to that kind of process. fo2PX's ArtMasterPro (www.fo2pix.com) uses a kind of picture engine that's not found in any other graphics or image-processing program. The picture engine unlocks—and some might say liberates—the essential artistic elements within a photograph to generate over 700 sources from the original image. These sources are laid out in ArtMasterPro's virtual Studio where they are labeled and indexed so you can quickly get on with the business of creating high-quality digital artwork. The program includes fifteen ArtWizards that create different fine art or photo-realistic effects. You can stop an ArtWizard during any step of the automated process and choose to paint manually or even select an alternative step from a different ArtWizard. You then have the option to continue to paint manually or return to the automated steps to finish the artwork.

Using ArtMasterPro to create digital art is straightforward; there are no hidden or floating palettes. For the less artistically inclined (me, for instance), the program contains ArtWizards of different styles that are suitable for a wide range of subject matter.

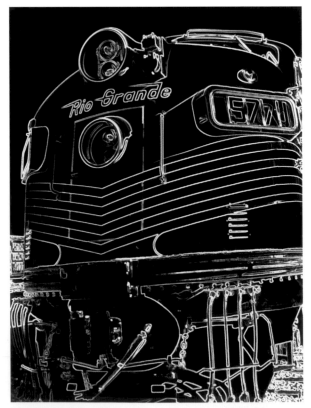

The Glowing Edges filter creates an almost opposite look to Colored Pencil, darkening the background and drawing in the lines in a kind of neon "Boogie Nights" look.

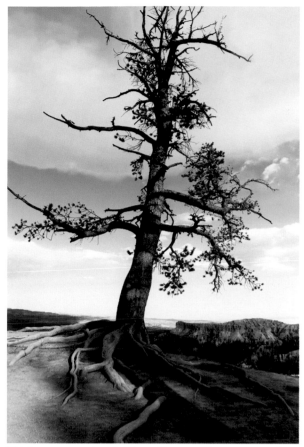

This image was captured at Bryce Canyon with an exposure of 1/500 second at f/8.0 and ISO 400.

I expected nik's Paper Toner filter (found in both the Select and Complete Editions) to create effects similar to Photoshop's Photocopy filter, but instead it created a soft monochrome effect that looked more like a platinum print than a copy. This filter is supposed to emulate the different types of chemical toners used in traditional darkrooms. When used on an image containing color, Paper Toner automatically converts the photograph into black and white before applying one of the different toners.

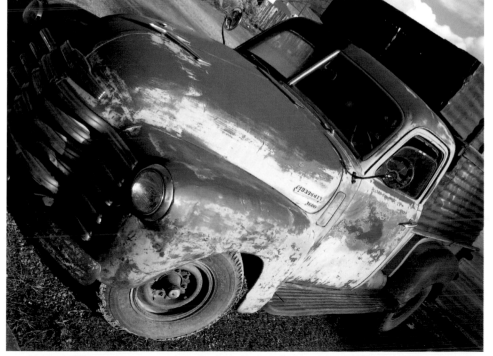

I made this original image of an old truck in Taos, New Mexico with an exposure of 1/125 sec at f/5.6 and ISO 200. I then imported the original JPEG file directly into ArtMasterPro and tweaked it using the program's built-in controls for brightness, contrast, hue, and saturation.

ArtWizards reduce the time needed to draw and paint backgrounds, middle grounds, and pre-determined styles, leaving you to focus on the finer and more dexterous aspects of finishing off the picture. You can also record, save, and replay your own ArtWizards so you can reproduce a signature style across a sequence of images. Don't need as much help? Take a look at fo2PiX's less expensive ArtMaster program. Demo versions of both programs are available for download from the company's website (www.fo2pix.com).

Programs, such as fo2tPix's ArtMasterPro literally demand that you use a graphics tablet and stylus! With a program such as this, it's not only much easier to apply the pen and brush strokes in this fashion, but the results are more natural looking than what might be accomplished using a mouse.

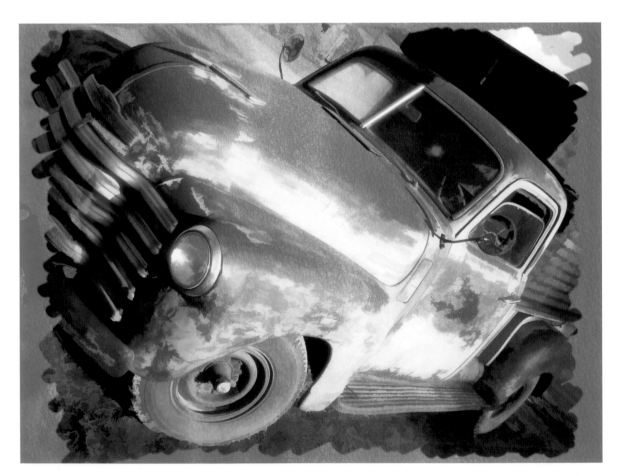

Bronze Patina is one of the monochrome ArtWizard effects. It takes the image well beyond typical sepia toning, again using only the default choices. You can finish the effect by printing the image on an artistic paper such as Media Street's Royal Plush (www.mediastreet.com). It has a pH neutral base with a rich, soft look and feel. When printed with pigmented inks, Wilhelm Research Institute rated this combination's longevity as beyond 100 years. (See pages 140–160 for more printing tips.)

Corel Paint Shop Pro

Adobe Photoshop is not the only game in town. Aficionados of Corel's Paint Shop Pro (www.corel.com) have always claimed that it is just as good as Photoshop, and with many improvements in recent years, it takes a giant step in challenging the 800-pound gorilla of digital imaging. Paint Shop Pro Photo lets you edit, manage, and share photos as well as create photo projects such as presentations, technical documents, collateral materials, and emails. The latest version contains lots of one-step fixes along with a set of advanced image-processing tools that many pros will enjoy.

The Color Changer tool lets you change the color of an object or an area in a photo with just a few clicks. It detects and analyzes variations in brightness caused by real-world lighting and reapplies the illumination to the new color, producing a realistic effect. The Time Machine filter replicates processes from bygone ages of photography to create an old fashioned look to your images. There's also enhanced RAW camera support so you can open and edit RAW files from many different digital cameras.

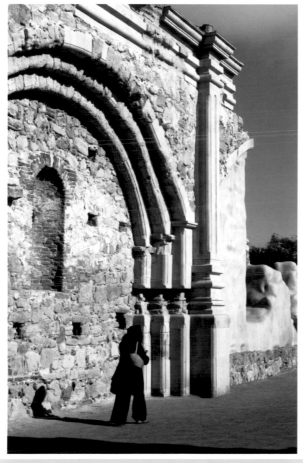

Step 1: I took this original shot in after 5:00 PM at Mission San Juan Capistrano, so the colors are slightly warmer than if I had shot the scene at midday. Plus, the drama and the long shadows would have been missing if I took the shot in the flat, harsh midday light. Exposure was 1/640 second at f/16 at ISO 200.

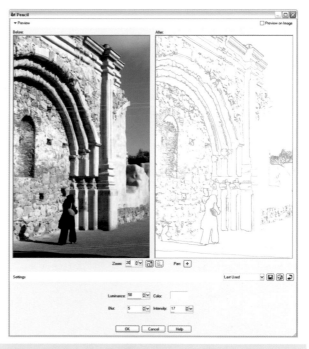

Step 2: I created a duplicate layer in Photoshop (Layer > Duplicate Layer) then applied the Corel Paint Shop Pro Pencil effect (Effects > Art Media Effects > Pencil). Some of the features I like best about many of Paint Shop Pro's filters are the resizable dialog box, the check box that lets you preview the effect on the image, and a dice icon that randomizes the parameters. I keep clicking the dice until I get an effect I like.

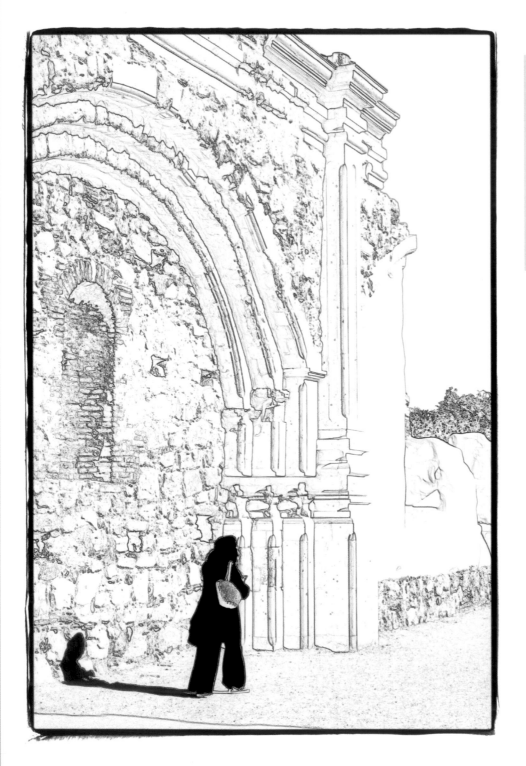

Step 3: As you can see in the previous shot, the lady walking is seen as an outline, and I wanted her to have more weight in the image. I used Paint Shop Pro's Eraser tool to erase part of the top pencil layer—but not her shoulder bag—to allow her black outfit and her shadow to show through from the bottom layer. To warm up the package, I applied a border from Kubota's Sloppy Borders (www.kubotaimagetools.com).

Texture Screens

The use of texture screens is nothing new; the technique has been around for more than fifty years and was used heavily by darkroom artists such as William Mortensen. In the traditional darkroom, a texture screen is a piece of film that has a texture printed on it. It is placed over the paper or sandwiched with the negative during exposure to create the effect.

deviantART (www.deviantart.com) has a collection of textures that might work with your images, depending on their resolution. Or, you can just shoot your own texture screens by photographing tree bark, rocks, rusty metal, or any other textured surface. Use your camera's Auto Bracket mode to create potential texture screen backgrounds in various densities. When used in a texture screen application, perfectly crisp files may not be that critical, but the final effect is always a subtle once requiring a large print to fully appreciate. The technique for using texture screens with digital images is the same as using texture screens with film—you sandwich them together. In the "digital darkroom," this is accomplished by placing the image and the texture on different layers and varying the relationship between the layers using the Opacity slider and/or various blending modes.

While admiring the photographs on Jesh de Rox's website (www.jeshderox.com), I was impressed with the textures he added to his images and quickly found out that they are for sale through the Fine Art Textures home page (www.finearttextures.com), where you can see dramatic before and after examples. Fine Art Textures are not Photoshop actions; they are high-resolution files. The JPEG files are approximately 8.3 x 12.5 inches (21.08 x 31.75 cm) at 350dpi and can easily be sampled up to many times higher. Jesh says he "frequently prints 40 x 50-inch wall prints using these same textures and they look beautiful." The package includes a license to use them for personal, commercial, or art pieces, as well as a $100 credit towards one of de Rox's "life (as an art form)" workshops sponsored by FineArtTextures.com and its parent, LifeAsAnArtform.com.

The original photograph I used ot make this image was captured in color then converted using OnOne Software's PhotoTools plug-in (www.ononesoftware.com). Exposure for the original photograph was 1/90 second at f/4.5 and ISO 400 with a +2 exposure compensation to emphasize the high-key tones of the portrait. I applied two different texture files from Jesh de Rox site (www.jeshderox.com), one layer at a time, and I modified each layer by first using one of the available blending modes then individually adjusting them using the Curves tool.

It was a Dark and Stormy Night...

Just because it's a bright and sunny day doesn't mean you want that same mood for the photographs you're making. That thought was running through my mind as I shot the portrait you'll see in the following example. Adobe Photoshop, along with some powerful digital power tools, helped me to create the look I envisioned.

The starting image I chose to work with is actually a composite of two photographs, combining her upper torso from a three-quarters shot with a full-length image to give me the look I wanted. The technique for accomplishing this montage simple: I selected the image from one shot using Photoshop's Lasso tool, then dragged it onto the other, and in the process created a new layer. After re-sizing the upper layer to match the background (see the step-by-step instructions for details), I used the Eraser tool to blend the two images. This is an easy way to combine the expression on a model from one shot with the pose you like from another. As long as it's the same model from the same shoot I don't think it's "cheating."

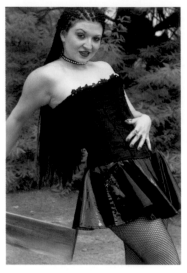

This is an unaltered JPEG file of the second image used in the composite. I like the model's facial expression and where she placed her left hand. This became the top layer for my composite image.

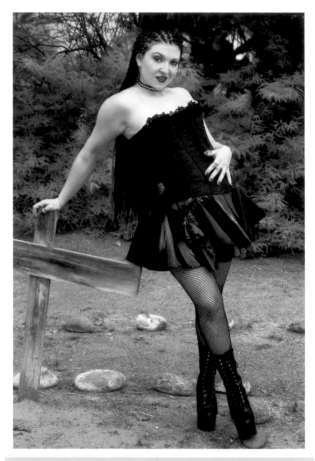

This is an unaltered JPEG file of the first image used in the composite. I like the way the model is posed but not the fact that she is not looking at the camera. This became the background layer for my composite image.

Step 1: I started by using Photoshop's Transform tool (Edit > Free Transform) to resize the top layer so that the torso part of the composite matched up with the legs part. Next, I used the Eraser tool to blend the two layers, keeping what I liked from each. Then I flattened the image (Layer > Flatten Image) to make a single new photograph, my base for creating an artistic nighttime composition.

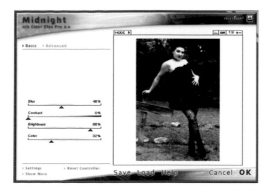

Step 2: To add a nighttime mood to the photograph, I reached for the Nik Color Efex Pro Midnight filter set (www.niksoftware.com). The Midnight filters (also available in Blue, Green, Sepia, and Violet) create the illusion of a photograph taken at night, using a classic cinematic effect to soften the details. I used the standard Midnight filter and manipulated all of its sliders to get the effect I wanted.

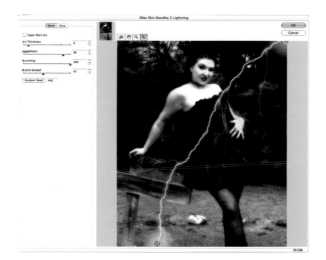

Step 3: To give the photograph a little "BAM!" seasoning, ala Emeril, I decided a lightning strike would be a nice touch. That's when I selected the Xenofex package of from Alien Skin Software (www.alienskin.com) and applied it to a duplicate layer (Layer > Duplicate Layer). Although the photograph is in mostly monochrome, it's still an RGB file so I decided to give the lighting a green exterior glow in homage to "The X Files."

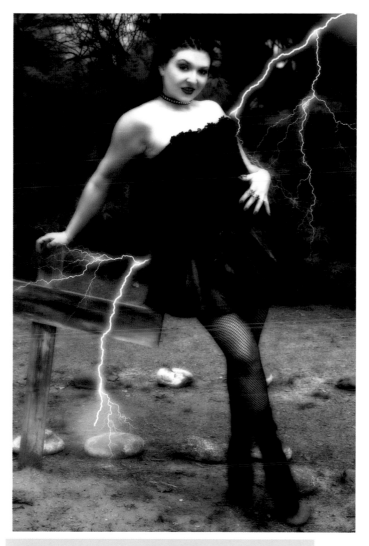

Step 4: Because I wanted the lighting to appear behind the model instead of distractingly across the front of her corset, the effect was applied to a duplicate layer (Layer > Duplicate Layer.) That way I could use the Eraser tool to erase the portion of the lighting that crossed in front of her.

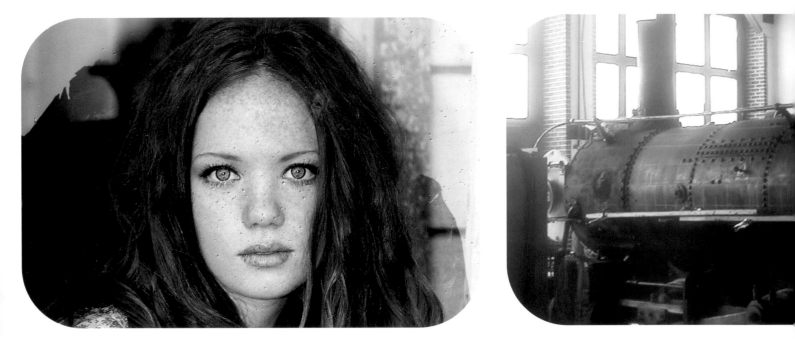

Emulating Old Photographic Techniques

"Gotta get back in time..."—Huey Louis

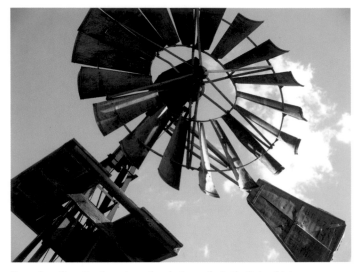

One of my favorite places to make photographs is the living history part of the Adams County Historical Museum where my wife Mary captured this image of an old windmill. Exposure was 1/800 second at f/5 and ISO 200. © Mary Farace

Once upon a time, Kodalith was the "modern" gateway to working in the wet darkroom to produce antique and lost printing techniques. What's Kodalith? It's an extremely high-contrast orthochromatic film that's primarily designed for making line and halftone negatives for photo-mechanical reproduction. It has wide exposure and development latitude, and was also used to make highlight masks to improve the reproduction of important highlight details when making duplicates from transparencies. Those photographers wishing to try older arcane printing techniques would make contact-sized negatives (often the only way to make prints with these processes) using Kodalith sheet film produced from 35mm originals.

That was then, this is now. In this chapter, I'll show you the latest "modern" digital techniques to accomplish looks that are similar to old processes that formerly required you to dunk your fingers or tongs into smelly and potentially hazardous chemicals. Since so many processes required the use of Kodalith, it's worth a look at a few digital techniques for producing Kodalith-like effects in the digital darkroom.

Photoshop's Threshold command (Image > Adjustments >Threshold) lets you instantly create high contrast images. To identify a highlight, drag the slider to the far right until the image becomes pure black. Then drag the Threshold slider slowly toward the center until some solid white areas appear in the image. Conversely, you can drag the slider to the far left until the image becomes pure white, then drag it slowly toward the center until some solid black areas appear in the image. © Mary Farace

The Photoshop Threshold command creates a similar high-contrast effect to the program's Stamp and Torn Edges filter (see pages 112–113), so you can use either one. © Mary Farace

Ambrotype and Daguerreotype

Many older print making processes depended on the actual surface of the print to add a unique character to the image and, as you will discover in the next chapter, this is difficult if not impossible to reproduce using today's digital software. The best we can hope for is an approximation of that original experience and to have fun with the process. That has been my guiding philosophy in producing the collection of tips, tools, and techniques that follow.

The daguerreotype was introduced in 1839 by Louis Jacques Mandé Daguerre and was the first commercially successful photographic process. During processing, a copper plate was lightly coated with silver and was exposed to iodine vapors, creating a mirror-like light-sensitive surface. The plate, held in a light-proof holder much like sheet film, was then transferred to the camera and exposed often by just removing the lens cap and counting instead of shutter. The plate was developed over hot mercury until an image appeared, a process I'm not sure OSHA would be so keen on today. To fix the image, the plate was immersed in a solution of sodium thiosulfate, then toned using gold chloride. If all this sounds hazardous to your health, it was.

An ambrotype print consists of placing dark paper or cloth behind a glass negative. When seen in the proper light, the image appears to be positive. In 1854, Boston photographer James A. Cutting took out a patent for the process where glass is coated with iodized collodion and sensitized in a bath of silver nitrate. Back then (1854 - 1865), many photographers sold ambrotypes in velvet-lined leather cases with brass mats that resembled daguerreotypes but were cheaper to buy and simpler to make.

Step 1: I shot this original portrait on a movie set in Phoenix using an exposure of 1/200 second at f/7.1 and ISO 400.

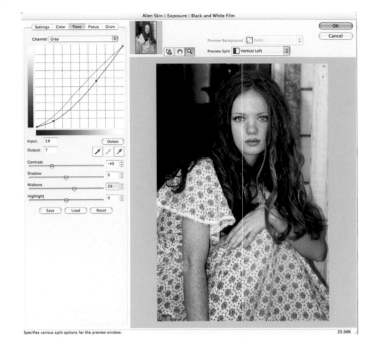

Step 2: I used Alien Skin Software's Exposure (www.alienskin.com) to create the daguerreotype effect. Exposure is a set of two Photoshop-compatible plugins. One is for color film effects and the other is for black-and-white effects, which is where the daguerreotype effect can be found. Depending on your original image, the default settings can produce a dark, sooty effect that looks nothing like a daguerreotype. Click on the Tone tab and gently massage the curve to produce a more pleasing and realistic effect.

Step 4: Unlike silver-based photographic prints, which were done on paper, ambrotypes and daguerreotypes were done on either sheets of metal or glass and had some thickness to them. So, I used Alien Skin's Eye Candy 5: Impact, which has a Bevel filter, to add some depth to the image. There are lots of presets in Impact, and I chose one that had some pits in the surface to make this image look like it had been around awhile. In the Pitted Surface Light preset I used for this example (there is also a Pitted Surface Heavy), you may not be able to see the pitted surface very well, but if you download a demo version from www.alienskin.com (it's functional for 30 days) you can see if you like it or would prefer the more pitted version.

Step 3: Because ambrotypes and daguerreotypes spent most of their time in a oval framed case, some deterioration under that mat was inevitable, so to duplicate that effect I used onOne Software's PhotoFrame Pro (www.ononesoftware.com) to add a not-so-smooth oval to the image. I placed the effect on a second layer by clicking the Apply to New Layer button in the plugin's interface.

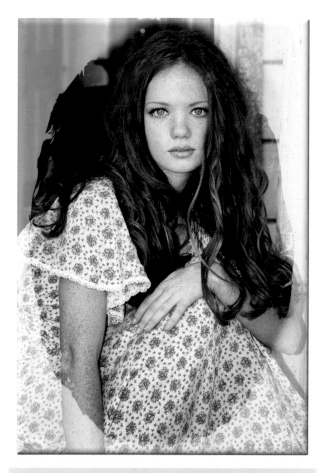

Step 5: To add the daguerreotype's mirror-like look, the final image needs to be printed on Adorama's ProJet SilverMirror media (www.adorama.com), or on your favorite paper to have it appears as an ambrotype. ProJet SilverMirror is actually Mylar media, but it looks like metal. You can mount finished prints in reproduction daguerreotype cases from CasedImage (www.casedimage.com) for the ultimate look.

Bromoil

One of the favorite darkroom techniques of Pictorialists, like the late Edward L. Bafford, was the bromoil print. This conventional process starts with the creation of a black and white print using traditional darkroom methods, with the image typically printed on a textured paper. The print was then treated with a "tanning" solution that bleached the image almost to the point of invisibility and hardened the gelatin on the print in proportion to the depth of silver.

After fixing and drying, the tanned print was hand-brushed with a boar's-hair paintbrush using oil-based ink. At this point, the hardened portions of the emulsion will accept more ink and the other areas will accept less, allowing the bromoil maker to eliminate distracting elements and even add compositional elements using an ink-filled brush. The finished print exhibited artist-like brush strokes, and some photographers even toned their bromoil prints to give them a warmer appearance. I had an idea of trying to create a similar effect using only the standard digital tools found in Photoshop and here's how it went with "The Hunchback of Notre Dame," my homage to Bill Mortensen.

Step 1: I made this photograph in Paris outside the cathedral of Notre Dame. It features street players in costumes related to the classic tale of "The Hunchback of Notre Dame." This image seemed like the kind of classic story-telling photograph that Bill Mortensen would have made, and it inspired me to digitally apply some of his darkroom techniques.

because the "tolerance" number in Photoshop's Options bar is set too low. Since increasing the tolerance sometimes makes the selection too big, I prefer to just use the Shift-Select expansion technique. If your sky—or whatever area you're trying to select—is not selected the first time you click the Magic Wand, hold the Shift key and click the Magic Wand as many times as you have to in order to select the area.

Step 2: I converted the image to monochrome using Alien Skin Software's Exposure plugin (www.alien-skin.com). You, however, can use any of the monochrome conversion methods we've covered in this book.

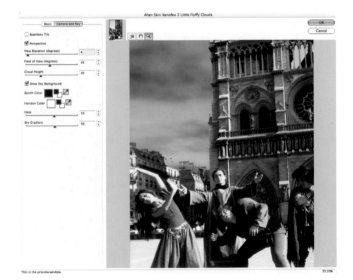

Step 3: Since bromoil artists almost always enhanced the sky, I decided to use Alien Skin's Little Fluffy Clouds plugin (www.alienskin.com) to add some depth to the blank sky in my original photograph. I could have used Photoshop's Clouds filter (Filter > Render > Clouds) to do something similar, but I think that Little Fluffy Clouds does a better job. You may not agree with me, and that's okay. Using the Magic Wand tool, I clicked on the sky and it automatically selected the entire sky area to apply the effect. If an area is not selected with a single click, it is usually

Step 4: The next step involves the application of the brush lines that appear in bromoil prints. Do achieve this effect, I selected Filters > Sketch > Graphic Pen. This brings up a dialog box that allows you to control stroke length, light/dark balance, as well as the direction of the stroke. There's a preview window that lets you see what changing the various settings accomplishes, but since I believe in keeping it simple, I used the default settings when applying the filter. The results of applying the Graphic Pen filter looked more like a sketch than a photo, so I used the Fade command (Edit > Fade) to blend the strokes into the image. While I've found that the Fade command doesn't usually work with Photoshop plugin effects, it did work in this case. There are no hard and fast rules once you enter this realm of digital artistry, so experiment and see what works for you.

PhotoKit by Pixel Genius LLC

Please Select a Set and Effect OK

PhotoKit Set: B&W Toning Set Cancel

PhotoKit Effect: Brown Tone Info

Step 5: Since many bromoil printers toned their prints, I decided to apply a warm tint to the finished image. To do this I used PhotoKit's B&W Toning set (www.pixelgenius.com) to apply a toning effect designed to be similar to traditional chemical tone effects. The B&W Toning set includes a nice Brown Tone filter, which is what I used here.

Step 6: To give the finished image a handmade look, I used onOne Software's PhotoFrame Pro plugin (www.ononesoftware.com) to create the rough edges.

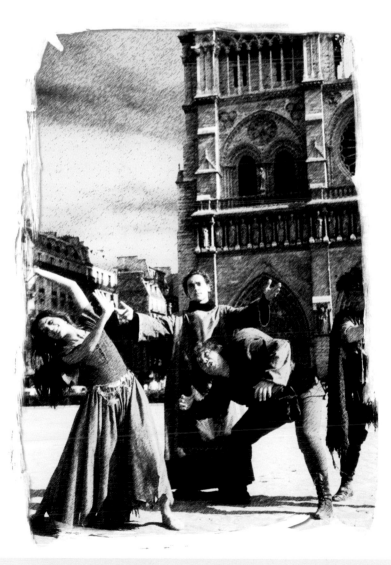

The finished image captures the spirit of the bromoil process. Using these steps as a jumping off point, go ahead and try to emulate the techniques of your favorite bromoil master.

Kallitype

In 1889, the kallitype process was patented by W.W. J. Nicol, a chemist, who went on to patent a large number of variations on the process. The kallitype is, like a cyanotype (see pages 131–132), a printing process based on the light sensitivity of ferric iron salts. Here, the reduced iron compound is used to form an image made of silver. However, the kallitype silver images are less stable than those of the other processes, and the kallitype has a reputation for fading. Kallitypes can also be gold or platinum toned, which can make them difficult to distinguish from platinum prints.

Step 2: Power Retouche's Toned Photo (www.power-retouche.com) is a Photoshop-compatible plugin that first converts a color photo to grayscale. You can then adjust contrast by applying digital colored filters to the conversion (see pages 18–19 for details on color filters for black-and-white photography). You can digitally tone the image any way you like, or use a preset that emulates traditional photographic print techniques, including kallitype.

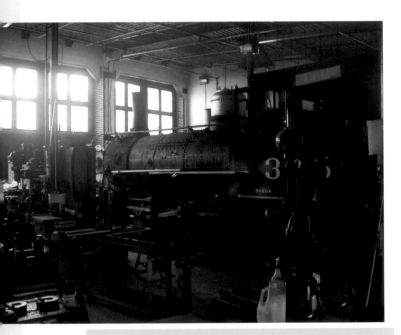

Step 1: I made this original photograph at the Colorado Train Museum with a digital point-and-shoot digital camera. The exposure was made through the window of their repair shop, and the scene already seems delightfully old-fashioned.

Step 3: Printing with a paper negative produces an image that is far from sharp, so I used B+W's digital Soft Focus filter (www.schneiderkreuznach.com/filter_e/software_filter.htm) to soften the final photograph.

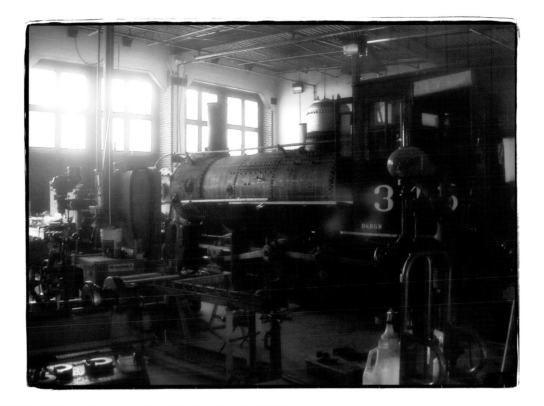

Step 4: The final touch was to add Sloppy Borders from Kubota Image Tools (www.kubotaimagetools.com) to give the look of a image that had been in made in a printing frame over a long exposure, adding a dash of antique imperfection.

Cyanotype

The cyanotype was one of the first photographic printing processes, and was used for the first photographically illustrated book. Sir John Frederick William Herschel, an English mathematician, astronomer, chemist, and experimental photographer invented the cyanotype process in 1842. He experimented with color reproduction, noting that rays of different parts of the spectrum tended to impart their own color to a photographic paper. It was also Herschel who coined the term "photography" and originally applied the terms "negative" and "positive" to the medium. So it may be Herschel, more than anybody else, who could be considered to be the father of photography.

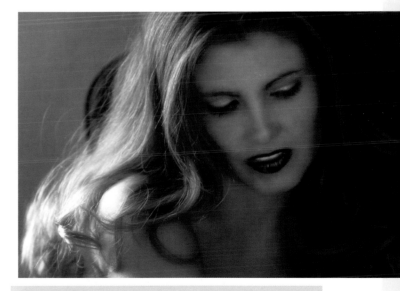

Step 1: Legendary digital photography guru Kai Krause was fond of saying that there were thousands of images hidden inside of your photographs just waiting to be unleashed. This is just a tiny piece of a photograph I made of a beautiful model whose classic looks, I thought, would make an ideal cyanotype.

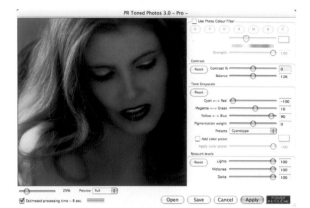

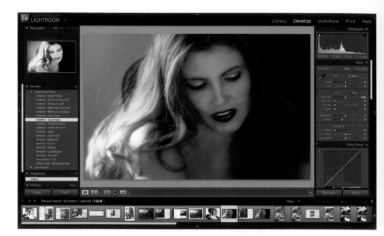

Step 2: As mentioned previously, Power Retouche's Toned Photo (www.power-retouche.com) is a Photoshop-compatible plugin that first converts a color photo to grayscale. You can then adjust contrast by applying colored filters to the conversion, and can digitally tone the image any way you like, or use a preset to emulate traditional photographic print techniques including cyanotype.

Photoshop is not the only way to emulate old photographic processes, and while most of the ones found in Adobe Lightroom's Develop module are generic in nature, there is one for cyanotype that produces very nice effects.

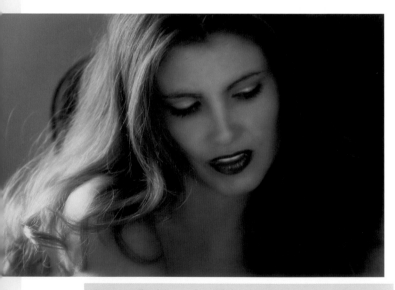

Step 3: The blue color of the final cyanotype adds an air of nocturnal mystery to what was otherwise a nice photograph of a beautiful woman.

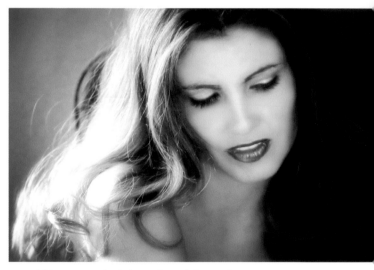

I could have tweaked the color of the Lightroom version of the digital cyanotype to match that of Power Retouche's Toned Photo, but I used the default setting on purpose. As you will find later in my discussion on creating a digital tintype, even if you use an original image to create the digital emulation, there are so many variations in how the original was created and cared for that there is no one perfect way to produce these recreations. What I am trying to introduce you to in this chapter and in this book are tools and methodologies you can use to create your own version of these historic processes.

Tintype

The tintype, also known as ferrotype or melainotype, is a photographic process developed in the 19th century that replaced the ambrotype by the end of the Civil War. It then went on to become the most common photographic process until the introduction of modern film. A tintype is a positive image on a thin sheet of iron that has been coated with black lacquer. Prior to placing the plate into the camera, a wet collodion (gun cotton dissolved in alcohol and ether) with silver salts emulsion is applied to the plate, and the plate is immediately developed after exposure. Tintypes were used almost exclusively for inexpensive portraiture and were typically placed in a leather case.

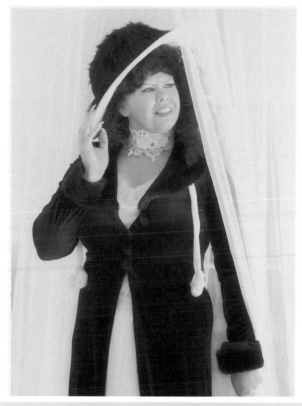

Step 2: Dave Ward (www.DaveWard.net) created a faux tintype (ferrotype) Photoshop action that produces two different tintype effects. The free action may be downloaded from Flickr (www.flickr.com/photos/94336434@N00/9760716). The first one creates a light tintype result, but I thought it was too light. © Mary Farace

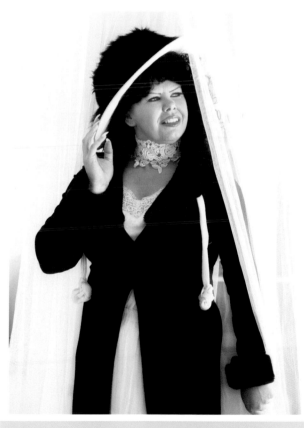

Step 1: This original image was captured this using an in-camera monochrome mode. © Mary Farace

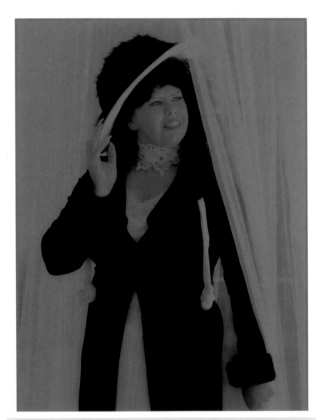

Step 3: The Tintype 2 action creates a dark tintype result, and while both effects were created using real tintype photos as examples, sampling the actual colors from the tintypes, I thought this one was too dark. © Mary Farace

Step 4: When you run Dave Ward's faux Tintype Photoshop action, it adds five layers to the background photo layer, and I decided to exploit these layers to create a tintype effect that was "just right" doe the look I was going for. To achieve this, I changed the layer opacity settings for the top three layers until it looked somewhat in between the light and dark versions of the action. This action, like all of the effects illustrated in this book, are subject and image file dependent. What worked for this image may not work for yours. Working in layers allows you to tweak the effects to produce the desired result. © Mary Farace

Palladium, Platinum, and Platinotype

Platinum prints are part of the group of processes based on the light sensitivity of iron ferric salts. In the presence of oxalate ions, these iron ferric salts are reduced using energy from light to produce iron compounds that react with platinum salts to produce platinum metal. The salts are then removed, leaving a stable image. Like the other iron processes, platinum

printing is slow and requires a large UV light source like the sun and large format negatives for contact printing, hence the popularity of Kodalith for creating large format negatives from 35mm images—preferably slides so they result was a negative.

Palladium prints use an iron-based process similar to platinum prints, except that they generally end up appearing warmer. Palladium is usually less expensive than platinum and is often used by newcomers to platinum printing. In fact, most platinum prints contain a mixture of platinum and palladium.

Platinotype is a monochrome photographic printing process that is based on the light-sensitivity of ferric oxalate as it reacts with platinum or palladium, reducing it to basic platinum, which creates the image.

Step 2: Steven Almas' free Platinotype Photoshop action can be found at Action Central (www.atncentral.com) and mimics the platinotype look. There are two versions, and Version 1 has slightly more green in the toning.

Step 1: This image made at Mission San Juan de Capistrano is an homage to the greatest of all photographers to work with the platinum printing technique—Frederick Evans. By some accounts, Evans was the foremost British photographer in the 1900s and was a bookseller by trade. He is best known for his photographs of the interiors of cathedrals, and in my small way, I wanted to pay tribute to his memory with an image of a mission.

Step 3: Version 2 of Steven Almas' Platinotype Photoshop is slightly more yellow. As with Version 1, all the instructions you need are prompted via dialog boxes while the action is running.

Step 4: Pixel Genius' PhotoKit (www.pixelgenius.com) is a photographer's plugin toolkit comprising 141 effects that offer accurate digital replications of many analog photographic techniques. PhotoKit's image enhancements and adjustments are designed to work in a way that is familiar to photographers. A simple dialog box calls up the PhotoKit tool sets where you can easily select the desired image effect, allowing PhotoKit do the work. The B&W Toning Set effects are designed to be similar to traditional chemical tone effects, and include a Platinum Tone (applied to a separate layer), which is what was used here.

Solarization

Although often confused with posterization, nothing could be further from the truth. It is also sometimes called the Sabatier Effect, although some purists might disagree. In 1857 William L. Jackson noted that exposing a partially developed photographic plate to light, then continuing its development to completion, would sometimes cause a reversal of tones, affecting all or part of the negative. If you want to get into the nuts and bolts of solarization, real William J. Jolly's "Solarization Demystified."

The solarization process produces unpredictable effects, with tone reversal usually occurring in the lighter background areas. A distinct black outline is created around areas where the reversal of tone meets areas where it has not occurred. Usually this effect is applied to a black-and-white image, but it can be applied in color photography by using different colored lights, although the results are even less predictable in the traditional darkroom. This is not so, as you will see, for the digital darkroom.

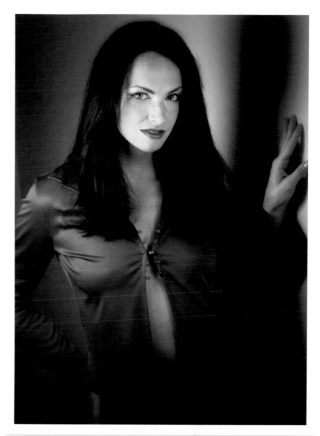

Step 2: I then converted the image to black and white using Alien Skin's Exposure: Black & White Film plugin (www.alienskin.com).

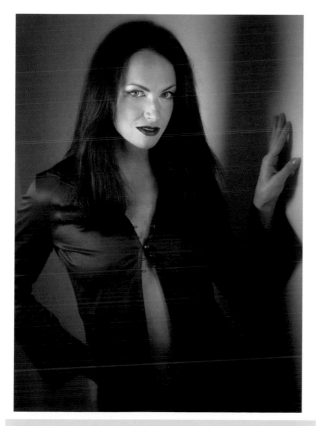

Step 1: I captured this original "film noir" style image in color with an exposure of 1/125 second at f/4.5.

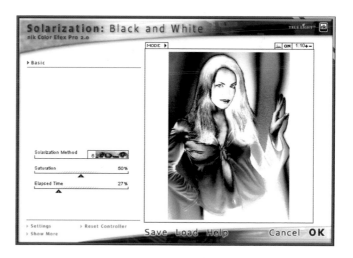

Step 3: nik's Solarization: Black and White filter emulates this conventional darkroom process while offering more control over different methods of solarization and the amount of time the effect is applied to the image. The filter provides unlimited control, allowing you to emulate different paper emulsions as well as experiment with the different variables in the application of the process to produce the end result.

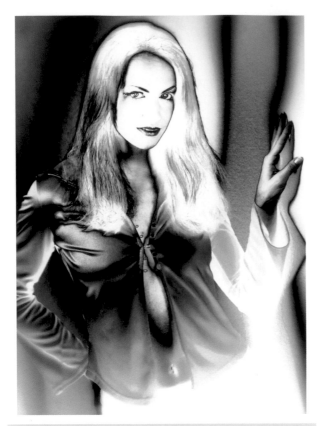

Here is the final image, and at the risk of it sounding like an endorsement, the effects created by nik's Solarization: Black and White filter are the best way to reproduce what would otherwise be a complex and unpredictable conventional darkroom effect.

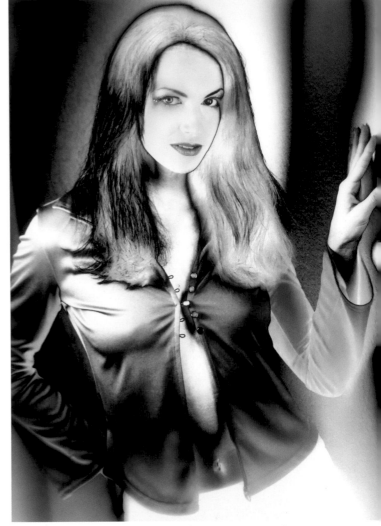

nik's Solarization: Color emulates the solarization process with color photography, but of the many options, none produced a combination that created an overall effect that included a clear view of the model's face for this particular image. So, I created a duplicate layer (Layer > Duplicate Layer) and applied nik's Solarization: Color filter to the layer. Then, using the Eraser tool set at a low (18%) opacity level, I erased the effect layer around her eyes, nose and mouth, allowing them to show through.

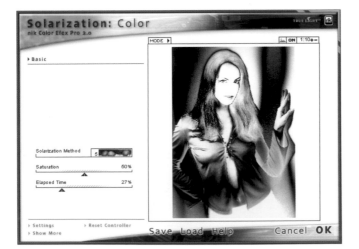

I would never even be able to attempt in the traditional darkroom the kind of complex effects that nik's Solarization: Color can produce.

The Vandyke Process

The Vandyke brown process is one of three alternative photographic methods that rely on the photo reduction of ferric ions rather than silver ions. (The other two are cyanotype and palladium.) These prints have a rich, brown color with subtle gradations in tonality. As in many early photographic processes, there is some controversy about the Vandyke process. In one version, the name Vandyke is applied in photography to a water-developed kallitype print which produces a similar deep brown color to that known as Vandyke brown. Traditional kallitypes use a ferric oxalate based sensitizer and require the use of a suitable developer. Vandykes are sometimes known as sepia, or brown prints. In another version of the story, the process is name after F. Vandyke, a civil servant in India, who invented the process to print maps. I won't take sides on this one.

Step 2: I used Power Retouche's Toned Photo (www.powerretouche.com), which first converts a color photo to grayscale then allows you to digitally tone the image any way you like or use one of their presets. Here, I used a preset that emulated the Vandyke process.

Step 3: Since Vandykes were often called brown or sepia tones, I used PhotoKit's B&W Toning Set to apply an additional brown toning effect.

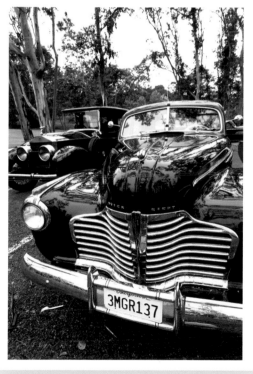

Step 1: I made this original photograph in color on an overcast day in San Diego—a great time to photograph all that chrome! Exposure was 1/60 second at f/8 and ISO 200.

Step 4: Alien Skin Software's Exposure: Black and White Film plugin (www.alienskin.com) has several presets for sepia toning, but the only one I like is the Split-Tone Septa effect, shown here. It creates a deliciously old fashioned look.

Printing Your Images

> "...here in this paper bag / 'Cause if I cant see you Then you can't see me...."— Anna Nalick

This is an important point to keep in mind when reading this chapter. All the chapters leading up to this have been aimed at helping you create unique monochrome images, even some that mix black and white and color, but all is lost if these subtle tones are not reproduced the way you see them on you monitor. That's the main purpose of this chapter—to show you ways to create prints that match your vision. It's true that a digital print that emulates an old photographic technique will simply not look identical to a print that was actually made with that old technique. However, as I have paid homage to several of my favorite photographers and printing methods throughout this book, think of your digital artwork as an homage to the photographic process you are trying to emulate. In drawing on the old, we can honor it and take pride in our new creations.

Before jumping into this chapter, I want you to consider the following words from Shutterbug magazine editor and master printer (in both traditional and digital darkrooms), George Schaub: "An inkjet print is different in the same way that a platinum or salted paper print is different from a gelatin silver print. True, one can emulate the look of any photographic process with the digital/inkjet process, be it cyanotype, ambrotype, collodion, or any other hand or photomechanical printmaking technique. And when reproduced in a book or magazine, where all surface and texture is flattened, the differences are moot. But hold a print made with those processes in your hand next to an emulation (digital) print and the differences are clear."

At the end of this chapter, you will find a few simple, practical printing based projects that can be used to showcase your photography, but if you want a whole book dedicated to this topic, check out Theresa Airey's "Beginners Guide to Digital Photo Art." This is a superb and inexpensive book for photographers interested in the craft of photographic artwork, including digital scrapbooking, inkjet transfers, and information on how to print artistic-looking images on non-traditional media.

If you want to print panoramic photographs that have been digitally stitched together from several image files, such as this one, be sure to get a printer that takes roll paper.

Before You Get Started

Printing with digital technology is simply the latest link in a chain that started when Louis Jacques Mandé Daguerre placed a silver covered copper plate in iodine vapors and watched an image appear. Printing photographic images in a desktop darkroom means no more working in the dark with your fingers soaking in smelly chemicals while waiting for results to appear on dripping wet paper. This is not to demean traditional darkroom methods (there is nothing more luminescent that a platinum contact print made from a properly exposed large format negative), but the inkjet print is clearly this millennium's medium of choice.

Some purists may scoff at digital printing, claiming the images created using computer technology aren't permanent. The truth is that digital prints can easily be produced using inks and papers that will create an archival print. The image maker's choice of ink and paper will ultimately determine whether the print is archival. Here are a few things you should know before getting started so that you can ensure that your prints are not only archival, but also appear visually the way you intended them to.

Aspect Ratio

The main reason that people often end up disappointed in the prints made from their digital files is not the quality of photograph but what's missing from it. What's missing might be Uncle Bernie, who was on the edge of the group photograph taken at last year's family reunion. When you look at the file on a computer, Bernie appears in the image, but when you make the print, he's been cut out. This problem relates to a difference in aspect ratio between your camera and your print. This is one of the most overlooked and misunderstood characteristics of digital printing.

Aspect ratio is the numerical relationship between the height of the image and its width and is usually expressed by two numbers. All 35mm cameras use the same 24 x 36 mm (3:2) aspect ratio. (Those camera collectors out there who want to argue about half-frame 18 x 24 mm film cameras will have to admit that that particular format never really caught on with the majority of photographers.) By comparison, D-SLRs and point-and-shoot cameras are available in many different aspect ratios, and that can cause problems when making prints on standard-sized paper. A 4 x 6-inch (approximately A6) print has an aspect ratio of 3:2, making it perfect for some cameras (causing no cropping if the camera sensor also shares that aspect ratio), while an 8 x 10-inch print (approximately A4) has an aspect ratio of 4:5, making it "ideal" for printing images captured with other camera sensors.

There's a bit more to the story than just mismatched aspect ratios. Digital camera sensors are often cropped internally to match up with one of the standard print aspect ratios, and that can cause some problems in the "what you see is what you get" department. If you've ever made a picture and just know that you captured the entire image but somehow the file seems cropped, you know the feeling.

After taking a photo of a bird then reviewing the image file only to find that the bird's wing tip appeared outside at the frame, photographer and software pioneer Thomas Knoll was positive that he had captured the full wingspan when he took the shot. So he did something about it and created DNG Recover Edges. DNG Recover Edges is a droplet software (you drop the file onto the icon, it does the rest) that's designed to reveal pixels at the edges of RAW files that have been converted into Adobe's Digital Negative (DNG) format. (The Adobe DNG Converter is a free download from www.adobe.com that converts most

RAW files into the DNG format.) The extra ten pixels that Thomas Knoll recovered from that RAW file were enough to put the entire bird back into the frame. The Luminous Landscape website (www.luminous-landscape.com/contents/DNG-Recover-Edges.shtml) hosts this free software and provides additional information about it.

How can the aspect ratio of your camera's sensor affect the final print? Sometimes this mismatch only crops the image a little tighter, and many snapshots benefit from being a little more tightly cropped so it may not be a problem. Difficulties do occur, however, when a subject gets too close to the edge of the original camera file.

This original photograph was made with a camera that produces images that have an aspect ratio of about 4:5. It was converted to monochrome, then layers were used, with the black-and-white layer erased on the rider's helmet. The capture aspect ratio is not a perfect match for all print sizes, but if you were to make an 8 x 10-inch (approximately A4) print, you wouldn't notice anything different from the original. Problems would occur, however, if you decided to make a 4 x 6-inch (approximately A6) or 5 x 7-inch (B6) print from this file. © Mary Farace

[DNG Converter — Adobe Digital Negative Converter window]

① Select the images to convert
 Select Folder... No images have been selected
 ☐ Include images contained within subfolders

② Select location to save converted images
 Save in Same Location
 Select Folder...
 ☐ Preserve subfolders

③ Select name for converted images
 Name example: MyDocument.dng
 Document Name + +
 +
 Begin numbering:
 File extension: .dng

④ Preferences
 JPEG Preview: Medium Size
 Compressed (lossless) Change Preferences...
 Preserve Raw Image
 Don't embed original

 About DNG Converter... Extract... Quit Convert

Camera manufacturers often mask off pixels at the edges of the frame to make your image files fit into traditional aspect ratios. These missing pixels are not available when the image files are displayed normally, but DNG Recover Edges software allows you to recover between four and sixteen pixels around the edge of a RAW file after converting it to a DNG file.

When cropped into a 4 x 6-inch (approximately A6) print, the bike rider gets dangerously close to the edge of the frame. Automated photo printers crop from all edges equally (as opposed to the manual crop I've done here), so my guess is that an actual 4 x 6 print made from this file would clip the rider's elbow. © Mary Farace

Sometimes the best way to solve the cropping dilemma is to manually change the print size yourself, which in turn changes the print's aspect ratio. As shown here, the 5 x 7-inch print frame is slightly different (wider) than the 4 x 6-inch print frame. © Mary Farace

I captured this image file with a camera sensor that has the same 2:3 aspect ratio as 35mm film. This file makes 4 x 6-inch (approximately A6), 8 x 12-inch (approximately A4), and 11 x 14-inch (approximately A3) prints with little or no cropping.

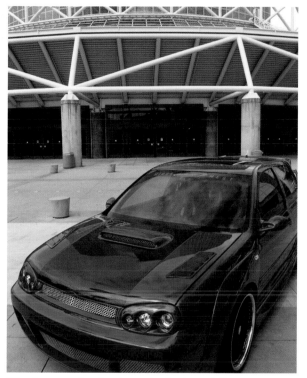

What happens when I make a print that has a different aspect ratio than the original file? At this point, something's got to go. The first thing to disappear is the sign in the background. Unlike the bicycle photo example that was cropped from the side, this particular example must be cropped from the top and bottom. If this were a horizontal image, the sides would get cropped, and any people on the edges of a group photograph would be gone.

The point of this aspect ratio discussion is not to say that one format (3:2 or 4:5) is inherently superior to the other. There are advantages and disadvantages to both. Usually, the aspect ratio of the sensor is not one of the deciding factors in choosing a camera. The most important thing to keep in mind about aspect ratio is how it will affect what print sizes your images translate most easily into. Play it safe and provide extra space at the edges for group photos, or any time the image contains something of importance at the edges.

What is EXIF Data?

The Exchangeable Image File format standard was established in 1995 as a way to accommodate a range of image file formats and allow playback of photos made with one kind of camera on a different device. As such, EXIF is part of the Design rule for Camera File Systems (DCF), a larger file system standard that's designed to ensure image file compatibility between digital cameras and printers. The EXIF standard is the file format used by most digital cameras to define file name and folder structures standards, including telling the camera how to store image data. When a digital camera is set to capture and record a JPEG image file, it's actually recording an EXIF file, using compression to store additional photo data within that file.

Opanda PowerExif (www.opanda.com/en/pe/index.html) is a Windows-based software tool that can be used to edit the EXIF data in image files. You can manage and record photographic data, including GPS data, using a maximum of 60,000 multi-language characters.

Right now, EXIF supports storing extended camera information within the image file's header, such as the time and date the image was made, the name of the device the image was made with, the shutter speed, aperture, compression mode, color space, and number of pixels, to name just a few of the information bits stored here. You can read all of this image file information externally using EXIF-compatible software that in turn can use it for image file management.

In addition to image data, the next most important feature of EXIF is its inclusion of thumbnails. Thumbnails are small versions of the original images that can be used by software applications, including image management and image-processing software, to display a series of image files. Under DCF standards, the typical thumbnail measures 160 x 120 pixels.

Photoshop Elements uses EXIF data to display thumbnails in image management mode. Clicking on a thumbnail allows you to view all of the EXIF data associated with that specific image. Many other image editing programs also let you view EXIF data so you can read specific details of how an image was captured, unlike when using film when you had to make a physical note!

Together with the image data, EXIF records all of the information set by the photographer, including capture parameters and scene information in the form of EXIF tags. When you go to print, the printer reads all of this photographic information to ensure optimal printing. This can be especially important when capturing an image using any of the camera's scene modes. Photographic scene information records that the image was captured in Night scene mode, for example, and printing is optimized to suit the original effect without increasing image brightness. Consequently, the output produced will more faithfully reflect the photographers' original intentions.

If shooting in one of the many scene modes or in-camera filters available with digital cameras these days, the latest version of EXIF makes sure that when an image made under different kinds of lighting conditions is printed, it is printed with those specifications in mind. For this image, I used an in-camera zoom effect filter.

Color Space

One of the differences between the current version of EXIF and previous ones is the color space that's used. Color space describes the range of reproducible colors that a camera can see, a printer will print, or a monitor can display. Monitors, for example, use the sRGB color space, so the appearance of the colors on-screen is limited to reproduction within this range. Some digital cameras, however, use the sYCC color space, which allows a wider range of colors to be recorded and reproduced than sRGB.

Long used in the video world and in Kodak's original Photo CD format, YCC represents the familiar Red, Green, and Blue (RGB) channels as luminance (Y) and two color-difference channels, Cr and Cb. Cr is chrominance red; Cb is chrominance blue, with the green being handled by the luminance component.

Previously, when sYCC images captured with digital cameras were transferred to a computer, all of the monitor colors outside the sRGB range would be discarded or clipped. The current EXIF, however, allows more accurate image processing because handling sYCC images directly using compatible applications and printers means that virtually all of the original

digital camera image can be accurately printed. Who supports EXIF printing? Here is a list (in alphabetical order) of companies that support EXIF printing, with links to their websites: www.cipa.jp/Exifprint/contents_e/02support1_e.html.

DPOF: Printing Made Easy

As we discussed in the first chapter of this book, you can capture images directly in monochrome with your digital camera. Using Digital Print Order Format (DPOF), you can even makes prints directly from your camera. DPOF is a feature that's found in most digital cameras that enables the camera to select which pictures and how many copies of each you want to print. DPOF data consists of a set of text files and is stored in a special directory on the memory card along with the image files. It can only be used with JPEG capture, and cannot be applied to RAW files. When you insert the card into a DPOF compatible printer, the number and sizes of prints you requested are automatically printed. If you use a

photo lab that has DPOF compatible equipment, you save time because you don't have to tell the photo center which pictures you want printed and which you don't.

If your camera fully supports Digital Print Order Format, it will allow you to specify number of prints, print sizes, and offer the option to request an index print showing all of the images contained on the memory card. It can also allow you to print the date, title, or other text with your photos. The Equipment/Use features of DPOF contain data about the camera itself, along with capture date and time from the EXIF data. Other user information such as your name, address, and phone number may also be recorded. The DPOF option can be accessed through your camera's internal menu system. Check your camera manual (or the Magic Lantern Guides book about your camera, if available) to find out exactly which internal menu DPOF is located in.

What comes next is the actual print making experience, and even here there is some variation in what you may expect. You can make prints directly from the memory card, but not all printers have a built-in card reader even though they may be DPOF-compatible. In that case, you will need to connect the camera to the printer using a USB transfer cable, usually provided with the camera. The technology used to make prints directly from camera to printer is called PictBridge (see page 149 for more information).

To print pictures with a DPOF-compatible photo printer that directly accepts memory cards, remove the card from the camera, insert the card into the appropriate memory card slot on the front of the printer and, using the printer's controller, select DPOF from its menu options. The controller will usually alert you to the total number of images on your memory card that have been tagged with DPOF data. Then, simply press the Print button and your selected photos print automatically.

The software used by most, if not all, online printing services does not usually recognize DPOF data, so you probably won't be able to use that capability when uploading image files to order prints through the Internet . On the other hand, almost all photo printing kiosks that let you insert memory cards recognize DPOF data and will produce the prints you specified. Depending on the lab's equipment, the date may or may not be imprinted even if that particular DPOF selection was made.

I made this photograph in Zion National Park, Utah. Exposure in Program Mode was 1/500 second at f/8 and ISO 200. And no, I don't remember the exposure settings listed in this book off the top of my head, or keep meticulous notes about them as was necessary in the film days; this information is contained in the EXIF data that's part of the image file.

It all comes down making the prints that you want simply and easily, and that's what DPOF is all about.

PictBridge

PictBridge is an open industry standard developed by the Camera & Imaging Products Association (www.cipa.jp/english) that allows photographs to be printed directly from digital cameras without being connected to a computer. In the past, some manufacturers marketed systems that allowed certain digital cameras to be directly connected to certain printers, but PictBridge was created for direct printing from digital cameras to printers regardless of who manufactured either piece of equipment.

PictBridge will let you print images from a digital camera without a computer and includes a wide range of built-in tasks, though some functions depend on the individual devices being used. Nevertheless, all PictBridge products are capable of performing the following minimum functions:

• You can connect a PictBridge compatible digicam to a PictBridge compatible printer with a USB cable and establish a direct connection, regardless of brand, without having to install any software.

• PictBridge controls allow you to immediately print an image displayed on the digital camera's LCD preview screen.

• If an error occurs during printing, an error message appears on the printer or digital camera's LCD screen.

Other functions may also be provided depending on the particular equipment being used. Some of these include the option to print multiple images, select number of copies, trim images, specify print size, or display the printer status. If your digital camera doesn't support these options, PictBridge uses the printer's default settings for media size, media type, or print quality.

Note: Before printing directly from camera to printer, you must first set your camera's transfer mode to PictBridge. Check your instruction manual or Magic Lantern Guides book for details.

PictBridge is compatible with all kinds of cameras, from digital point-and-shoot models on up to D-SLRs. It only works with JPEG files though; images captured in RAW format cannot be printed in this way. So which products are PictBridge compatible? For a complete list of compatible cameras, printers, and other devices, go to CIPA's "PictBridge Certified Model Listing" page: www.cipa.jp/pictbridge/CertifiedModels/PictBridgeCertifiedModels_E.html.

Hint: To save battery life, it's a good idea to use the camera's AC adapter when printing via PictBridge, and be sure not to disconnect the USB cable during transfer!

This is an actual letter-sized print I made with a Pentax K100D connected to a Canon Pixma MP830 printer.

Real World Printing

Inkjet printers spray ink through nozzles—sometimes called jets—onto paper. This technology falls into two general categories: micro piezo and thermal. Some printers have nozzles built into the print head while others place them in the ink cartridges, but I've never seen much visible difference in the output due to this difference in design.

Micro piezo print heads are used in Epson printers, and they squirt ink through nozzles using mechanical pressure caused by an electrical current that squeezes the head to make the ink squirt. The print head changes shape depending on the amount of current applied to the print head, regulating the amount of ink that's released.

For thermal print heads, ink in the print head is heated and it then expands and is forced though the nozzles onto the paper. This system is used by Canon, Hewlett-Packard, and Lexmark printers, to name a few. There are slight variations in how each company's printers accomplishes this task, but you get the idea.

The amount of ink leaving a print head is measured by droplet size and, in general, the smaller the size, the better the print quality. Ink droplets are measured in picoliters, which is one billionth of a liter. Printer resolution is rated in dots per inch, dpi. A 720dpi device prints 518,400 dots of ink in one square inch (720 x 720); the greater the number of dots, the higher the resolution. A higher end printer such as the Epson Stylus Photo R2400 outputs photos up to 13-inches wide at a maximum of 5760 x 1440 dpi and produces 8,294,400 dots per square inch.

All inkjet printers are not alike in their choice of ink formulations. Some companies use either dye-based inks or pigmented inks, while others use pigment-based inks for their black ink cartridge and dye-based inks in their color cartridges. On regular printer paper, dye and pigmented inks mix easily because of this media's high ink absorption rate, but when printing on coated stock such as photo paper, printers that use different types of inks for black and color turn off the black ink. Black in the output then becomes a composite of the CMY (cyan, magenta, and yellow) inks.

Pigmented black ink is slightly better than dye-based ink for printing sharp, dense, black text on plain paper, and some printer manufacturers prioritize black text over photo quality. Why should you care? Pigmented inks produce prints that last longer but may not be as vibrant as output from dye-based inks. Prints made using dye-based inks are colorful but don't last as long. Epson's UltraChrome inks are water resistant and provide bright colors that are similar to dye-based inks but retain pigmented ink's characteristic lightfastness.

Printer Driver Paper Specifications

Selecting the correct paper type in the printer driver menu is a critical step in achieving the best possible printer output. Each type of paper shown in the printer driver uses a different table and assigns different ink saturation. That's why it's a good idea to read the paper's instruction sheets to see which driver settings are compatible with the particular paper you are using, and which will produce the best results. Keep in mind that not every paper and ink combination works together perfectly. Before making a big investment in paper, purchase a sample pack or small quantity of a few different kinds of photo papers and make your own test prints. (See pages 152–153 for more on test printing.)

Printing Monochrome Images

One of the biggest challenges in color managing printer output is printing black-and-white or mono-chromatic images. This can be especially problematic when using inkjet printers with pigmented inks because an unsightly effect called metamerism can occur. Metamerism is an effect sometimes created by pigmented inks in which the photograph exhibits different colors and tones depending on the light source.

You can always print using black ink only. I have successfully produced output this way, especially using high-resolution printers, but the results are heavily dependent on the original image. Some photographs, notably landscapes, seem to do better than others, such as portraits. Low- and high-key images seem to be able to handle this approach better than ones with lots of mid-range tones, which tend to be flat anyway! To get truly continuous tone black-and-white output, you may need a grayscale ink set, or an ink set that uses multiple black or gray inks. Monochrome ink sets and complimentary software are available from companies such as Media Street (www.mediastreet.com) and Lyson (www.lyson.com). These companies offer archival quality inks that, when used with acid-free paper, produce museum quality monochrome images that can be sold in art galleries anywhere in the world. The best way to output photos that mix black and white with color, such as sepia, cyanotype, etc., is to print them just as you would a traditional full-color image file, starting with calibrating your monitor and using the common sense techniques that follow.

As more and more inkjet printers add multiple black and gray inks to their ink sets, getting great monochrome prints may not be as much of an issue. The Epson Stylus Photo R2400 uses the company's Ultrachrome K3 inks and has matte black, light black, and photo black ink cartridges installed for high quality monochrome reproduction. In addition to the normal color or black ink choices presented by the R2400's printer driver, there's an Advanced B&W Photo mode that utilizes these additional monochrome inks for spectacular results. (Product photo courtesy of Epson.)

Monitor Calibration

There are a few obstacles standing in the way of obtaining an exact color match between what you see on the monitor and what your printer will deliver. The most fundamental difference is that, when looking at a monitor, you are viewing an image through transmitted light as opposed to reflected light. Much as when viewing a slide on a light box, light is coming from behind the image on your computer screen. When looking at the actual print, you are seeing the image by reflected light. Right away, there is a difference, but these differences can be exacerbated by environmental factors such as glare and ambient light. While light may appear white to our eyes, it actually comes in many hues.

Once you're aware of the environmental effect on your output, you need to take steps to bring your computer system into color harmony. There are a few ways to minimize problems, but the key is knowing what the color of your original image is to begin with. Try using Adobe's Gamma software (www.adobe.com), which is automatically installed in Windows versions of Photoshop CS2 and earlier (although beginning with CS3, it installs it differently and is a little harder to find). Mac users on Photoshop CS3 won't find Gamma at all; Adobe expects you to use the Display Calibration Assistant that is part of the Mac OS system and is located in System Preferences.

The Gamma control panel lets you calibrate your monitor's contrast and brightness, gamma (midtones), color balance, and white point. The settings you obtain by working with the Gamma control panel are used to create a profile for your monitor that is used by color management systems such as ColorSync for Mac OS and Microsoft's ICM (Image Color Matching) for Windows. There are two ways to work with Gamma and both are easy, including a step-by-step wizard approach. Detailed information on setting Gamma controls can be found in Adobe's online technical guides (www.adobe.com/support).

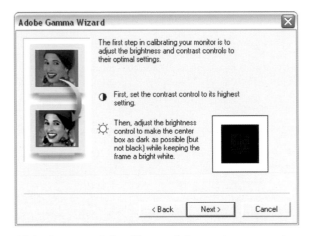

Adobe Gamma can help calibrate and characterize your monitor. Calibrating your monitor brings it into compliance with a color standard. Characterizing your monitor simply creates a profile that describes how the monitor is currently reproducing color. It also helps you set optimum brightness and contrast ranges.

While Gamma isn't perfect, it will get you into the ballpark of correct color calibration. Be careful, though; the better the color match, the pickier you may become. The secret in pursuing great color accuracy is not to hunt until the color dragon is slain, but until you are satisfied with the match between the image on your monitor and the print of that image. One of the least expensive ways to calibrate your monitor, and one that I use, is by using ColorVision's Monitor Spyder (www.colorcal.com). This combination of hardware and software can calibrate any monitor and will produce International Color Consortium profiles (www.color.org) for Mac OS and Windows color management systems. This is not the only hardware solution that's available, it's just the one that I

use. Other modestly prices calibration systems are available from Gretag Macbeth (www.gretagmacbeth-store.com), Pantone (www.pantone.com), and XRite (www.xrite.com).

Making and Utilizing Reference Prints

Some inkjet printers automatically output a test page shortly after you connect them to the computer and install the driver. While these pages may tell you that the printer is actually working, you may want more information than that. One of the best ways to discover your printer's capabilities is to create your own test print.

This Spyder is a Plexiglas and metal device that attaches to your LCD or CRT monitor. When used with ColorVision's software, such as PhotoCal or OptiCal, it's relatively simple to calibrate your monitor.

The key to comparing results from different printers or papers is to create a standardized test file and use it to compare results. Start by using your favorite image-processing program to save a photograph in a high-resolution format, like TIFF. Instead of making the image full letter size, keep it around the 5 x 7-inch size range (B6). This will make the file size smaller and it will take less time to print. The file should then be saved on some kind of removable media, such as recordable CD/DVD so it can be used later when testing new printers, inks, or papers.

Custom Profiles

Start by printing the test image on your own printer, but also ask friends if you can output it on their printers so you will be able to make a valid comparison… and so will they! Use the test print with the printer driver's advanced settings and experiment with the sliders for brightness and contrast. Next, take a look at color bias. Black-and-white test prints will clearly show any kind of color shifts for the paper, inks, or printer because color shifts will be more apparent with no color in the image. Working with your customized test file will let you know what driver settings will produce the results you want and can also be a big help when evaluating different kinds of paper. After a little testing, you'll find the best paper and settings that will produce the optimum quality output from your printer.

Perhaps the best way to make sure the ink and paper work well together is to apply a profile to your image file that matches the desired output. A profile is a color management standard for specifying the attributes of imaging devices such as scanners, digital cameras, monitors, and printers so that the color of an image remains true from source to destination. Most third party paper companies offer free profiles for their papers, and there are many services that will create a custom profile base on your printer, specific ink set, and a particular kind of paper. Applying that profile can be a hassle, but most photographers will find that after they've tried it, they will appreciate the results. Submitted for your approval, here's one way to apply a custom paper profile using Photoshop and an Epson printer with a Mac OS X printer. Windows users will find the approach similar for a similar combination of software and hardware.

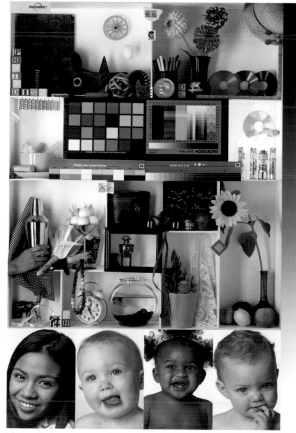

If you don't want to make you own test print, you can use one that has been widely adopted. The PDI target was created by Photo Disc Inc. (now part of Getty Images) from industry standard targets from Gretag Macbeth, Heidelberg, and Kodak. You can download a copy to do your own test prints from at: www.inkpresspaper.com/PDI%20TargetLetter.jpg.

Step 1: Download a profile for your printer and paper choice. In this case, I downloaded the profile for Inkpress Fine Art Matte (www.inkpresspaper.com). It contains 25% cotton fibers and 75% wood fibers, and it works with most desktop inkjet printers and both dye and pigment based ink. It is acid and lignin free and is an economical alternative to rag media, especially for portfolios and other non-archival or fine art applications that do not require a 100% cotton rag. Most papers you use every day are made from wood

fibers that are acidic and prone to discoloration and disintegration over time, but PH-neutral papers made from fabric, also known as rag fibers (such as cotton), are stronger, tend to take more "wear and tear," and are, most importantly, more archival.

Step 2: Place the profile into the appropriate folder. For Macintosh OS X, place it in Users/Library/ColorSync/Profiles. In Windows XP, you can just right click the profile and select the install option.

Step 4: In the Printer Profile drop-down menu of Options, select the custom profile you were sent or downloaded. For most profiles, set the Rendering Intent selection to Perceptual and check the box next to Black Point Compensation. You can also try the Relative Colorimetric as a Rendering Intent setting to see if that gives you better results.

Step 3: Select the Print with Preview option in Photoshop by going to File > Print with Preview. (Depending on your version of Photoshop, you may also be able to access the print preview directly from File > Print.) Choose "Let Photoshop Determine Colors" from the Color Handling drop-down menu in the Option section of the Print with Preview dialog box.

Step 5: In the Print dialog box, select Color Management and click the box next to Off (No Color Adjustment) since the color management is being handled by the profile. Then click the Print button.

Printer Adjustments

Buried in the Color Management section of printer drivers from Canon, Epson, and Lexmark, you will usually find a screen that allows you to slightly tweak the output for color, saturation, and contrast. Some of these drivers are far more elaborate than others and even include a little thumbnail of your image. The point is that you don't have to use a profile if you don't want to. I don't use one all the time. In fact, I only do it when working with new or special printing media. Most of the time, I make the tweak in the file or the printer driver, especially if it's not too major. As I said at the beginning, this is not a "my way or the highway" book. I want to expose you to several different options so you can use the one you like or pick the features of one or the other and make changes to suit your workflow.

Instead of creating a profile, you can use the printer driver to tweak the output by adding more of a certain color, removing a color, or just bumping the contrast a bit.

File Adjustments

PhotoTune's Test Strip Proofer (www.phototune.com) lets you emulate the time honored system of incremental proofs known as test strips and "ring-arounds" by traditional wet darkroom workers. You can tweak your image files without wasting paper and ink. Test Strip Proofer is a Photoshop automation plugin that automatically makes calibration proofs with your choice of color variation and amount. It's available in two versions; the Home version makes horizontal and vertical proofs in sizes from 4 x 5 inches (approximately A6) up to 12 x 15 inches (approximately A3). Test Strip Proofer Pro offers horizontal and vertical sizes up to 36 x 45 inches (approximately A0) plus a selection of proofs from 16 inches (40.6 cm) to 43 inches (109.2 cm) wide. Test Strip Proofer makes all proof images using a 4 x 5 aspect ratio, and if your image is taller or wider than that, it will be cropped to fit. With images that are shorter or narrower than the 4 x 5 aspect ratio, more white space will be added between images.

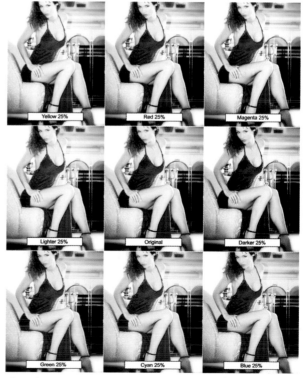

If you don't want your image cropped when making a Test Strip proof, use Photoshop's Image > Canvas Size or Crop tool to alter your image's dimensions to match the 4 x 5 aspect ratio before using Test Strip Proofer.

Inkjet Papers

In the heyday of the home darkroom, every photographic paper manufacturer offered lots of different kinds of textured papers, not just smooth, matte, or glossy. Over time, however, all of these wonderful choices have just about disappeared. When working in a traditional wet darkroom, I used Agfa, Ilford, and Kodak papers, and would try to match the paper I used to the image. Now I keep papers from Epson, Inkpress, Moab by Legion, Media Street, Sihl and others on hand and use the same concept of matching paper to the image's mood. Textured papers, media, substrates, or whatever you want to call them are now enjoying a renaissance because of inkjet printing.

The inkjet paper you use can have a dramatic effect on the quality of your output. Printer manufacturers may insist that the best output will only be produced when using their own papers, and I won't argue that some of them are spectacular, but we wouldn't be photographers if we weren't looking for the next best thing.

For me, part of the joy of printing digital images is working with different kinds of paper and media. Some digital imagers may be cautious about this, having read their printer manufacturers' warnings that in order to obtain the best results only paper and inks produced by the same people who made the printer should be used, but this is one time you can ignore what the manual says and experiment a bit.

There are many varieties of papers and each has its own base color and tactile characteristics that distinguish it from another. Papers are also available in different interpretations of white that can make the final print's tones warmer or cooler. In fact, what most people think of as a "pure" white often has some blue in it. Some papers tend to add more contrast, while others will make your colors more saturated. ISO Brightness (www.iso.org) specifications refer to the "absolute brightness" of a paper, which is a measurement of the reflectance of blue light with a specified spectral distribution peaking at 457nm compared to that of a perfectly reflecting, perfectly diffusing surface. The higher the number, the brighter the paper, and numbers above 100 are possible. These specifica-

tions may be found on the outside of the paper box, inside the box, or better yet, on the manufacturers website. If you can't easily find this data, it's a sign that you might want to skip that particular manufacturers product. Brighter papers won't create more contrast because it the base of the material that's brighter. The same is true with color saturation. Both contrast and saturation will be more affected by the paper's surface type. A glossy paper will look brighter and more saturated; a matte paper will appear flatter (less contrast) and more muted in color.

Paper weight is specified in grams per square meter, usually abbreviated to gsm. Thickness of the media is expressed in thousandths of an inch, or mils, and is referred to as caliper. There are also a seemingly infinite number of texture choices available. Some inkjet printers can handle heavy textured papers and some cannot, so be sure to check your printer's specifications before trying to stuff something in it that just won't fit. Usually, though, there's an adjustment on the printer for printing envelopes or heavier paper. Find out where it is because you're going to need it for printing with thicker media.

Choosing Paper

I believe that you should treat your choice of inkjet papers the way that photographers have always done. Experiment with different kinds of media to learn their individual "personalities," such as base color, contrast, and ink absorption characteristics. Then, you can use this uniqueness when it's appropriate—or even purposefully when it seems inappropriate—for a specific image.

When printing fine art images, I prefer the softer look of matte paper. I use Adorama's ProJet Photo Rag (www.adorama.com) because it has more "tooth" than most smoother matte papers. Photo Rag is a100% cotton acid-free smooth textured watercolor paper and is available in warm and cool/warm toned versions. Both papers work great for fine art images, although the cool version was, to my taste, a bit too cool for

portraits. Photo Rag is also available in two thicknesses (190gms and 16 mils or 300gsm and 24 mils) providing four total paper varieties.

As a guy who often photographs cars and motorcycles, I flipped out over ProJet SilverMirror media. This printing media really can't be called "paper" in any traditional sense. It is a dimensionally stable polyester-based material that has a highly reflective mirror finish. It looks like you're printing on shiny metal! With a price tag of $26.95 for a letter-sized pack of ten sheets, you need to be careful about making mistakes, so carefully examine both sizes before printing; the coated (printable) side has a slightly frosty appearance compared to the reverse. The material is thin and can be "dented" if not handled carefully, especially in larger sizes. When printing, I used the Transparency setting on my Canon printer and the Inkjet Back Light Film setting when using my Epson printer. The results are spectacular, especially at the 11 x 17-inch size (approximately A3).

There are some fine art photographers who prefer a thick paper because it adds an air of quality and authority. If you are one of these people, you're going to love Sihl Studio Pro 300 gsm luster and glossy paper. The Swiss-based Sihl group is part of the Italian-owned Diatec organization that is well known in Europe for its wide format products and boasts a 100-year history of paper coating and 500 years of paper manufacturing. The company developed a coating technology that guarantees color saturation, a wide range of tonal values and contrasts, and maximum thicknesses.

Recently, I have been using Ink Press Papers (www.inkpresspaper.com) with my Epson inkjet printer and have been impressed with the results. Besides obvious product quality, Ink Press media is truly universal and works with Epson Ultrachrome, Dye based, Pigmented, and Durabrite inks. On their website, Ink Press Papers offers some suggested printer driver settings and provides downloads of ICC profiles for new and upcoming printers. They offer 23

Sihl claims that their media is "the Ferrari equivalent in inkjet photo-paper" so I printed a picture of a Ferrari Formula One car to see for myself. Wow! The glossy paper is impressive both in its heft as well as image quality. Both the glossy and the luster (Sihl call it "silky") paper have the look and feel of traditional fine art photographic prints.

Ink Press Papers are available in lots of different sizes, and since they manufacture all their own media, custom sizes also available.

different paper types and surfaces, from the insanely cool White Gloss Film to their Fine Art Matte. You'll also find Waterproof Canvas, Linen Texture, and Watercolor Rough. Check their site for the full product lineup including unexpected media such as Adhesive Vinyl.

Creating a Portfolio Photo Book

Most people's inkjet printer use can be broken down into three categories: proofs, prints, and portfolios. For professional photographers and aspiring amateurs, one of the advantages of producing photo quality output in-house is the ability to update and customize a portfolio of work. Presentation is also an important part of making a good first impression, and nothing impresses potential clients more than a bound portfolio. There are many ways to produce a bound-book portfolio, and my favorite is Unibind's PhotoBook Creator (www.myphotobookcreator.com). It requires a simple binding tool and lets you make beautiful portrait or landscape-oriented books in about 90 seconds. Let me show you how it works…

Step 2: Insert some blank sheets between the covers and trace the location of the window opening onto the top sheet of paper. I like to use a book cover that has a window opening because it acts as a teaser and, hopefully, gets people's attention before they even open the finished book. Use a ruler and measure the exact size and location of the window opening. Then measure the depth of the left-hand page edge that will be covered by the binding. These dimensions will vary depending on the Unibind cover set you use.

Step 1: Start by editing and selecting images for the portfolio using browser software. This is the first and most critical step because it doesn't matter how nicely bound the portfolio may be if the images don't attract the viewer's attention. When evaluating photographs to include, think in terms of impact and select images that have strong eye appeal or dramatic composition. If the photos themselves make a great first impression, the potential client will be tempted to linger over them. You can even think of a theme for the photographs that are bound in the portfolio, and consider having separate books for different style categories to appeal to different clients.

Step 3: Create a page template for the inside and following pages. I use Adobe Photoshop for this project because I like to use the Rulers (View > Rulers) as a digital measuring tool and be able to pull out blue-line guides from the top and side margins of the document window. You don't really need to draw any kind of permanent lines or boxes, the guide lines only serve as an aid in planning placement of the image that will show through the cover window and take into consideration the gutter (the part of the page hidden by the binding). Save the document as a template and, after you place an image, use the Save As command to save that particular page with your specific image on it. You may also want to consider having a "credit" page thanking anyone who contributed to the image-making process, such as models or notable locations that enhanced the images.

Step 4: Choose the paper you want to print your portfolio images on and prepare and print them using your favorite image-processing program. The paper that you use is important, so select a paper that reproduces the image files in the way that most enhances the photographs' characteristics. I prefer a glossier paper stock for my automotive images than I use for my portrait or glamour images, but you should also to keep in mind that the thickness of the paper you choose also determines how many pages you can bind between the covers. Place a stack of your preferred paper between the covers and see what works best without any unsightly bulges.

The book's stylish covers are finished in black paper on the inside and guarantee an impressive presentation with four different window cuts that let you to personalize your portfolio. Depending on the thickness of the book, each cover set can hold 10 – 30 pages.

Step 5: Insert all of the portfolio pages between the covers, place the unbound book into the Photo Book Creator biding device, and wait for the light to turn green. When it does, the book is finished, but it's not quite ready for prime time! The binding device uses heat to melt adhesive in the binding that keep the pages in place, so if you try to use it right away you'll discover that the adhesive is still soft and the pages can loosen. Wait until the binding cools before you put your portfolio into action. Cooling times will vary based on the different types and sizes of paper and the cover size used. I take the "freshly baked" book and set it on the cool granite counter top in my kitchen for a half hour, but I don't hand it to anybody to look at right away.

A Virtual Portfolio

PanosFX Analysis (www.panosfx.com) is a set of Photoshop Actions for Adobe Photoshop CS2 and CS3, and rumor has it a Photoshop Elements version is on its way. The set consists of 11 effects with 23 variations that convert an image into a number of elements such as the inner pages of a book, a book's cover pages, individual photos, and filmstrips. After running the action, the original photograph is presented as a combination of these elements. All layers are placed within a group for you to manipulate to suit your preferences. The actions are optimized for landscape orientated images, but I converted a portrait into a square and it worked for me.

Note Cards

It doesn't matter whether you're a pro or amateur photographer, it's always a good idea to send thank you notes to people that help you with projects. Recently, I've tried making themed thank you notes on my inkjet printer with Red River Paper's pre-scored papers (www.redriverpaper.com). These cards are available in glossy, one- and two-sided matter, and watercolor media. On their website, Red River Paper sells matching envelopes, translucent inserts, and even high-quality boxes so you can create a professional-looking presentation. To help with card layout and design, they also offer tips for printing using Photoshop and Microsoft's PictureIt.

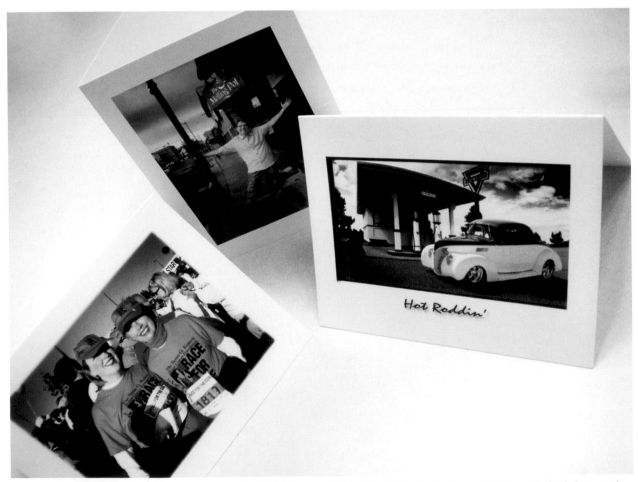

The least used pair of words, it sometime seems, in the English language is "thank you." I send thank you notes to people that help me with photographic projects that feature my photographs, selecting an image that I think will appeal to the person receiving it. The kindness you do today can be an opportunity that presents itself tomorrow.

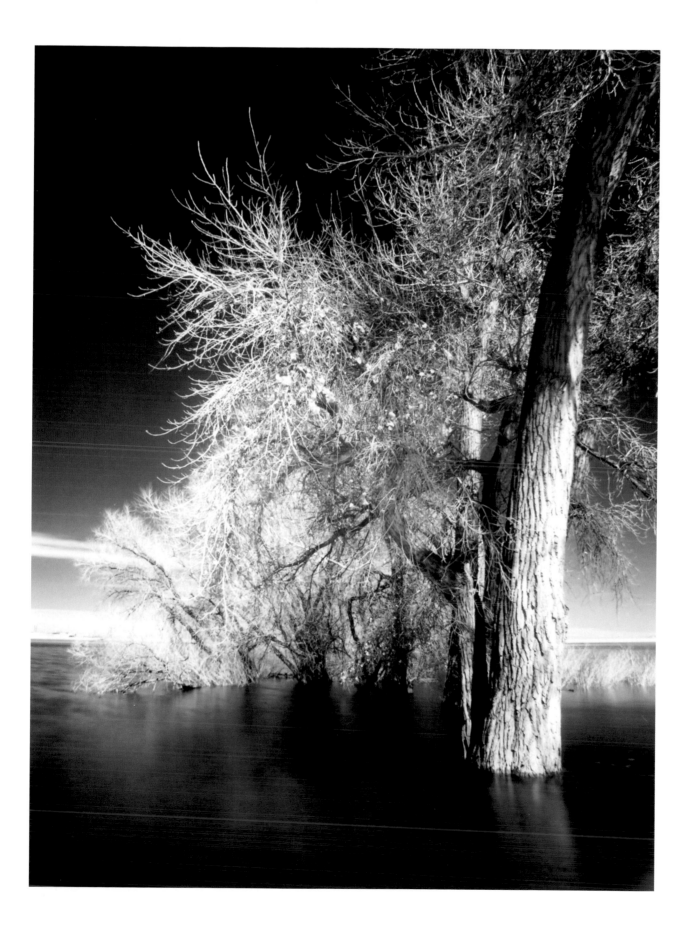

Glossary

Photographers may be familiar with traditional film-based terms and acronyms, many of which have their origins in the disciplines of optics, chemistry, and physics. The language of digital imaging, however, has its roots in the fields of computing and commercial printing, and has given birth to remarkably inventive new buzzwords at the drop of a microchip. Here's a brief introduction to some terms that digital photographers might find useful, as well as a review of some of the general terms found throughout this book.

A

AF

Autofocus; automatic motorized focusing.

AI Focus AF

An autofocus mode that automatically switches from One-Shot autofocus to AI-Servo autofocus when a subject moves.

AI Servo AF

An autofocus mode for moving subjects, with focus tracking and shutter priority.

aliasing

Sometimes when an image is displayed on a monitor, you will see jagged edges around some objects. These extra pixels surrounding hard edges, especially diagonal lines, are caused by an effect called aliasing. Techniques that smooth out these "jaggies" are referred to as "anti-aliasing."

ambrotype

An ambrotype print is made by placing dark paper or cloth behind a glass negative. When seen in the proper light, the image appears positive. In 1854, Boston photographer James A. Cutting took out a patent for the process where glass is coated with iodized collodion and sensitized in a bath of silver nitrate.

aspect ratio

The numerical relationship between the height of the image and its width. 35mm cameras employ a 3:2 aspect ratio, but digital cameras are available in many different aspect ratios. This can cause problems when making prints on standard-sized paper.

average metering

Through-the-lens (TTL) metering that takes into consideration the illumination over the entire image.

B

bit

A binary digit. Computers represent all data, including photographs, in bits.

bromoil

The bromoil was one of the favorite darkroom techniques of Pictorialists. It starts with the creation of a black-and-white print using traditional darkroom methods, with the image typically printed on a textured paper. The print was then treated with a "tanning" solution that bleached the image almost to the point of invisibility and hardened the gelatin on the print in proportion to the depth of silver. After fixing and drying, the tanned print was hand-brushed with a boar's-hair paintbrush using oil-based ink. At this point, the hardened portions of the emulsion will accept more ink than the others, allowing the bromoil maker to eliminate distracting elements and even add compositional elements using an ink-filled brush. The finished prints exhibit artist-like brush strokes, and some photographers, like Bill Mortensen, even toned their bromoil prints to give them a warmer appearances.

byte

Each electronic signal is one bit, but to represent more complex numbers or images, computers combine these signals into larger 9-bit groups called bytes.

C

CCD

Charged Coupled Device. This is the kind of sensor is used in scanners, digital cameras, and camcorders to convert the light passing through a lens into the electronic equivalent of your original image.

CD-ROM

Compact Disc Read-Only Memory. This is a disc that resembles a music compact disk but can hold all kinds of digital information, including photographs.

CD-R

Compact Disc Recordable. With these discs, you can write image file data only once, and read it many times.

CD-RW

Compact Disk Recordable Writable. You can write and read these discs many times, but the disks themselves cost more than CD-Rs.

CMOS

Complimentary Metal Oxide Semiconductor. An alternative to the CCD, these sensors are used by many digital cameras. The CMOS chip is simpler to manufacture, so costs less. It also uses less power than CCD chips do, so it doesn't drain batteries as fast. The downside is that the chip does not perform as well as CCD imagers under low-light conditions, but recent digital SLR models are said to have improved performance under less than ideal lighting conditions.

CMYK: Cyan, Magenta, Yellow, and Black. For magazine reproduction, an image is separated into varying percentages of cyan, magenta, yellow, and black. Inkjet printers also use CMYK pigments and dyes to produce photographic quality prints.

CPU

Central Processing Unit. A CPU is what powers your computer, although many cameras and lenses also have built-in CPUs.

compression

A method of removing unneeded data to make a file smaller without losing any critical data (such as image quality, in the case of a photographic file).

color depth

Sometimes called "bit depth," color depth measures the number of bits of information that a pixel can store, and ultimately determines how many colors can be displayed at one time on your monitor. Color depth is also used to describe the specifications of devices such as scanners and digital cameras, as well image files.

cyanotype

The cyanotype was one of the first photographic printing processes and was used for the first photographically illustrated book in the early 1840s. Cyanotype prints are known for their cyan-toned look. Sir John Frederick William Herschel, an English mathematician, astronomer, chemist, and experimental photographer invented the cyanotype process in 1842. He experimented with color reproduction, noting that rays of different parts of the spectrum tended to impart their own color to a photographic paper. It was also Herschel who coined the term "photography" and applied the terms "negative" and "positive" to the medium.

D

Daguerreotype

The Daguerreotype process was introduced in 1839 by Louis Jacques Mandé Daguerre. During processing, a copper plate lightly coated with silver was exposed to iodine vapors created a light-sensitive surface that looked like a mirror. The plate, held in a lightproof holder, was then transferred to the camera and exposed to light. Plates were developed over hot mercury until an image appeared. To fix the image, the plate was immersed in a solution of sodium thiosulfate and toned with gold chloride. If all this sounds hazardous to your health, it was.

DVD

Digital Video Disc. Unlike the 600+MB capacity of CD-ROM discs, a DVD can store 4.7GB or more on a single disc that is the same physical size.

E

EV

Exposure value. A numeric value to describe the exposure where a variety of shutter speed/aperture combinations produces the same exposure given a constant ISO sensitivity. For example 1/250s + f/2 = 1/125s + f/2.8 = 1/60s + f/4 = 1/30s + f/5.6 = 1/15s + f/8, etc.

G

gamma

A measurement of the contrast that affects midtones in an image. One of the differences between Mac OS and Microsoft Windows operating systems is that they have different basic gamma settings. For a Windows computer it's 2.2, while on a Mac it's 1.8. This is why images that look fine on a Mac appear darker on a Windows computer.

gamut

The range of colors that a printer, monitor, or other computer peripheral can accurately reproduce. Every image reproduction device from every manufacturer has a unique gamut. If you find that the output of your color printer doesn't match what you see on screen, you are beginning to understand the need for color management. The image may be "in gamut" for the monitor, but not the printer.

GIF

Graphics Interchange Format. This is a compressed image file format that was originally developed by the CompuServe Information Systems (www.cis.com) and is platform-independent.

gigabyte

Abbreviated as GB; about one billion bytes or (more correctly) 1,024 megabytes.

grayscale

Refers to a series of gray tones ranging from white to pure black. The more shades or levels of gray, the more accurately an image will look like a full-toned black and white photograph. Most scanners will scan from 16 to 256 gray tones. A grayscale image file is typically one-third the size of a color one.

I

ICC

The International Color Consortium is a group of eight large manufacturers in the computer and digital imaging industries. The consortium works to advance cross-platform color communications, and has established base-level standards and protocols in the form of ICC Profile Format specifications to build a common foundation for communication of color information.

ICC profile

An International Standards Organization approved color management standard for specifying the attributes of imaging devices such as scanners, digital cameras, monitors, and printers so the color of an image remains true from source to destination. For more information, visit the International Color Consortium Web site at www.color.org.

icon

A picture or graphic that represents a file or computer program. They are used by graphical user interfaces (GUIs) for operating systems such as Mac OS or Microsoft Windows.

ISP

Internet service provider.

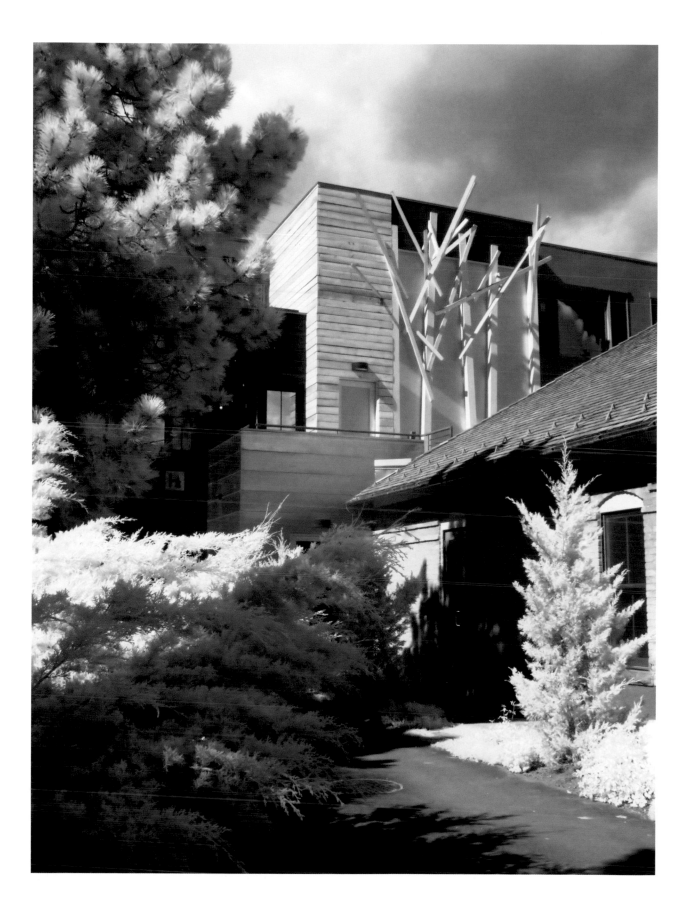

image-processing program

Also referred to as image-editing programs, these are software programs that allow digital photographs to be manipulated and enhanced.

inkjet printer

This kind of printer works by spraying tiny streams of quick-drying ink onto paper to produces high-quality output. Circuits controlled by electrical impulse or heat determine exactly how much ink—and what color—to spray, creating a series of dots or lines that form a printed photograph.

interface

The "real world" connection between hardware, software, and users. This is the operating system's method for directly communicating with you. It's also any mechanical or electrical link connecting two or more pieces of computer hardware.

interpolation

The process of adding pixels to a digital image to simulate higher resolution.

ISO

(1) International Standards Organization. Founded in 1946 with headquarters in Switzerland, the ISO sets international standards for many fields, including photography. (2) Refers to film speed or digital sensor light sensitivity levels. The higher the ISO number, the greater the light sensitivity.

J

JPEG

Joint Photographic Experts Group. JPEG was designed to discard information that the eye cannot normally see and uses compression technology that breaks an image into discrete blocks of pixels, which are then divided in half until a compression ratio between 10:1 and 100:1 is achieved. The greater the compression ratio that's produced, the greater the loss of image quality and sharpness you can expect. Unlike other compression schemes, JPEG is a "lossy" method. By comparison, LZW compression (used in file formats such as GIF) is lossless, meaning no data is discarded during compression.

K

kallitype

A process patented in 1889 by W.W. J. Nicol. It is a printing process based on the light sensitivity of ferric iron salts. The reduced iron compound is used to form an image made of silver. Kallitype silver images are less stable than those of the other similar processes, and they have a reputation for fading. Kallitypes can also be gold or platinum toned, which can make them difficult to distinguish from platinum prints.

kilobyte

KB; 1,024 bytes.

L

layer

In image-processing programs, like Adobe Photoshop, layers are any one of several on-screen independent levels for creating separate but cumulative effects for an individual photograph. Layers can be manipulated independently, and the sum of all the individual effects on each layer make up what you see as the final image.

LZW

Lempel-Ziv-Welch. A compression algorithm used by Adobe Photoshop to perform lossless compression on TIFF files.

M

mask

Many image-processing programs have the ability to create masks—or stencils—that are placed over the original image to protect parts of it and allow other sections to be edited or enhanced. Cutouts or openings in the mask make the unmasked portions of the image accessible for manipulation while the mask protects the rest.

megabyte

MB; 1,024 kilobytes.

moiré

Moiré patterns are an optical illusion caused by a conflict with the way the dots in an image are scanned and then printed. A single pass scanner is all most people require for scanning an original photograph, but when scanning printed material, a three-pass scan (one each for red, green, and blue) will almost always remove the inevitable moiré or dot pattern.

N

ND filter

Neutral Density filters are rated by how many f/stops they decrease your lens aperture setting by. An ND filter lets you control an image when the stated combination of film speed, lens aperture, and shutter speeds won't let you produce the effect you're attempting to produce. These filters are particularly effective for dampening an overly bright part of a scene.

P

pixel

An acronym for picture element. A computer's screen is made up of thousands of these colored dots of light that, when combined, produce a photographic image. A digital photograph's resolution, or visual quality, is measured by the width and height of the image in numbers of pixels.

palladium

A rare metal that was discovered in platinum ores in 1803 and named after the asteroid Pallas by William Hyde Wollaston, an English chemist physicist who developed a way to process platinum ore. Palladium prints use an iron based process are similar to platinum prints, except they are generally warmer in appearance. Palladium is usually less expensive than platinum and is often used by newcomers to platinum printing. In fact, most platinum prints contain a mixture of platinum and palladium.

platinotype

A monochrome photographic printing process that is based on the light-sensitivity of ferric oxalate that reacts with platinum or palladium, reducing it to basic platinum to create an image. William Willis discovered the process in 1873, and the first platinum paper reached the market in 1881 from Willis's Platinotype Company that he founded in 1879.

platinum

These prints are part of the group of processes based on the light sensitivity of iron ferric salts. In the presence of oxalate ions, these are reduced using energy from light to produce iron compounds that react with platinum salts to produce platinum metal. The salts are then removed leaving a stable image. Like the other iron processes, platinum printing is slow and requires a large UV light source, such as the sun, and large format negatives for contact printing.

PNG

Portable Network Graphics. This successor to the GIF format was created by a coalition of independent graphics developers to design a new royalty-free graphics file format.

PPI

Pixels per inch.

R

resolution

A digital photograph's resolution, or image quality, is measured by an image's width and height as measured in pixels. The higher the resolution of an image (i.e., the more pixels it has), the better the visual quality.

RGB

Red, Green, Blue. Color monitors use red, blue, and green signals to produce all of the colors that you see on the screen. The concept is built around how these three colors of light blend together to produce all visible colors.

S

saturation

Often referred to as chroma, it is a measurement of the amount of gray present in a color.

shareware

A creative way of distributing software that lets you try a program for up to thirty days before you're expected to pay for it.

SLR

Single Lens Reflex. In an SLR camera, the image created by the lens is transmitted to the viewfinder via a mirror and the viewfinder image corresponds to the actual image area.

solarization

In 1857 William L. Jackson noted that exposing a partially developed photographic plate to light, then later continuing its development to completion, would sometimes cause a reversal of tones, affecting all or part of the negative. It produces unpredictable effects, with tone reversal usually occurring in the lighter background areas. A distinct black outline is created around areas where the reversal of tone meets areas where it has not occurred.

T

thumbnail

This is an old design industry term for "small sketch." In the world of digital photography, thumbnails are small, low-resolution versions of your original image.

TIFF

Tagged Image File Format. An uncompressed, bitmapped file format that is platform independent.

tintype

Also known as ferrotype or melainotype, this is a photographic process developed in the 19th century that replaced the ambrotype by the end of the Civil War. It then went on to become the most common photographic process until the introduction of modern film. A tintype is a positive image on a thin sheet of iron that has been coated with black lacquer. Prior to placing the plate into the camera, a wet collodion (gun cotton dissolved in alcohol and ether) with silver salts emulsion is applied to the plate. The plate is immediately developed after exposure. Tintypes were used almost exclusively for inexpensive portraiture and were typically placed in a leather case.

TTL metering

Through-the-Lens metering. A system used by cameras to measure the light entering the lens.

V

Vandyke process

One of three alternative photographic methods that rely on the photo reduction of ferric ions rather than silver ions. (Cyanotype and palladium are the other two.) These prints have a rich brown color with subtle gradations in tonality. Vandyke prints are sometimes known as sepia or brown prints.

Index